W9-CFO-295

Cultural Heritage in Asia and the Pacific: Conservation and Policy

Proceedings of a Symposium held in
Honolulu, Hawaii, September 8-13, 1991

Cultural Heritage in Asia and the Pacific: Conservation and Policy

Proceedings of a Symposium held in Honolulu, Hawaii, September 8-13, 1991

Organized by the U.S. Committee
of the International Council on Monuments and Sites
for the U.S. Information Agency
with the cooperation of the Getty Conservation Institute

Margaret G. H. Mac Lean, Editor
The Getty Conservation Institute

DS
12
C85
1993

Photo Credits

Cover Temple bas relief, Bali, Indonesia.
 Steve Satushek / The Image Bank.

Page iv Fresco at Sigiriya, Sri Lanka.*
 Marcel Isy-Schwart / The Image
 Bank.

Page xiv Boroboudor Temple, Central
 Java, Indonesia.* Marc Riboud /
 UNESCO.

Page 104 Konarak, India. Detail of the
 thirteenth-century Sun Temple.*
 Sunil Janah / UNESCO.

Page 117 Symposium participants. Wendy
 Chen.

 *World Heritage Sites

Editing and Project Coordination
 Margaret Mac Lean
Design and Publication Coordination
 Jacki Gallagher
Printing
 Westland Graphics
 Burbank, California

© 1993 The J. Paul Getty Trust

All rights reserved

3 1254 01605 6141

Library of Congress Cataloging-in-Publication Data

Cultural Heritage in Asia and the Pacific : proceedings of a symposium
 held in Honolulu, Hawaii, September 8–13, 1991, organized by the
 U.S. Committee of the International Council on Monuments and Sites
 for the U.S. Information Agency with the cooperation of the Getty
 Conservation Institute / Margaret G.H. Mac Lean, editor.
 p. cm.
 Includes bibliographic references.
 ISBN 0-89236-248-0 : $25.00
 1. Cultural prperty, Protection of--Asia--Congresses.
 2. Cultural prperty, Protection of--Pacific Area--Congresses.
 3. Historic sites--Asia--Conservation and restoration--Congresses.
 4. Historic sites--Pacific Area--Conservation and restoration--
 Congresses. 5. Monuments--Asia--Conservation and restoration--
 Congresses. 6. Monuments--Pacific Area--Conservation and
 restoration--Congresses. I. Mac Lean, Margaret G.H. (Margaret
 Greenup Holmes) II. International Council on Monuments and Sites,
 U.S. Committee. III. United States Information Agency. IV. Getty
 Conservation Institute
 DS12.C85 1993 93-25491
 363.6'9'095--dc20 CIP

US/ICOMOS

The United States Committee of the International Council on Monuments and Sites is one of 65 national committees that form a worldwide alliance for the study and conservation of historic buildings, districts, and sites. The committee serves as a U.S. window on the world by encouraging exchange of information and expertise between preservationists in the United States and abroad. ICOMOS is headquartered in Paris, France.

US/ICOMOS
Decatur House
1600 H Street, NW
Washington, D.C. 20006, U.S.A.
(202) 842 1866

USIA

The United States Information Agency is an independent agency of the executive branch of the United States government that promotes and administers educational and cultural exchange programs to bring about greater understanding between the people of the United States and those of other nations. The USIA is represented in U.S. embassies around the world through the United States Information Service.

United States Information Agency
301 4th Street, SW
Washington, D.C. 20547, U.S.A.
(202) 619 4700

THE GETTY CONSERVATION INSTITUTE

The Getty Conservation Institute, an operating organization of the J. Paul Getty Trust, conducts worldwide, interdisciplinary professional programs in scientific research, training, and documentation, through in-house projects and collaborative ventures with other organizations in the U.S. and abroad. Special activities such as field projects, international conferences, and publications serve to strengthen the role of the Institute.

The Getty Conservation Institute
4503 Glencoe Avenue
Marina del Rey, California 90292
U.S.A.
(310) 822 2299

Contents

Foreword

Preserving the world's cultural heritage for the enrichment and education of present and future generations is foremost in the mission of the Getty Conservation Institute. The opportunity to join efforts with USIA and US/ICOMOS in participating in a conference on cultural heritage issues in the Asia/Pacific region was a unique occasion to contribute to creating awareness for the protection of the cultural heritage.

Too often governmental policies meant to encourage economic development or to increase the rate of growth necessary for the social good fail to consider the implications for cultural property. By the same token, experiences of management of historical or archaeological sites that have been successful in one country or region cannot be easily transferred and applied to another country. But it is important to know of these experiences and to understand the concepts of protection of cultural property at all levels of technical and political decision making.

Participating in the conference that brought together responsible officials from Asia and the Pacific also gave the Getty Conservation Institute the unique opportunity to learn about the problems faced by many authorities regarding the conservation and protection of the cultural heritage and to obtain first-hand information about the most pressing issues in this region.

So many individuals and organizations participated in arranging for this meeting that it would be difficult to recognize all their contributions. Nonetheless I must mention specifically the work of Dr. Margaret Mac Lean as she brought her knowledge, expertise, dedication, and vision in a very special manner to the success of the conference.

Considered choices must be made to save the cultural heritage and to ensure that the image of humanity is defined for now and for the future. The Getty Conservation Institute is happy to have participated in and contributed to this symposium and looks forward to a continuing dialogue on these pressing issues of the artistic and historic legacy of an important part of our world.

Miguel Angel Corzo
Director, The Getty Conservation Institute

Preface

In this symposium, the United States Information Agency (USIA) sought to increase the general awareness of cultural heritage issues in the Asia/Pacific region, bearing in mind the considerable diversity of heritage and of environmental settings in which those issues are confronted today. A variety of conservation concerns challenge the professional communities in the region, focusing on a broad range of issues from historic town centers to museum collections to offshore archaeological sites.

One set of concerns relates to the selection of technical or managerial means for the protection of treasured material and places. Another important set of concerns relates to the policies and mechanisms common in societies all over the world that have the effect of allowing the inadvertent destruction of cultural property. Damage or destruction of significant sites or materials usually occurs because of conflicting interests of public or private agencies or sectors, and results from miscommunication or misstatement of goals. There is a rich heritage of art, archaeology, and architecture in Asia and the Pacific, and the USIA was particularly interested in bringing together the individuals most concerned with its protection to discuss potential solutions to shared regional challenges.

The Agency also sought to stimulate opportunities for increased regional cooperation while establishing new linkages between the region and the United States. Many USIA programs could be enlisted to help counter the diverse threats to the Asian and Pacific cultural patrimony. These include the Fulbright and Humphrey Fellows exchanges, the university and museum linkages projects, overseas libraries and information services, the traveling professional development seminars operated by the U.S. International Visitors Office, and the lecturing and consulting specialists operations. These program opportunities may be utilized at the initiative of the USIS officers at American embassies throughout the region.

A major factor in our support of this symposium is the Agency's responsibility for exercising the President's executive functions under the U.S. Cultural Property Act, which is the legislation that enables American participation in the 1970 UNESCO Convention on the unauthorized trade in cultural property. As a major art-importing country that has ratified the 1970 Convention, the U.S. government is part of the institutional mechanism for making the Convention operational for other signatories, particularly those that are losing unrecorded archaeological and ethnographic material to the U.S. art market. Thus far, the Asia/Pacific region has been underrepresented in this process, but we would welcome the opportunity to collaborate with governments in this region to curb such unauthorized trade. At the same time, we recognize that for such collaboration to be effective in the long term, nations must develop comprehensive cultural resource management systems that are better integrated with national policies for economic development and the environment. Thus, the overarching purpose of the symposium was to advance the notion that successful long-term preservation of cultural resources rests on this premise.

Together with our experienced and knowledgeable partners—US/ICOMOS and the Getty Conservation Institute, both of which provided considerable support and substantive guidance in its development—we earnestly hope that the Hawaii symposium was a major step in achieving the objectives we all so enthusiastically endorse.

United States Information Agency

Acknowledgments

The symposium was possible because of the initiative, support, and sponsorship of the United States Information Agency. Its staff in Washington and in the United States embassies in the countries represented provided invaluable support in assembling this international audience. The symposium was organized and coordinated by the United States Committee of the International Council on Monuments and Sites (US/ICOMOS) in close cooperation with the Getty Conservation Institute.

Private sector grant support for the symposium was generously provided by the Montauk Foundation and the American Express Foundation. Appropriately, the symposium was convened at the East-West Center at the University of Hawaii. The Center's architectural and natural environment contributed to a sustained interaction among the participants and facilitated a productive gathering.

The Pacific Preservation Consortium of the American Studies Department at the University of Hawaii contributed invaluable advice and arrangements for the program, tour destinations, facilities, logistics, and accommodations.

The symposium was planned to allow the foreign participants to relate their discussions to local cultural heritage institutions, programs, issues, and projects in Hawaii. For their extended efforts in planning and conducting a series of related program events and assistance, we are indebted to:

- American Institute of Architects (Hawaii Chapter) for provision of tour guides

- The Bishop Museum for a special tour, reception, and closing ceremony

- Friends for Ewa for the plantation site visit

- The Hawaii Department of Land and Natural Resources for tour destinations

- The Historic Hawaii Foundation for the coordination of local programs

- The Mission Houses Museum for a site tour

- The National Park Service for a site visit to the U.S.S. Arizona Memorial

- The National Trust for Historic Preservation for local advice and assistance

- The Pacific Regional Conservation Center for the tour of its facilities and of archaeological sites

- The Hawaii International Hospitality Center for an evening of home hospitality for symposium participants

Terry Morton, Hon. AIA
President, US/ICOMOS

Endorsement

ICOMOS is proud to congratulate such enlightened bodies as USIA, US/ICOMOS, and the Getty Conservation Institute for the vision and foresight with which they have addressed issues concerning the cultural heritage of Asia and the Pacific.

In an address to the Ministers of Culture in Asia in 1973, we stated the need to learn from the experience of two World Wars, when much of the European cultural heritage in the city centres and in the countryside was razed to the ground. Asia, which had been more fortunate, needed to be wiser and to resist firmly any such catastrophe. On this occasion a resolution was accepted to bring together the senior physical planners of Asia to develop a code of cultural ethics for such calamities of war and peace affecting Asian monuments and sites.

Whatever the ultimate outcome of this resolution be, the monuments and sites in Asia are going the way of Europe at even a faster pace. It is, indeed, opportune that institutions such as the Getty Conservation Institute and ICOMOS are able to spotlight such threats to world culture and to gather those responsible for its protection to deliberate, discuss, and devise strategies to preserve the cultural heritage in this region.

We are delighted to have had the opportunity to participate and to share the enlightened views of experts in these fields. Hopefully, we will be able to make some small dent in raising the consciousness of Asia—and the world—as to the importance of safeguarding the heritage of mankind for future generations.

Roland Silva
President, ICOMOS

Introduction

In September of 1991, US/ICOMOS, under a program sponsored by the United States Information Agency, convened a group of twenty-eight people from fifteen countries in Asia and the Pacific who work in ministries, agencies, and other organizations with important responsibilities in cultural heritage protection. Joined by seventeen conservation and policy professionals from the United States, France, and Australia, they came together to discuss the challenges of conserving their nations' patrimony and to consider how government policies assist or confound this process.

The Getty Conservation Institute worked with both organizations to define an agenda and design a format for the five-day meeting that would encourage the most interesting and productive atmosphere possible. Given the many ways in which the subject of protection of cultural property can be discussed, the organizers considered carefully the selection of the themes in order to achieve these objectives.

We wanted to identify themes that were of recognized and shared interest for the entire region represented in the symposium. Toward this end, we designed a questionnaire to be completed by the invited participants in a conversation with the cultural attaché in the U.S. Embassy in each of the fifteen nations to be represented. By setting up such a meeting, we hoped to open a dialogue that would ultimately advance the interests of the nations involved regarding cultural heritage protection.

From the thoughtful responses to the questionnaire, we learned that one concern at the regional level involved the planned and unplanned consequences of policy in the protection of the cultural patrimony. In this as in other regions of the world, there are government policies—explicit and tacit—that unintention-ally impede or conflict with the effort to protect the cultural resources of these nations. The second overarching concern reflected in the responses to the questionnaire was that many cultural sites are not being managed in a coordinated manner, and losses and damage were resulting from inattention and disordered or ill-conceived priorities.

These two concerns dictated the theme for the entire meeting. As the planning of the substance of the symposium progressed, we all recognized the importance of the ideas for the region, and we determined that we would publish the papers and discussions of the meeting. This book is the result of that decision. Two main presentations were commissioned to frame these issues for discussion in plenary sessions and in working groups. Three background papers were commissioned in response to stated needs for basic information in the region.

In the first presentation to the assembled group, Dr. Lyndel V. Prott addressed the problem of unplanned consequences of policy decisions from her unique vantage point as Chief of the International Standards Section of the Cultural Heritage Division of UNESCO. She highlighted vivid examples of successes and failures from her years of experience in the arena of international law and policy. Sharon Sullivan, Executive Director of the Australian Heritage Commission, addressed the issue of conservation management from her long experience in creating schemes for managing and protecting cultural heritage in non-European contexts. She encouraged the recognition of the value of indigenous approaches and the integrity of local values in the design, analysis, and implementation of policy.

From the questionnaire responses, other research, and experience in the field, the organizers recognized

that the participants in the symposium would also be interested in some very specific information relating to conservation in this geographical and climatological zone. In order to satisfy some of those questions and to level the field for discussion, we commissioned a second group of three papers.

The first, by American archaeologist Dr. Cathy Costin, provides information on the international, regional, and national legislation and other mechanisms that were designed to protect the cultural heritage from damage, deterioration, and illegal export. The second, by Australian conservation scientist and educator Dr. Colin Pearson, deals with issues that affect the protection of cultural property, including storage, presentation, conservation practice, and education of conservators. The third, by Australian architect and educator Steve King, addresses the unique physical conditions found in the Asia/Pacific region, and the properties and dynamics of buildings meant to protect material collections of cultural importance.

The final section of this book, published separately for the conference participants, is a summary of the discussions on the last two days of the conference. It is well known that such summaries can never capture the full value of the exchange of thoughts and force of personalities found in such dynamic company. However, these valuable and enlightening discussions gave rise to some creative ideas that could assist the nations in the region to navigate around potentially damaging policies, and to establish schemes to care for their patrimony in more effective ways.

At the close of five days of listening to and talking with one another in formal and informal sessions, the participants generally agreed that a strong regional network of colleagues and allies can be a great force in this work. Identifying and employing the international institutions and mechanisms established to assist in cultural property protection are essential first steps. The publication of these papers and discussions from the Hawaii symposium was seen by all involved as an important contribution to the work of conservation of the cultural patrimony in the Asia/Pacific region. The Getty Conservation Institute staff who contributed their time and ideas to this conference came away with a sense of the needs and aspirations of the nations represented, and a very positive impression of the dedication of the individuals who so ably represented their countries.

The staff of the Getty Conservation Institute were generous with their support of the planning, realization, and publication of this symposium, particularly Director Miguel Angel Corzo, Dr. Frank Preusser, Marta de la Torre, Dr. Nicholas Stanley Price, and Jacki Gallagher. For their excellent contributions to the development of the agenda of the conference, we are indebted to the other members of the planning group: our moderator Max Bourke, keynote speaker Sharon Sullivan, author and rapporteur Dr. Colin Pearson, symposium coordinator Russell Keune of US/ICOMOS, and organizer Maria Papageorge of the USIA. The entire experience was a rich and positive one for us, out of which has come very valuable information and warm friendships.

Dr. Margaret G. H. Mac Lean
Senior Training Program Coordinator
The Getty Conservation Institute

The Impact of Policy on Cultural Heritage Protection

Lyndel V. Prott

Administrators in charge of cultural heritage are often faced with a difficult problem: The objects and sites under their care can be damaged—sometimes severely—by decisions in which they took no part. Policy decisions made in other areas may have implications for cultural heritage that are overlooked in the decision-making process. Having a carefully thought-out cultural policy and a ministry or unit to administer it is not sufficient, if its best efforts can be frustrated by policies adopted elsewhere. This paper will try to indicate some of the many cases where this can happen, and then look at what can be done to prevent it.

Types of Threat

Many of the threats to the cultural heritage come from other agencies of government. These hazards take many forms, as described below.

DAM CONSTRUCTION

During the 1960s, it seemed that some of the famous monuments of Nubia—such as the temples of Abu Simbel, the temple complex of Philae, and other major temples dating back to the fifteenth century B.C.E.—as well as other important remains were doomed to disappear forever beneath the waters to be dammed by the new Aswan High Dam in Egypt. The decision to flood the Valley of the Kings had earlier been rejected by British engineers, who built a lower dam in order to avoid endangering these heritage sites of outstanding universal value. When it was later decided to flood the valley, on the grounds of economic development, no provision was made to save the monuments. Over a period of twenty years, a worldwide campaign orchestrated by UNESCO resulted in the moving and reconstruction of these monuments in appropriately similar locales, using the very best available expertise. The case is hardly an ideal one to cite, as preservation *in situ* must be the aim of those who act as trustees for future generations of the cultural heritage, but it could hardly have been a more dramatic example of how major decisions of government in areas that initially have little to do with the cultural heritage can in fact be crucial to its survival.

The case of the Nubian monuments spurred the adoption of the 1972 UNESCO Convention Concerning the Protection of the World Cultural and Natural Heritage, according to which a World Heritage List of sites of outstanding universal value was established. As of September 1991, there were 337 sites on this list, and over the nineteen years of its administration many policies have emerged that have affected, or have had the potential to affect, the preservation of heritage sites of world significance.

A relatively recent instance also involved dam construction. The Monastery of Studenica in Yugoslavia was placed on the World Heritage List in 1986. In 1988, information was sent to UNESCO by concerned persons in Yugoslavia that there were plans to build a dam within 10 km of the monastery. Preservationists feared that the consequent rise in humidity would damage the fragile site. An expert mission was sent by the World Heritage Committee to examine the problem. The Yugoslavian government decided to build the dam elsewhere—a decision, it should be noted, that entailed some other disadvantages, since the water at the site originally proposed was apparently less polluted (UNESCO 1988).

ROAD CONSTRUCTION

Economic development often prompts plans for road construction. At a recent session, the Bureau of the World Heritage Committee considered reports on two such projects. One of them concerned a proposal to build a road through the National Park of Niokolo-Kobo in Senegal. An expert study concluded that although the proposed road would risk some damage to the integrity of the park, the suggested alternative route around the park would cause even more damage by bringing more traffic near the park. Special measures to minimize the damage are to be adopted. A different conclusion was reached concerning road plans at Kahuzi-Biezi National Park in Zaire, where an alternative to the originally planned route—which would have passed through the park—was devised (Unesco 1991a).

AIRPORT CONSTRUCTION

The construction of an airport during World War II at Anglesey in the United Kingdom provided minimal time to rescue some treasures of Celtic art at what is considered an important sacrificial site. Whatever could not be rescued in the brief period allowed is now buried under many tons of concrete (Ross and Robins 1989:121–23). When Fiumicino Airport was constructed on the coast of Italy, several historic shipwrecks and wharf areas were discovered from the old Roman port of Ostia. Once again, insufficient time was available for complete archaeological examination.

MINING

The risk of mining to cultural heritage sites has been serious in a number of cases. At Kakadu National Park in Australia, for example, a site important for its natural values as well as its rock art, plans to mine have been the subject of public controversy for many years. The park has been nominated for inclusion on the World Heritage List in three separate stages, the first two in 1981 and 1987. A final decision of the Australian federal cabinet to prevent mining in the third area and to nominate it to the World Heritage List was made only in July 1991 (Unesco 1991b). Mining here, as at Mount Nimba in Guinea, not only threatens the surface appearance but, because of the large scale of modern mining operations, entails the building of towns for the miners and their families, with the necessary infrastruc-

ture of roads, sanitation, water, electricity, and other services—changes that will have a major impact on the environment and whose possible effects on the cultural and natural heritage need to be carefully studied before a final decision is made. Plans at Mount Nimba are being followed with concern by the World Heritage Committee and negotiations with the bodies concerned, including the World Bank, which is financing the project, are under way.

INDUSTRIAL DEVELOPMENT

The large industrial projects required by today's technically advanced economies often pollute air and water and destroy scenic views. Although they may be seen as essential on economic grounds, their placement is often decided without consultation with cultural administrators, who are then left with the task of trying to mitigate their adverse impact on sensitive cultural sites. World Heritage sites in several areas have suffered in this way. The city of Kraków in Poland is contending with the polluting effects of heavy industry in its environs—a nearby ironworks was recently shut down. Atmospheric pollution from a neighboring industrial complex is a problem for Venice, too. There the development of a port, and the dredging of deep navigation channels it required, has contributed to problems of subsidence. Marble disease from pollution has plagued both the Acropolis of Athens and the Taj Mahal in India. The World Heritage Committee is concerned about a planned hydropower plant and an asphalt plant already under construction near Durmitor National Park in Yugoslavia.

HYDROLOGICAL WORK AND LAND RECLAMATION

Flood mitigation measures, the clearance of marshes, and other hydrological work may cause changes in the water table, causing unintended side effects for cultural sites. One of the most potent examples is the case of Venice. A very large industrial and petrochemical complex at Marghera, across the lagoon from Venice, needed great quantities of water to service its industrial processes. The water was pumped from groundwater by means of artesian wells. The unfortunate result was the gradual sinking of the city, a World Heritage site—a subsidence that has made this artistic treasure subject to increasingly severe periodic flooding. An interna-

tional campaign to save Venice is repairing the damage and ensuring restoration, and the artesian wells have been closed. Water is now brought to the industrial complex by an aqueduct to avoid further damage. Another example is Mont St. Michel in France, where land reclamation and flood mitigation measures over a long stretch of time have contributed to the gradual silting of the bay.

URBANIZATION AND TOWN PLANNING

Urban development can be a severe threat to heritage sites. A well-known example was the encroachment of suburban Tunis on the World Heritage site of Carthage. Most of the archaeological zone is now under special protection that forbids new building. The encroachment of habitations from a neighboring village is also of concern near the pyramids of Egypt, and an international committee of experts has recommended the preparation of a master plan to control development there. Tipasa, a Roman site in Algeria, was placed on the World Heritage List in 1982, and became the chief town of its district in 1984, which has created a demand for the construction of new services and facilities. A UNESCO expert, financed by the World Heritage Fund, visited the site and developed an urban plan that would take into account of the need to preserve the heritage values in any new development.

Problems such as these are particularly acute when the site is a living town as well as a historic ensemble. The need to provide modern services to the population—for example, the installation of sewerage and drainage in cobbled streets without appropriate resurfacing, or the intrusion of telephone and electricity cables in ancient districts—unless carefully handled, can damage street surfaces and views. The intrusion of new buildings unsympathetic in style, scale, materials, or workmanship may well destroy the traditional ambience of a site. Problems such as these are being resolved in towns such as Sana'a in Yemen, where a complete project has been devised to take account of all these factors while preserving the traditional streetscape. The International Council on Monuments and Sites (ICOMOS) has produced a Management Guide—currently being revised—for those who are responsible for sites of these kinds. (Copies are available by contacting M. Serge Viau, World

Heritage Towns Colloquium, 2 rue des Jardins, Ville de Quebec, Quebec, Canada.)

Another problem is caused by the unexpected discovery of archaeological remains in the midst of a construction project. Many examples can be given: Two recent ones are the discovery of Shakespeare's "Rose" theater in London during excavation for a building and the unearthing of Viking settlement remains in Dublin during site clearance for new municipal chambers. The discovery of important traces of Viking settlement in York is another well-known instance. Solutions to this problem include rescue archaeology, the zoning of archaeologically sensitive areas to which special conditions are applied, special requirements for surveying in historic areas, and the provision of contingency funds in construction contracts. Wide powers are often given to authorities providing services such as water and telecommunications to cities: Trenching and tunneling can proceed at great speed with modern machines, and unless provision is made for adequate consultation with cultural authorities, considerable damage—often irreparable—can be done to cultural resources.

Urban development also brings increased traffic, including heavy trucks and other vehicles ill-suited to the narrow streets of older areas. Modern traffic may damage the fabric of old buildings because of inadequate clearance. They also create vibrations that can damage old structures. Efforts to ease vehicular access by street widening may worsen the problem for heritage sites. The solution in many cities has been to create pedestrian or light-traffic zones in sensitive areas. To do this requires input from the cultural administrators at the earliest stages of traffic planning.

SLUM CLEARANCE AND MODERNIZATION PROGRAMS

As housing stock ages, municipalities are tempted to clear entire areas so that redevelopment in modern style can take place on a *tabula rasa*. Many older areas suffered this fate in the 1950s. Such drastic clearances appear to have become less popular, now that the bleakness of some of these new districts and the social dislocation caused by them has become evident. More important, programs that have preserved at least some existing features of a neighborhood, and used them in an attractive way, have proved the value of integrated planning.

LAND USE

Changes in land use can also cause serious deterioration. In Kakadu National Park, a World Heritage site in Australia, the introduction of the Asian water buffalo led to damage to the rock art. The buffalo would use the rock to scratch their hides, thus wearing away the paintings. Forest clearance often alters the delicate ecological balance between natural and cultural factors, and sawmills, for example, may also be significant polluters. These problems are being closely monitored in the World Heritage site of Wood Buffalo National Park in Canada. Reports of plans to set up a pig-farming complex near Mont St. Michel were mentioned at the last meeting of the Bureau of the World Heritage Committee; the French delegation assured the Bureau that permission for the project would be denied.

FREEDOM OF TRADE

The desire to increase trade has often led to the reduction of border controls and an increase in international traffic. This may well make it more difficult to prevent theft and illegal export of cultural objects not only from museums and private collections, but also from sites in which potentially movable heritage objects, such as sculptures, frescoes, and mosaics, are an integral part of the complex. Sites such as Sukothai in Thailand and Angkor in Cambodia have suffered seriously from the rapacity of dealers and collectors in wealthy countries, as have many Hindu temples in India. The European Common Market is currently debating what to do when internal border controls among its member states are dissolved. The countries of Eastern and Central Europe, which previously had strict border controls, are now facing serious problems of theft of cultural objects, as material previously inaccessible and difficult to smuggle out can be moved much more easily nowadays. When decisions are made on trading policies that have potentially important deleterious effects on the cultural heritage, considerable attention should be paid to the question of how to ensure control by other means when those historically relied on are no longer available.

A recent example of how decisions on trade may unwittingly affect cultural heritage protection can be seen in Australia. In planning the federal Protection of Movable Cultural Heritage Act 1986 (designed to implement the 1970 UNESCO Convention on the Means of Prohibiting and Preventing the Illicit Import, Export, and Transfer of Ownership of Cultural Property), it was found that the existing legislation on secondhand dealers in the various Australian states with significant markets in antiques sufficiently complied with the obligations in Article 10(a) of the convention, which requires the registration of dealers and their transactions. The legislation was drafted and enacted on that basis. Just before the Instrument of Acceptance was lodged, a notice appeared in some newspapers advertising the work of a new task force in Victoria, set up to try to simplify trading regulations. The task force was proposing to recommend the repeal of the dealers' legislation—it had been given no information by the state government about the UNESCO Convention. A short while later, it was ascertained that the state of South Australia had set up a similar body and was considering the same step. Rather than delay acceptance of the Convention, Australia entered a reservation until this problem had been sorted out. This example shows how easily bodies set up by governments with completely different functions produce results at cross-purposes to those of other governmental entities, owing largely to failures of communication.

HUMAN RIGHTS LEGISLATION

Though human rights legislation may seem to have no bearing on the protection of the cultural heritage, policies aimed to improve the lot of disadvantaged groups may have unforeseen implications for heritage protection. On the one hand, for example, laws in the United States requiring that public buildings be made accessible to physically disabled people (e.g., by wheelchair ramps or elevators) hardly took into account the number of historic buildings that could not be adapted in this way without severely compromising their aesthetic and historical integrity. On the other hand, policies requiring the return of cultural material to indigenous groups in Canada and the United States were often formulated by cultural experts, and intense discussion has ensued in many places on how to best handle such returns so as to be true to the cultural traditions of the relevant group, while at the same time ensuring the optimum achievable protection of the objects concerned.

Changes in Administrative Status

Changes in the way sites are administered may not be devised primarily with cultural sites in mind. For example, transfers of large areas, such as parks that also happen to include important cultural sites, from local to central authorities, or from private hands to trusts, or to authorities who administer national parks, should not take place without careful consideration of the primary tasks of the administering authority. That is, if its primary function is to ensure the use of an area for purposes of recreation and leisure, sporting activities may be encouraged in sites that are culturally sensitive— unless careful thought is first given to this aspect. Such a policy of the United States Forest Service of increasing access for leisure to an area in New Mexico that included Blue Lake, sacred to the Taos Indians, created a policy conflict of this kind (Wilson and Zing 1974).

Taxation and Fiscal Policy

Decisions taken in departments of finance can have a dramatic impact on the preservation of the cultural heritage. A classic example was the Settled Land Act of 1882 in the United Kingdom. Passed at a time of agricultural depression as a means of freeing up transactions and investment in land, it also affected movable cultural objects that would otherwise be inherited with the land. It has been argued that this led to the selling off of the contents of important country houses in the United Kingdom, where the fittings and movables designed for the house or representing the collecting taste of its owners over generations provided much of the site's cultural value and meaning. In 1915, it was estimated that more than half of the major items so sold had already been exported; in recent years the figure must be well over 90%. The process has been accelerated by other aspects of the tax law (Robinson 1979). A capital-gains tax that applies to immovables but not to movables will also encourage the sale of cultural objects out of historic houses.

Fiscal policy can be used to reverse these effects, for example, by providing that the state will accept donations of important cultural objects (which may in fact be left *in situ*) in lieu of death duties, or by granting tax concessions for donations to public collections. An exemption from import duties on cultural materials, a dramatic change in policy in the United States in the early years of this century, led to a great influx of collectors' items (Prott and O'Keefe 1989). In some countries where there is strict exchange control, it has been suggested that this leads to increased export of cultural objects, since cash is converted into movable cultural objects, which can then be taken out of the country.

Subsidies for the repair of old buildings, for the installation of solar hot water systems, and for providing access for the disabled may all have deleterious effects on the immovable cultural heritage, unless they are carefully linked with appropriate controls by cultural experts to ensure that the changes do not destroy cultural values.

Changes to tax laws that formerly gave advantages to the holders of cultural property likewise may have unintended ill effects. For example, the exemption of publicly owned property from local taxes may enable the authorities to retain some old buildings in their existing form, rather than sell them to developers or try to make them commercially viable. If demands to make such properties subject to the same rating system as other properties are successful, however, severe pressure against their retention in their existing form will undoubtedly result. The survival of spacious low-storied colonial buildings in the heart of modern overpopulated cities would likely be jeopardized under such circumstances.

Education

Educational policies may, in the long term, have a profound impact on the preservation of cultural property. Emphasizing the importance of economic development while neglecting to impart the significance of cultural values means that future decision-makers are not alert to the needs of heritage planning. Curriculum changes that lead to less emphasis on history, especially that pertaining to cultural development, may have a similar effect. The desire to enhance the teaching of sciences and technical subjects, though often preached as important by economic planners in developing economies, may have such results as these as an unintended side effect. This can be countered by ensuring that children are exposed to the cultural values in question. In the United Kingdom, for example, school groups participate in archaeological mini-digs; in France there are archaeology-oriented programs in which students take part; and UNESCO is also organizing programs for youth.

Many of the more general ideas afloat in the community have unwitting consequences for the preservation of cultural property. For example, an emphasis on private property, without discussion of the importance of the public administration of goods of community-wide importance—such as museum collections or historic buildings—or on the important values behind policies of access and preservation, may breed insensitivity to the concept of trusteeship for future generations, a concept vital for the future of the cultural heritage. Ideas valorizing "collecting," without some information about its social context and effects, can be equally harmful. Finally, a strong bias toward giving greatest weight to economic factors in policy-making may equally skew the decisions of future policymakers if there is no counterbalancing discussion of cultural values.

Encouragement of Tourism

The importance of tourism as a money-earner is now so patently evident that economic planners may make many decisions encouraging its expansion without full appreciation of what this may mean for the continued preservation of the cultural heritage.

First there are the problems of direct impact: How many visitors can a site absorb without degrading? Deterioration may occur as a result of the humidity created by human breathing in confined areas. Damage of this kind has been detected at the Hypogeum in Malta, the Lascaux caves in France, and the interior of the pyramids (all World Heritage sites). In the last two cases, copies of paintings are being made accessible to visitors nearby to avoid loss of the originals, which will be accessible only to scholars. The simple repeated tramping of feet may wear away floorings and paths not designed for such heavy traffic. The congregation of cars and buses close to sites increases atmospheric pollution, a problem that has been seen at several World Heritage sites, and adjacent parking lots often create visual pollution.

Then there are problems caused by the need to provide special facilities to accommodate tourists: These include toilets, food and drink close to the site, parking lots, souvenir stalls, and visitor centers or site museums. These can encumber the site and, especially when not properly planned, can destroy views, atmosphere, and authenticity. Entrepreneurs have planned

theme parks close to World Heritage sites—at Avebury Manor (close to the Stonehenge complex) and near the Chateau of Chambord and Mont St. Michel in France. Fortunately, none of these has been approved by the national authorities, although one remains under consideration. The World Heritage Committee has had before it complaints of the noise created by helicopters over the Iguazu Falls (in Argentina and Brazil), and a press report of a near crash of a helicopter over a fragile church in Romania has also caused concern. In the late nineteenth century, a desire to ease access to Mont St. Michel led to the building of a causeway to the island, which has contributed to the silting up of the bay, changing the ecology of the area and, over a century, gradually detracting from its island appearance.

A series of small decisions over many years may lead to the progressive deterioration of a site. An international committee, set up to advise the Egyptian government on the management of the pyramids area, included in its report recommendations to remove all modern buildings, platforms, walls, fences, and macadam roads (to be replaced by stabilized sand). It also called for the development of a management plan that would include a light reversible structure to permit the controlling of access to the site, prohibit motorized vehicles, create a fixed route for camels and horses, and exclude all other animals. Funds are available from the World Heritage Fund for the preparation of an appropriate management plan for any site on the World Heritage List.

The desire to please tourists has occasionally led to some decisions directly antithetical to the interests of preserving the cultural heritage. For example, the tourist authority of one country was advertising undersea "wreck hunting" as one of that country's attractions, while the need to preserve the underwater cultural heritage was apparently ignored. An even more insidious danger is the desire to overrestore ruins and historic buildings to provide the tourist with an experience of what the restorer considers the building must have looked like—even where firm historical evidence is lacking—thereby destroying the authenticity of the site and falsifying the record for later researchers.

For issues of this kind, the guide is the Venice Charter (ICOMOS 1966), which forms the basis of the

criteria of authenticity used by the World Heritage Committee. A site will not be placed on the World Heritage List unless it meets the test of authenticity in design, materials, workmanship, or setting. Reconstruction is acceptable only if it is carried out on the basis of complete and detailed documentation of the original and based to no extent on conjecture. Decisions to "restore" are sometimes taken by local authorities, such as elected town councils, without proper input from cultural experts.

Finally, the desire to attract tourists may result in indirect and unforeseen consequences. The pyramids of Egypt, from Giza to Dahshur, were placed on the World Heritage List in 1979. The unplanned development mentioned above occurred after the collapse of an ambitious scheme to develop tourist facilities by the Egyptian government, even after a contract for the design and construction of a tourist complex was signed. The plan created enormous controversy on the basis that the influx of such crowds and the design of hotel and recreation facilities for them would change the ecology of the region, in particular raising the humidity to an unacceptable level for structures that had survived only by virtue of centuries of aridity. The Egyptian government canceled the contract.

Decisions and Legislative Controls

The authorities responsible for the policies that affect the cultural heritage so profoundly are many. Sometimes they are semi-independent statutory bodies—those that manage services such as water, electricity, telephone and telecommunications, and port facilities, for example. They may be special area authorities, such as port authorities, or government departments, such as departments of finance or trade. Sometimes they are ad hoc bodies set up for a specific purpose, such as the small groups established to simplify trading regulations in the Australian states. Sometimes they are bodies carrying out special functions, such as those established for economic planning or development, including those specifically related to tourism. They may be local (municipal) governing authorities, such as city councils planning new headquarters or establishing land use zones. Sometimes the decision-maker is private industry, which may develop highly

sophisticated projects; in some cases, government intervention (whether local or central) may be limited to the process of granting approval.

TECHNIQUES

What techniques should be used to ensure that the needs of the cultural heritage are represented? The following are some of the basic principles.

It is essential to be informed of any impending change at the earliest date. This means establishing a climate wherein every decision-maker in government sees heritage protection as part of his or her function. This will require changes in general education and in the training of public servants. Cultivating contacts in other sections of government is especially important; it is probably of more use to have an alert individual in each relevant section than to build a strong conservation unit that will have only one voice in conservation arguments. The development of ad hoc governmental units should also be monitored, however unlikely it may seem that their activities will affect the heritage.

Cultivate media and citizens' heritage groups. A strong public conservation lobby that is critical of policies insensitive to the cultural heritage can be very effective. Conservation groups in Australia, aroused at the loss of important natural heritage caused by the building of the Franklin Dam in Tasmania, were the major factor in preventing further dam building in Tasmania.

Set up a formal structure whereby all the government bodies likely to be involved in major construction work must involve cultural authorities in the planning stages. The planning of major works such as dams, ports, airports, and major highway networks takes many years. When a great deal of professional effort has already been expended in the planning of such projects, the authorities tend to be reluctant to change their plans and to start again. Once contracts have been entered into, legal obligations and financial considerations make it even more difficult. It is therefore essential that cultural authorities be involved at the outset, when the location of these facilities and their connected infrastructure (pipelines, deep water channels, service roads, etc.) are first being considered.

Require that private organizations involved in construction investigate the possible impact of their projects on the cultural heritage.

LEGISLATIVE RESPONSES

There are patterns of legislation that have proved helpful in reinforcing some of these approaches.

Require environmental-impact statements. The 1969 National Environmental Policy Act of the United States requires all federal agencies to assess the impact on the environment (including cultural resources) of projects at the planning stage. Similar legislation binding their agencies has been passed by the various states, and many other jurisdictions have followed this example.

Assess cultural property in government hands. Since much potentially important cultural property is in government hands (e.g., government buildings, which may include old palaces and their contents, forts, governors' residences, and the like), legislation should require their assessment for cultural importance. An Australian report in 1985 showed a particularly egregious example of a building of architectural importance vandalized by the addition of a totally inappropriate new facade—in this unfortunate case, the Post Office was the culprit (Yencken 1985). The situation has been improved by the setting up of the Heritage Commission, which has established a register of important buildings. This has an educational impact as well as a practical one.

Establish archaeologically sensitive zones. Other systems of law have established archaeologically sensitive zones, or defined sites where construction activity is either forbidden or subject to strict control. In Denmark, the Conservation of Nature Act provides that when finds are made during a project, work is suspended until excavation is carried out by the authorities or the site is acquired. Every known site is entered on a map, and prospective builders can ask whether any known site exists in the area for which a project is planned. In the case of the laying of a gas pipeline 2,000 km long, the entire route was mapped at the planning stage and the line rerouted where necessary to avoid significant sites. The route was then surveyed for any indications of settlement in a zone 30 m wide, and small preliminary investigations were carried out to determine whether a full investigation should be undertaken. Full excavations were undertaken at well-preserved sites. When the pipeline was put down, the removal of topsoil was monitored by an archaeologist to record, if possible, what was lost as a check on the reliability of the surveys and test

excavations. The Danish approach is based on prevention rather than confrontation, and has shown the benefit of "early warning" systems.

Plan laws to require management plans and buffer zones. The World Heritage Committee has in recent years increasingly asked for the creation of a buffer zone around sites before they are listed. These zones may themselves not include anything of outstanding universal value, but their redevelopment in an inappropriate fashion (e.g., by out-of-scale buildings or destruction of views) may destroy some of the values for which the site was nominated to the List. Increased control over buffer areas may therefore be one way to avoid confrontation with planners and speculators. In France, not only heritage buildings can be classified (and thus all restorations, demolitions, and alterations controlled), but also immovables necessary to reveal them better or to rehabilitate them, as well as any buildings within view from the classified building, to a distance of 500 m —and, in exceptional cases, even further [Law of 31 December 1913 on Historic Monuments, Art, 1(2) and (3)]. Any changes in these areas must have the approval of the cultural authorities. The Operating Guidelines devised by the World Heritage Committee for the implementation of the Convention also require both full legislative protection and a management plan— that is, a description of the administrative structures ensuring the long-term control of the site. Funds are available from the World Heritage Fund for technical assistance, emergency assistance, and training in relation to sites on the World Heritage List.

Adopt international standards for cultural heritage preservation. Rules appropriate for the protection of the heritage have been set out in a number of UNESCO recommendations. These are listed in Appendix A and represent a consensus of expert opinions on the issues addressed. The three UNESCO conventions on heritage protection are also very useful as standard setters, even for states that are not party to them. For example, the 1970 UNESCO Convention on the Means of Prohibiting and Preventing the Illicit Import, Export, and Transfer of Ownership of Cultural Property has been the inspiration for many ethical-acquisition policies for museums all over the world, including those in countries whose governments have not yet seen fit to accept the Convention. Adequate protective legislation, together with a manage-

ment plan as required by the World Heritage Committee (UNESCO 1991b), is a useful standard to aim for in the protection of immovables on national lists.

Update and revise legislation according to UNESCO standards. Where legislation needs updating or revising, UNESCO can provide expert help, whether the heritage property concerned is movable or immovable, inscribed on the World Heritage List or not. Expert consultants also advise on management strategies both for movables (e.g., museum collections) and immovables. Of course, though based on standards already developed, such studies are refined to deal with local conditions. Areas of legislation that can be used to forestall policy conflicts include: requiring integrated planning of all major projects and the approval of cultural authorities; the control of archaeologically sensitive areas; requiring environmental-impact studies; providing for rescue archaeology; and adopting reciprocal-return policies for objects in illicit trade (i.e., implementing the 1970 UNESCO Convention on the Means of Prohibiting and Preventing the Illicit Import, Export, and Transfer of Ownership of Cultural Property).

Particular Issues for Countries of the Region

In surveying the present state of cultural heritage protection in South Asia and the Pacific region, there seem to be certain things that could be done to enhance protection, apart from the general question of preventing policy conflicts.

PARTICIPATION IN UNESCO INSTRUMENTS

Studying the needs of cultural heritage preservation in tropical environments in South Asia and the Pacific region, one notes that there are a number of states that are not party to certain of the UNESCO instruments on the protection of the cultural heritage. Those states should consider the advantages of participating in the conventions and should look closely to see what the recommendations have to offer.

PREVENTIVE CONSERVATION

It is important to take steps now to prevent damage from international or civil conflict and natural disaster. The 1954 Convention for the Protection of Cultural Property in the Event of Armed Conflict (the Hague Convention) provides that states should take measures in peacetime to inventory and mark their important cultural immovables, inventory and provide refuges for movables, and make other contingency plans for emergencies (e.g., designating museum personnel and site directors to perform certain urgent safeguarding functions). Lack of such planning is a sorry theme in much of UNESCO's record, even when states are parties to the Hague Convention and where emergencies such as earthquakes or cyclones are known to occur at periodic intervals.

USE OF EXISTING NETWORKS OF INTERNATIONAL COOPERATION

It is important to know and make use of existing international mechanisms for the preservation of cultural property. For example, stolen cultural property should be reported immediately to Interpol and the International Foundation for Art Research (IFAR), both of which publish and keep a watch for stolen cultural property, and to the Canadian Heritage Information Network (CHIN), which has offered the services of its register of missing cultural property to other countries. Severe problems of pillage of archaeological materials should be reported to the United States Cultural Property Advisory Committee within the U.S. Information Agency (USIA), which may decide to impose import controls.

USING THE EXPERTISE OF NONGOVERNMENTAL ORGANIZATIONS

Good results can be obtained from the use of the expertise of nongovernmental bodies, such as ICOMOS and the International Council of Museums (ICOM). Some states in the region have active local sections of these organizations; others do not. Support from such independent international expert bodies may be of considerable help in changing public and governmental attitudes. Direct cooperation among museums in the region already occurs, but it could be expanded. Particular issues of conservation, research, and training in conservation of cultural property should be discussed with the International Centre for the Study of the Preservation and the Restoration of Cultural Property (ICCROM) in Rome.

Protecting the Underwater Cultural Heritage

An urgent need in this part of the world is for the protection, both administrative and legislative, of the underwater cultural heritage. Important finds are being made, and there is scant legislation specifically designed to deal with the special nature of this heritage. Meanwhile, many individuals and groups are approaching governments with proposals for "exploration"—which are really little more than scavenging expeditions—and for the disposal of "finds" in ways that violate the standards provided by the 1956 Recommendation on International Principle Applicable to Archaeological Excavations. Some proffer a form of contract that would give the "excavator" exclusive rights over a wide area for a term of years while providing no guarantee of adherence to excavation methods approved by archaeological expertise, or that qualified scholars will perform the tasks, or that proper conservation of finds will be carried out, or that results will be published—all measures required by the 1956 Recommendations. A UNESCO regional seminar on the protection of the movable cultural heritage for the Asian and Pacific region held in Brisbane in 1986 adopted a Statement of Principle Concerning the Underwater Cultural Heritage (see Appendix B) and recommended the development of regional training schemes. Prott and Specht (1989) include a report of the discussions and the text of the resolutions. Another regional seminar, this time directed to illegal traffic, is currently being organized by the UNESCO Regional Office in Bangkok.

Documenting the Cultural Heritage

The timely documentation of the cultural heritage is essential; it is too late when a site is already under threat or an object has disappeared. Documenting an object allows immediate transmission of data to cooperating bodies when something is missing, and this greatly improves the chances of its recovery. Documenting the cultural values of a site allows an immediate, reasonable, and rationally argued response when any policy is formed that may endanger it. The World Heritage Committee, through the UNESCO Secretariat, is currently organizing a global study of potential World Heritage sites. This is being established on the basis of geocultural areas, and it would be most encouraging to have the input of governments and experts of the region on the relative importance of cultural vestiges of civilizations that are spread over several modern states. For example, vestiges of Hindu civilization are found not only in India and Nepal. The World Heritage Committee is considering Prambanan, a Hindu site in Indonesia. Three Buddhist sites, one in Indonesia, one in Sri Lanka, and another in Thailand, are also being considered, while several other Buddhist sites in Bangladesh (Parharpur Vihara), China (Mogao Caves), and Sri Lanka (the Cultural Triangle) are already inscribed. The global study should reveal other outstanding sites of these great religious, cultural, and architectural movements of outstanding universal value that belong on the List. The World Heritage Committee asks for a comparative evaluation of a site being nominated in relation to other properties of a similar type (UNESCO 1991b, paragraph 13), and regional cooperation could be very helpful in compiling this kind of information.

Enhanced Regional Cooperation

Much more could be done by way of regional cooperation. For example, Malaysia, Singapore, Australia, and Papua New Guinea have been able to prevent a certain amount of illicit traffic by direct cooperation between museum and customs authorities. In 1980, a seminar was held in Tahiti on ways and means of safeguarding the cultural heritage of the Pacific region. It was pointed out at that meeting that most states in the area had little information about the legislation in effect in other states in the area—thus, if an object was presented to a museum in one of these states, museum personnel might not even know if the object was protected by the legislation of its country of origin. UNESCO accordingly commissioned a study on the subject in 1982 (O'Keefe and Prott 1982), which may be outdated in some cases, but nonetheless provides a useful point of reference. Extracts of legislation pertaining to the control of movement in more than 150 nations have also been published, and this will make available some information on other legislation in the South Asian and Pacific region. Extracts from the legislative texts on movable cultural property of the People's Republic of China, India, Indonesia, Japan, New Zealand, Pakistan, the Philippines, and Sri Lanka filled two volumes published by UNESCO in 1984—some of these now need updating. These two volumes also include extracts from the legislation of thirty-seven other countries. The full

texts of the legislation of thirty-one other countries have been published in a separate series (see Appendix C). Unfortunately, lack of resources has halted—temporarily, it is hoped—the publication of this series.

The Brisbane seminar also proposed the adoption of a regional seminar for the protection of the cultural heritage of the region and the conducting of regional workshops on particular issues raised in the seminar.

Conclusion

The tangible cultural heritage of the countries represented at this symposium covers an enormous range of objects and sites of significance. An important task over the next few years will be to maximize their protection. Making sure that their special requirements are taken into account in every government decision will require hard work. Even then, it will not be possible to prevent every hazard to their ideal conservation. It should, however, be possible to prevent unwitting and unnecessary damage; to mitigate the worst effects of decisions of other organs of government; and, often, to provide much better alternatives.

Biography

Lyndel V. Prott is Chief of the International Standards Section, Division of Physical Heritage, UNESCO. She is a widely published author specializing in the protection of movable cultural property, and holds the B.A. and L.L.B. from the University of Sydney, the Lic. Spéc. en Dr. Int. from the University of Brussels, and the D. Juris from the University of Tübigen. She was previously employed in the legal section of the Australian Department of Foreign Affairs and External Territories.

References

ICOMOS

1966 International Charter for the Conservation and Restoration of Monuments and Sites (Venice Charter).

O'Keefe, P. J., and L. V. Prott

1982 Existing Legislative Protection of the Cultural and Natural Heritage of the Pacific Region. UNESCO Doc. CLT/82/WS-35.

Prott, L. V., and P. J. O'Keefe

1989 *Law and the Cultural Heritage.* Vol. 3, *Movement,* p. 577. London: Butterworths.

Prott, L. V., and J. Specht

1989 *Protection or Plunder: Safeguarding the Future of Our Cultural Heritage.* Canberra: Australian Government Publishing Service.

Robinson, J. M.

1979 The Ruin of Historic English Collections. *Connoisseur* 162 (March 1979). [This point was already evident to a government committee in 1914, Curzon (Earl of Keddleston), Report of the Committee of Trustees of the National Gallery Appointed by the Trustees to Enquire into the Retention of Important Pictures in this Country and Other Matters Connected with the National Art Collections (Cd. 7878), p. 4. London: His Majesty's Stationery Office, 1915.]

Ross, A., and D. Robins

1989 *The Life and Death of a Druid Prince.* London: Rider.

UNESCO

1988 Report of the 12th session of the World Heritage Committee. UNESCO Doc. SC-88/CONF.001/13, 9.

1991a Report of the 15th Session of the World Heritage Bureau. UNESCO Doc. SC-91/CONF.002/2.

1991b Operational Guidelines for the Implementation of the World Heritage Convention, UNESCO Doc. WHB/2. Revised March 1991, para. 24 (b)(ii).

Wilson, P. E., and A. O. Zing

1974 What Is America's Heritage? Historic Preservation and American Indian Culture. *University of Kansas Law Review* 413:445–46.

Yencken, D. G. D.

1985 *Australia's National Estate: The Role of the Commonwealth,* p. 140. Canberra: Australian Government Publishing Service.

Appendix A

Conventions and Recommendations of UNESCO
Concerning the Protection of the Cultural Heritage

CONVENTIONS

Convention for the Protection of Cultural Property in the Event of Armed Conflict (the Hague Convention), with Regulations for the Execution of the Convention, as well as the Protocol to the Convention and the Conference Resolutions, 14 May 1954

Convention on the Means of Prohibiting and Preventing the Illicit Import, Export, and Transfer of Ownership of Cultural Property, 14 November 1970

Convention Concerning the Protection of the World Cultural and Natural Heritage, 16 November 1972

RECOMMENDATIONS

Recommendation on International Principles Applicable to Archaeological Excavations, 5 December 1956

Recommendation Concerning the Most Effective Means of Rendering Museums Accessible to Everyone, 14 December 1960

Recommendation Concerning the Safeguarding of the Beauty and Character of Landscapes and Sites, 11 December 1962

Recommendation on the Means of Prohibiting and Preventing the Illicit Export, Import, and Transfer of Ownership of Cultural Property, 19 November 1964

Recommendation Concerning the Preservation of Cultural Property Endangered by Public or Private Works, 19 November 1968

Recommendation Concerning the Protection, and National Level, of the Cultural and Natural Heritage, 16 November 1972

Recommendation Concerning the International Exchange of Cultural Property, 26 November 1976

Recommendation Concerning the Safeguarding and Contemporary Role of Historic Areas, 26 November 1976

Recommendation for the Protection of Movable Cultural Property, 28 November 1978

Recommendation for the Safeguarding and Preservation of Moving Images, 27 October 1980

Appendix B

Statement of Principle Concerning the Underwater Cultural Heritage

Underwater treasure hunters present a serious threat to the cultural heritage. Because of the cost and complexity of diving equipment, treasure hunting is usually carried out by Western salvors or salvage companies. Treasure hunting has until recently involved the research for European ships at the period of colonial expansion. The valuables searched for have been usually gold and silver bullion and specie. Such items when sold at auction pay for the cost of salvage and enable the treasure hunter to refinance searches for new sites. The bullion in vast quantities seldom realizes values greatly in excess of the metal value except where rare examples are found.

The recent discovery of a large consignment of eighteenth-century Chinese porcelain realized $17 million at auction. This sale has identified a new area for the treasure hunter.

To deal with this threat it is essential that a definition be made of what the cultural heritage of a country is and to then enact legislation to protect this heritage. In many cases underwater archaeological sites are inadequately

protected by legislation. Additionally, many countries are not concerned with underwater sites that belong to other cultures. As a result treasure hunters and looters are often granted permission to operate on such sites, with a subsequent division of the recovered material between the country and the salvor. Such agreements should be discouraged. Unless countries develop their own archaeological expertise and control their total underwater heritage, there will be an inevitable erosion of the heritage.

All work on sites of archaeological significance should be carefully controlled. Material from such sites should be kept together as a total collection, and under no circumstances should be sold. Proper attention should be given to conservation, and archaeological standards of excavation should be maintained.

International cooperation is a possible line of support for developing and developed countries. The Association of Southeast Asian Nations (ASEAN) and APAFA

training programs are examples of such programs. The objectives are twofold. First, by gathering together a large group of maritime archaeologists from a number of countries it is possible to carry out major projects, simply because of the concentration of expertise.

Second, such operations present an opportunity for field training. UNESCO would seem to be an ideal organization to sponsor a series of such projects in the region.

If positive steps are not taken immediately it is anticipated that the recent advances that have been made by treasure hunters internationally but particularly in Southeast Asia will result in a tragic loss of essential and important cultural heritage.

UNESCO REGIONAL SEMINAR ON THE
PROTECTION OF MOVABLE CULTURAL PROPERTY,
BRISBANE, DECEMBER 1986

Appendix C

National Laws and Regulations Governing the Protection of Movable Cultural Property

Since its foundation UNESCO has been constantly engaged in an effort to protect cultural property against the dangers of damage and destruction by which it is threatened and, in particular, against those resulting from theft, clandestine excavations, and illicit traffic. The work carried out in this field has shown that national laws and regulations governing the protection of movable cultural property are little known abroad. This has prompted UNESCO to embark upon the publication of legislation in force in Member States.

Two volumes of a compendium containing extracts from the legislation governing the protection of movable property in force in 45 Member States[1] have already been published by UNESCO under the English title "The Protection of Movable Cultural Property—Compendium of Legislative Texts" and under the French title "La protection du patrimoine culturel mobilier—Recueil de textes législatifs."

The publication of national laws and regulations in this field is being pursued in the form of a series of

booklets. Each booklet will, as far as possible, present the full text(s) of the legislation in force in one Member State which specifically concerns the protection of movable cultural property. Since 1985, 26 booklets have been published in English and 25 in French. Five new booklets have been published in Spanish on the legislation in force in the following countries: Ecuador, Honduras, Mexico, Nicaragua, Spain. Copies may be obtained free of charge from: Division of Cultural Heritage, UNESCO, 1, rue Miollis, 75015 Paris, France.

[1] In 1991, these were: Algeria, Austria, Bahrain, Belgium, Bolivia, Bulgaria, Byelorussian Soviet Socialist Republic, Canada, Chile, China (People's Republic of), Czechoslovakia, Federal Republic of Germany, France, German Democratic Republic, Ghana, India, Indonesia, Iraq, Japan, Jordan, Kuwait, Lebanon, Libyan Arab Jamahiriya, Madagascar, Malawi, Mauritania, Mongolia, Nepal, New Zealand, Nigeria, Pakistan, Philippines, Poland, Saudi Arabia, Senegal, Sierra Leon, Sri Lanka, Sudan, Syrian Arab Republic, Uganda, Union of Soviet Socialist Republics, United Arab Emirates, Venezuela, Yugoslavia, and Zaire.

Summary of Published Booklets

BOOKLETS IN FRENCH

Belize	CLT-85/ws/53
Kenya	cc-86/ws/11
Brésil	cc-86/ws/8
Lesotho	cc-86/ws/20
Burkina Faso[1]	cc-88/ws/15
Mali[1]	cc-88/ws/18
Cameroun[1]	cc-88/ws/17
Maroc	cc-87/ws/16
Chypre	CLT-85/ws/57
Mexique	cc-86/ws/21
Egypte	cc-86/ws/9
Nicaragua	CLT-85/ws/58
Equateur	cc-86/ws/17
Panama[1]	cc-88 /ws/14
Espagne	cc-88/ws/16
Qatar	cc-86/ws/12
Haïti	cc-87/ws/24
République de Corée	CLT-85/ws/54
Honduras	cc-86/ws/18
Tanzania (R. Unie)	CLT-85/ws/55
Hongrie	cc-85/ws/19
Tchad[1]	cc-87/ws/13
Iran (R. islamique)	cc-87/ws/15
Tunisie	cc-87/ws/14
Irlande	cc-86/ws/10

BOOKLETS IN ENGLISH

Belize	CLT-85/ws/20
Ireland	CLT-85/ws/24
Brazil	CLT-85/ws/21
Kenya	CLT-85/ws/29
Cuba[2]	CLT-85/ws/26
Lesotho	CLT-85/ws/30
Cyprus	CLT-85/ws/22
Mexico	cc-87/ws/12
Dominican Rep.[2]	cc-88/ws/3
Morocco	cc-87/ws/6
Ecuador	CLT-85/ws/23
Nicaragua	CLT-85/ws/35
Egypt	CLT-B5/ws/27
Norway[2]	cc-87/ws/7
Gambia (The)[2]	CLT-85/ws/33
Qatar	CLT-85/ws/36
Greece[2]	cc-87/ws/5
Republic of Korea	CLT-85/ws/37
Haiti	cc 88/ws/4
Spain	CLT-88/ws/6
Honduras	CLT-85/ws/28
Tanzania (United R.)	CLT-85/ws/25
Hungary	CLT-85/ws/34
Tunisia	cc-88/ws/2
Iran (Islamic Rep.)	cc-88/ws/5
Uruguay[2]	cc-87/ws/8

BOOKLETS IN SPANISH

Ecuador	cc-88/ws/41
México	cc-88/ws/38
España	cc-88/ws/39
Nicaragua	cc-88/ws/42
Honduras	cc-88/ws/40

[1] Exists only in French.
[2] Exists only in English.

Conservation Policy Delivery

Sharon Sullivan

Foundations, Assumptions, and Implications

The fabric of each city, town or cultural land-scape creates a document, which is legible and which describes the economic and social history of its people.... The question is this: As we edit the... text—adding, erasing and reshaping our built environment—will we write in our own dynamic dialect or in an ill-studied universal language, an Esperanto of building?... [T]he contradiction is resolved by the modernisation of tradition itself through a simultaneous process of rejection of the moribund ... and assimilation of its live, vital and relevant elements. The modern does not generate in a vacuum; it grows in the womb of tradition. It does not replace it; it trans-forms it ... [as] a new wave in the ocean of time.

This declaration from *A Sense of Place* (1990), edited by Joan and Serge Domicelj, speaks to us eloquently of some of the key themes of this symposium. In one way however, we can see immediately that it is a very different kind of statement— and on a very different level—from that made by Western-originated conservation conven-tions such as the Venice Charter, and other documents of ICOMOS (the International Council on Monuments and Sites). Such documents have their origins in European culture, and some of the values they espouse are alien to the cultures of many of the countries that have signed on to them. More important, however, they do not in them-selves provide a methodology for achieving a new future

for a nation or culture that arises authentically out of its past. This is because they are aimed at the provision of conservation standards and assume certain givens on which we can no longer necessarily rely—and in some cases, never really could.

In this paper I will review the origins of our cur-rent methodology; point to some problems with its underlying model and to some of its more universal and helpful features; and ask you to consider this ques-tion: What policies and standards shall we use? I then propose to review some elements of policy delivery in the conservation field:

- Legislation and administrative systems
- Identification and documentation
- Conservation planning
- Physical conservation options

In making this review, I am very conscious of the expertise, skills, and diversity of experience of my audi-ence and readers: I do not suppose that I will mention anything that has not been considered before by most of you. I do not have answers—only comments and questions, which may guide us in our deliberations on these matters. There is no good reason why I—rather any of a dozen other participants in this symposium— should be preparing this paper. I can suggest only one reason why my insights might be of use to you: Austra-lia has perforce needed to examine a lot of the tradi-tional European wisdom on this subject, in light of its own needs, and has come up with an adaptation that varies in significant ways from the original, yet still retains a relationship with it. We Australians may there-fore have some useful experience to pass on in this area.

Cultural heritage conservation, as we know it and as it appears in international conventions, is a recent—and not a universal—idea. How did it arise? Henry Cleere (1989:7) traces the desire for the preservation of cultural relics in Europe to the Enlightenment, which led to an appreciation of the material culture of the past. Monuments, temples, buildings, castles, streetscapes, landscapes, and the movable items that relate to them are now listed on European (and other) heritage inventories and museum catalogues (Byrne 1991).

In turn, this appreciation for cultural heritage material turned into a sense of fear at its possible loss, in the face of the great upheavals of twentieth-century European history and the advancing tide of the industrial and postindustrial revolutions. It is fear of their loss that increases the value of things we have previously taken for granted. The speed and scale of social and technical change in the twentieth century is unparalleled in history. It is no accident that it has been in the twentieth century that the Western world's appreciation of its heritage has developed into powerful and well-supported national and international conservation conventions and supporting administrative systems.

Such systems, however, show their ancestry plainly. They do not express a universal view of the value of the past, or its management. We can trace in many cultures a respect for, and an active use of and conservation of, the past over many centuries (see for example "Loving the Ancient in China," by Wang Gungwu, in McBryde 1985). Such traditions vary greatly both in their approach and in their philosophical origins. As Byrne rhetorically asks, "If the heritage management we now see in the West derived from an Enlightenment shift in Western thinking, then how can one account for the presence of this same heritage management of countries of the non-Western world which did not experience the Enlightenment?" (Byrne 1991).

To some extent, as Layton (1989), Byrne (1991), and others point out, the current international heritage conservation conventions, and to a large degree their adaptation to various non-Western countries, is in itself a postcolonial phenomenon, or at least a relic of Western influence. This prevailing conception of heritage is also, on the evidence, a very powerful and attractive idea. It is seen as good citizenship in the international community and as a potentially powerful tool for new

nations seeking to build a "modern" society and to foster national identity and self-esteem in their citizens. Hence most non-Western countries have adapted some form of these conventions or at least acknowledged their worthiness, and many have heritage management units that mirror Western systems. Byrne points out that an examination of the papers on archaeological management presented at the Southampton World Prehistory conference, which came from all over the world, shows that they all adhered closely to essentially Western-bred conservation methodology.

What, then, are some of the implications of the widespread application of this Western model on policy delivery in the Asian/Pacific region?

First, it is clear that the Western model, as well as Western rationale and methodology, can be an imposition on top of traditional values and lifeways that differ from it, and which run "across the grain." To quote Byrne (1991) once again:

> *The problem is… likely to be in the lack of fit between the Western approach to heritage management and indigenous social systems and values, a case of what the development experts call "inappropriate ideology transfer." Non-Western countries do have an appreciation of their past, but they are finding it difficult to develop appropriate mechanisms to implement it, beset, as they are, by outside insistence on the Western model.*

In particular, many non-Western cultures have a spiritual rather than material view of what of their past is valuable. They see individual objects and places as vehicles of great value for communicating deeper, spiritual meanings. The Western view focuses much more on the material aspects of place, and "sees heritage as deductive symbols, with an emphasis on historical legibility" (Wei and Aass 1989). It is this emphasis that leads to the "freeze-frame" methodology we are presented with as an ideal in such documents as the Venice Charter, which may not accord well with a non-Western "sense of place."

We should try not to exaggerate these differences and the resultant methodological difficulties. However, it should be noted that another possible result of the uncritical or unintegrated adoption of nonindigenous

models of heritage conservation can include the encouragement of divisions within the society and the disempowerment of certain sections of the community. The new models may be administered by a new heritage management elite whose values are rather different from those of the population at large, along with their traditional guardians, and the skills and long experience associated with them. Indigenous views and feelings about the past held by the wider community come to be disregarded. Often the definition of the "right" or "correct" training and skill is rewritten and then imposed without consultation or integration. A good example of this is the practice whereby in some areas "heritage items" have been removed from their living context, and their continuous use, with the aim of "conserving" them. They cease, for instance, to be living temples or sacred places and become "historic sites" set in heritage aspic.

Another typical phenomenon, which we have seen often in both Australia and America, is the tendency for the "heritocrats" (Bowdler 1988) to appropriate minority or indigenous culture as the heritage of the nation or the world. Hence the management and interpretation of Aboriginal or American Indian sites and culture passes to the academics and administrators, and effectively out of the ownership and control of their creators. This dispossession has powerful consequences. It constitutes a disinheritance of what is often the only remaining possession of such groups, and it takes control of society's perspective on such minority cultures out of the hands of the people most affected by how their cultures are viewed by outsiders (e.g., see Trigger 1985, Sullivan 1985). This in turn can lead to a tendency to denigrate or discourage traditional use, and to blame or denigrate the traditional users.

The Western model imposes on bodies of cultural material the analytical rigor of categorization, division, and quantification, in place of the synthetic interpretive modes of integration and association. This has important implications for conservation practice at many levels (a point to which I will return later in this paper), but a key point I would like to make now is that there is a tendency for there to be separation—affecting legal systems, administration, and methodology alike—between nature conservation and cultural conservation. This split is detrimental to both, and tends to impover-

ish and isolate our views on, and practice of, conservation of the cultural environment.

Western models are also often out of scale with the societies or nations that seek to adopt them. Many Western solutions are costly and require an infrastructure and level of maintenance that are unavailable in the region, and that are based on assumptions about conditions and priorities that are out of touch with local circumstances.

It is ironic that the new heritage management establishment, and the changes it seeks to impose are in themselves made necessary by the modernization or "development" of non-Western countries, itself a Western import. Many of the factors threatening heritage in the late twentieth century arise directly from this process, and have led (often as a desperate measure) to the imposition of laws and administrative structures that were not really necessary in the past. The complete disappearance of streetscapes, landscapes, traditional lifeways, and indigenous literature and language is proceeding more rapidly than at any time in the past— at a catastrophic rate, in many cases. This is quite symptomatic of the effects of development. A good comparison is with the plethora of anti-pollution laws, standards, and compliance mechanisms, made necessary by the rapid increase in the possibility of major pollution incidents.

So these are some of the well-acknowledged problems and tensions that affect policy delivery in the heritage field. However, it is easy to overestimate these difficulties, while failing to acknowledge the very real strengths of the methodology developed to date, and the real and exciting possibility of developing and enriching it further, through its thoughtful adaption to local needs. There are numerous examples of the adaption of international conventions with flexibility and wisdom. Two specific examples of the successful adaption of the Venice Charter are the Burra Charter, of icomos Australia, and the Declaration of Oaxaca, developed in Mexico. Icomos New Zealand is also developing a document that will be known as the Charter of Aotearoa.

In Australia, the greatest challenge has been to make the Burra Charter applicable to Aboriginal places, and adapt its methodology for use by their Aboriginal custodians. The charter's strength is in the methodology developed for the assessment of cultural values and

the important implications of this for the management of culturally significant places.

We now have some good examples of the flexible application of such principles to Aboriginal places, which has yielded an acknowledgment of the validity and authenticity of Aboriginal views about the primary value of a place and its consequent management. A good example would be the management of the important Aboriginal rock art corpus of the Kimberlies in Western Australia. Here the Western view of the aesthetic and scientific value of the art came into conflict with traditional Aboriginal views about their duty to repaint the sites and to use this process to teach young people in the group about the traditional significance of the art and their duties toward it, and to provide training and practice in traditional repainting methods and techniques (Mowaljarlai and Peck 1987, Bowdler 1988). Basically, it was possible to use the Burra Charter principles and methodology to establish the most significant aspect of sites—that is, their traditional value to their creators—and to thus justify Aboriginal management as outlined above (see also Lewis and Rose 1988, Ward and Sullivan 1989).

The charter recommends that where possible all the established cultural values of the place should be conserved. This is an unusual case, in that one value was considered, in this instance, to be more significant than others, and to require some compromise of other values to ensure its conservation.

Likewise, New Zealand's charter—the Charter of Aotearoa—is being rewritten to include Maori views of significance and value, particularly the Maori belief that places imbued with the spirit of the ancestors should be allowed to decay.

The Mexican Declaration of Oaxaca is another excellent example of an adaptation of an international convention to suit local, indigenous needs. This declaration concerns "cultural heritage in daily life and its conservation through community support." The declaration proposes that conservation methodology "should never be established as an activity lying outside the values, aspirations and practices of communities . . . [nor should it] ignore the very existence of the living heritage of cultural customs and traditions."

A review of the problems of international conventions and standards, and of the imaginative and creative adaptations of them, leads me to suggest that there are some key factors to consider when we come to matching an inherited cultural heritage conservation methodology to the needs of differing societies and political systems.

We need to continually test the models we are using for the appropriateness and effectiveness in the environment in which are trying to use them. The basic elements of our heritage management systems and their expression in legislation and in management structures and conservation practice must arise out of the ethos and social environment of the particular culture we are seeking to conserve. Overall, the power of place and object in the society, and its multifaceted significance to all elements in that society, must be continually kept in view. The development of integrated methods for assessing cultural value is a key task of policy deliverers.

Perhaps the most important consequence of these considerations is the necessity to ensure traditional and community involvement and support at all levels. This is often a slow and difficult path—and one that may produce fewer short-term gains—but in the long run, the conservation of cultural heritage can be achieved, and its integrity and meaning preserved, only by adherence to this principle.

It follows also that heritage practitioners should exercise the utmost caution about the uncritical adoption of recipes from elsewhere, no matter how enticing they may seem, or how appealing the recipe book. In particular, the scale of the proposed measure or policy should be matched with the situation in which it is being applied.

Ideally, the holistic nature of conservation and especially the integration of the cultural and the natural environment should be a principle that guides the development of conservation methodology and practice. (In Australia, under the Australian Heritage Act, this integration is achieved by the use of uniform or matching criteria for natural and cultural heritage. In particular, the Australian Heritage Commission is undertaking an integrated assessment of Australian forests, aimed at identifying all their national estate values—a process that is providing new methodological insight.)

The overall question we have to address in considering this issue is whether it is advantageous to adopt and use an international model, and if so, under which conditions? The adoption of such charters or official

policy and standards has had some advantages in Australia, which are summarized briefly below:

■ It is possible to extract the essential elements of heritage policy from existing international charters and to add particular national or regional requirements.

■ The official adoption of such a charter provides international prestige for local conservation endeavors.

■ The official adoption of such a national charter can be a very powerful conservation argument within the society for which it is written.

■ It also provides a set of standards, terminology, and conservation practices that can be applied throughout the country and used and understood by specialists and government officials.

■ A well-written charter with explanatory notes can be used as a standard for the private sector or local government carrying out conservation work.

Legislation and Administrative Systems

In this volume, Dr. Lyndel Prott has already discussed legislative and administrative systems and the need for international standards and laws, especially for the *in situ* conservation of movable cultural property. Thus I need not go over this ground but can simply refer to some key criteria, which in Australia seem to apply to effective heritage legislation, though many of these are not necessarily applicable in the other countries of the region.

Protective legislation is an expression of an ideal by or on behalf of society. It thus has a powerful symbolic value and can be used to justify and promote conservation, even when its actual force is meager. Often the mere existence of a law protecting sites has a very important psychological effect on the site's owners and visitors, since they recognize the site as something valued by society. Used in this way, legislation is an important management tool. Because legislation is not necessarily the expression of the present political will, however, it is often ineffective—or can be made to be ineffective; that is, when a government finds a particular piece of legislation inconvenient or politically problematical, it can usually overturn it or find a way around it.

Legislation is only a framework in which to work—it is not a management recipe. The more it attempts to prescribe detailed management practices

and actions, the more cumbersome and difficult to administer it becomes. Most of the planning and decision-making done by managers will not have a direct legislative base but will exist within a general enabling legislative framework.

A checklist, based on our experience to date, for the development of good legislation might include the following:

■ Heritage legislation must arise out of the society for which it is intended and must fit with the traditions, mores, values, and political/social structure of that society.

■ It must include strong, mandatory, and workable community involvement and consultation processes.

■ It is closely linked to, and provides for, an administrative structure and ongoing financial support (e.g., by the provision of a heritage fund).

■ It provides specific custodial and/or consultation rights for those groups (if any) particularly and traditionally linked to the heritage material it seeks to protect.

■ It recognizes both the rights of the individual and the fact that cultural property is everyone's heritage. It does provide for resumption by the state in some circumstances.

■ It emphasizes positive and enabling provisions (e.g., tax incentives, education funding, and listing of important places).

■ It has a minimum of deterrent clauses, which concentrate on key areas and which are enforceable.

■ It provides penalty clauses that are real deterrents in the case of serious offenses.

■ It provides for an effective field management component (e.g., local or regional staff and administrative back-up).

■ It is closely linked to, or embodies provisions about, land planning, environmental impact assessment, and land management legislation.

■ It is very simply written and readily comprehensible; it has the "flattest" decision-making structure that is practical.

■ It makes recording and registration procedures for sites mandatory.

■ It allows for—but controls—destructive research by professionals and managers.

■ It protects sites grouped into classes (rather than as individually gazetted places) and defines "damage" and "destruction" broadly.

■ It provides for emergency short-term protection (in the form of "interim conservation orders"), to allow investigation of significance, as well as long-term conservation.

■ It provides for the protection of a buffer zone around the actual site, to allow for its protection from indirect damage.

■ It protects sites on land of any status.

■ It provides for "conservation agreements" with site owners, with monetary incentives for cooperation.

In general, minimum rather than maximum legislation is recommended, especially when there is any question as to whether there exist adequate resources for effective implementation. As a general comment, and without entering into the rationale and complexities of the various international conventions, perhaps the most crucial for nations to adopt are the cooperative conventions that relate to the repatriation of movable cultural property and its protection *in situ*.

Identification, Documentation, and Inventories

The issues we need to consider relate to the establishment of workable recording systems and inventories, and the conservation and usefulness of records and other documentation. A usable and accurate database is the basis for effective heritage conservation, and it must be emphasized that such a database must be (1) designed to meet consumers' needs, (2) integrated with other systems, and (3) flexible and adaptable.

Inventories as we know them today are the tools of centralized, modern bureaucratic operations, where quantification and set rules for assessment are held to be desirable. We do need such tools to manage in our modern environment, but it is easy to fall into the trap of believing that the inventory is the heritage. Inventories and catalogues do not, however, represent the way people think about places or objects. Inventories almost invariably divorce places and objects from the historical and cultural context, and they ascribe to places and objects an importance they cannot have in themselves.

In Australia, cultural managers have built up an impressive inventory of Aboriginal places and have acted to conserve individual places, without recognizing that Aboriginal sacred sites are merely pinpoints or markers in a sacred and significant landscape, created by the ancestral heroes and from which the individual places derive their significance. In the same way, almost any site has a strong cultural landscape—the local regional and wider historical and cultural context—and a physical landscape, and it loses a great deal of its significance, richness, authenticity, and depth of meaning if it is studied or conserved in isolation. As David Lowenthal said recently, "Everything is important, or nothing is important" (personal communication 1991).

The dangers inherent in sampling or grading our history are also apparent. We can legitimately type and grade the temples in Thailand, or the churches in rural England, and decide which are the most typical, the most architecturally worthy, the most spiritually or historically significant, but these five hundred or five thousand buildings and complexes have, *en masse*, a profound effect on the landscape of these places: In a way, they define it and influence its other elements. Sampling—or seeking to conserve the "best" or most outstanding—will not preserve the ambience or sense of place which they give to the landscape. This pervasive quality of heritage is both more important and more fragile than its component parts.

We also need to consider the question of movable objects and their relationship to place. Often it is the authentic objects associated with a place that give it its richness of context, or that serve as a trigger to the imagination. Yet often the artifacts are lost, disposed of, or moved to the national museum for safekeeping. This is often necessary—but the cultural context and the primary significance of objects also need to be taken into consideration.

Conservation Planning

The Venice Charter and adaptations of it, such as the Burra Charter, are really recipes for conservation planning. The overriding question is: To what extent are they necessary, effective, and practical? There are very many conservation plans that have never been implemented sitting on all our shelves gathering dust. There are several reasons why conservation plans are inoperative or ineffective.

Perhaps the first thing to consider in heritage conservation planning is what is necessary and what

Table 1: Heritage Conservation Planning Framework

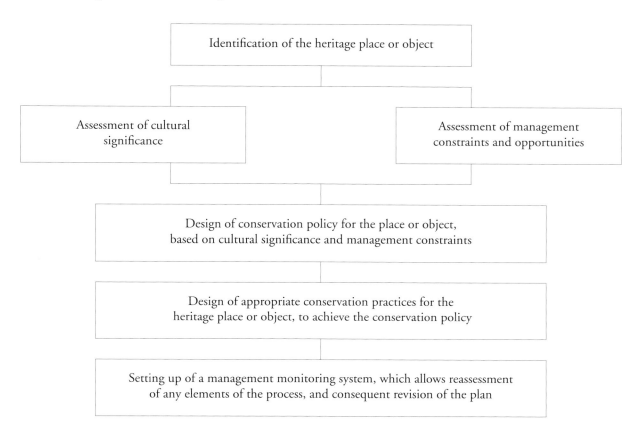

is not. In the face of all the models and the complexities of master plans, management plans, conservation plans, planning guidelines, manuals for site management, and so on, it seems from our Australian experience that we can extract some simple and necessary procedures—as well as a standard order of proceeding—that should be shared in common by the international models and their national or other particular adaptations. These include agreed-upon conservation definitions, planning processes, and sequence. Australia's Burra Charter and its explanatory notes on conservation planning cover all these areas. The charter was written by the members of ICOMOS Australia, including practicing professionals, consultants, academics, and cultural resource managers, representing a good mix of those involved in the discipline and practice of heritage conservation. Their involvement has had the effect of ensuring that the charter and its supporting documents are practical and usable.

The standards and processes are shown in Table 1 and apply to places and objects alike. They are quite

straightforward and logical. Their successful application, however, requires a clear understanding of their limitations and of the flexibility required to interpret them.

The sequence of the procedures is most important. It is crucial to establish the cultural value of the item before planning its conservation and to design a conservation policy that depends on this, as well as on management constraints and opportunities, before taking up the design of appropriate conservation measures.

Significance Assessment

Wide experience confirms that the assessment of cultural value or significance is the essential first step in this process. This may seem obvious, but its neglect is a major factor in poor conservation planning. Table 2 provides an outline of the process.

It is necessary for several reasons to state clearly all the values of a given place. First, an articulated statement about the significance of a place is an essential piece of information for any planner to consider in making basic decisions about the place's future. Second,

Table 2: Assessment of Significance / Cultural Value

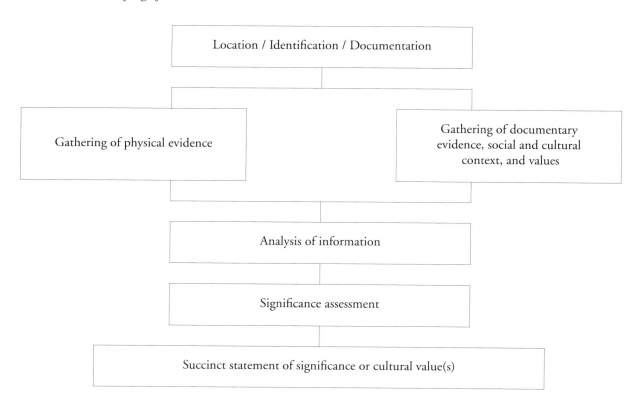

even when we are aware of the value of a place in general terms, and the decision has been made to conserve it, the comprehensive enumeration of all its values is needed for the formulation of a successful conservation plan. The aim of such a plan should always be to retain the cultural significance of the place. If we know of only one value of a place, we may, in aiming to conserve this value, inadvertently destroy another. Hence the conservation of the living tradition of a site is sometimes in conflict with its scientific value, or the social or religious significance of a place to a particular group may be in conflict with its potential educational value to the broader public. In the case of physical conservation, during a "restoration" process, we may unwittingly destroy fabric at least as significant as that which we are attempting to conserve.

The Venice Charter lays great stress on sensitive physical conservation aimed at preserving significant elements that relate to the place's past. However, an emphasis on the historical meaning is not always the automatic outcome of a significance assessment. The process of significance assessment may reveal that the

main value of the object is actually architectural, and that it requires stabilization or restoration (in Venice Charter terms). Or (and this is where the process seems adaptable to differing cultures and traditions) the main value of the item may be as a living spiritual or symbolic icon, which gains its significance by ongoing use, change, and development. Consequently, as Wei and Aass (1989:8) note in a discussion of an appropriate conservation policy for monuments in China that have this kind of value, in the field of the conservation of monuments such as Qufu, the Forbidden City, or Chengdu, allowing continuous repairs or even rebuilding respects this emphasis on the spirit of the original monument. Although the physical form may change, the spirit and purpose of the original not only is preserved as a continuity, but can be enhanced through the contributions of succeeding generations.

The decision on how to proceed in such a situation will depend very much on the value(s) the particular society gives to the place. This social context may dictate some unexpected cultural management options,

such as permitting its ongoing traditional use, a change in custodianship, no intervention, or ongoing renewal and rebuilding.

The concept of assessment of value is loaded with cultural assumptions and cultural interpretations, which make the process both very exciting and, of necessity, subject to differing processes and outcomes. It is rarely clear-cut and never objective (despite the Western bias to both overvalue objectivity and to believe in the possibility that it can be achieved). There are a few issues of further importance in the process of significance assessment. Perhaps they are best phrased in terms of the characteristics of cultural value, or significance:

Significance is almost always multifaceted. The cultural value of a place or object seldom (if ever) resides in a single definable value. Moreover, its value will be different for different elements in society. Perhaps the most common and dynamic clash of values in the late twentieth century is that between "scientific" and "social" values. In archaeology, this conflict is well expressed by Adouasio and Carlisle (1988): "The quest of the 'new archaeology' was to discover nomothetic covering laws to 'explain' human behaviour. The utility or simple desirability of writing culture history took a backseat to more formal hypothetico-deductive model testing." The more we move toward these concepts, the further we move from the present social or societal value and context of heritage sites. In one sense, a profound current of antihumanism lurks within modern scientific research into the past, which leads to serious conflicts between a site's research value and its social value. This is particularly a problem when it occurs in a postcolonial setting—that is, when the heritage material in question is the cultural heritage of an indigenous/minority group.

Significance assessment therefore demands a careful balance between empiricism and humanism (i.e., the values of the traditional culture). We all strive for "objectivity" in assessment, and the standard assessment procedures are designed in part to achieve this neutral, dispassionate stance. However, our initial interest in the material is rooted in humanistic concerns, and in the "love of place" that flows from them. The task for the cultural-resource manager is one of empathetically interpreting the different structures of meaning associated with sites, and of developing a broadly framed understanding of the significance of places in people's lives, in both the present and the past.

Cultural significance cannot be assessed in a cultural or geographic vacuum. The cultural context of the site needs to be assessed, and the site needs to be seen as one manifestation of a complex and changing human society, in order for its value to be fully revealed.

The multifaceted nature of significance has important implications for significance assessment methodology. It is important to ensure that all the key interest groups are involved in significance assessment. In many cases in Australia, regional or local heritage studies have been carried out by professional heritage consultants, but these projects have been termed "hit-and-run studies" because of the lack of community involvement in the assessment and in the proposed conservation solutions. This is one area in which conservation methodology in Australia needs improvement. An interesting study undertaken recently by the Australian Heritage Commission in a small Australian country town confirmed the results of an "expert study" of local heritage by surveying the views of local residents on these matters. There was a pleasing congruence between residents' assessments and those of the experts, but also some interesting differences. Local residents tended to have a more holistic view of the town and to value life processes and rhythms rather than individual buildings or events. They placed much more emphasis on the importance of particular landscape elements in the town's present life pattern and articulated clearly the value of continuity as well as the importance of some elements of change.

Significance or cultural value is always comparative. Ideally, we need to know the universe of such sites before we assess an individual sample. At the very least, sites must be assessed in a regional and local context.

Significance is a dynamic concept. The significance of a site may change as knowledge increases, as society's values change, and as sites become rarer. This means that assessment should be an ongoing process.

Significance or cultural value assessment is more often practiced for places than for objects. Yet such an assessment is an essential prerequisite for the conservation and display strategy for movable objects. To

recognize the importance of this principle, we need only look to the inappropriateness of displaying certain objects—or in some cases, the inappropriateness of attempting to conserve them—when such actions violate, endanger, or destroy the cultural significance the objects hold for their creators.

Conservation Options

Having assessed the significance or cultural value of a place or object, or of a corpus of such items, we often have to assess the options for their conservation. This process depends, in brief, on their value, on their cultural context (what is appropriate in the culture in which they exist), and on the management climate (what goals are practical).

The traditional culture in which these items exist plays a very important role in the conservation strategy chosen. Here once again we find that traditional assumptions and prescriptions stem from European attitudes about preservation and conservation. The Venice Charter was not written in the tropics. It was designed with a more stable climate in mind and with the mind-set that comes from this—one that favors stability, lack of change, and preservation with minimum intervention. Its designers apparently had two major aspects of heritage in mind: the great examples of European development that led to "the Rise of Civilization" (as they saw it) and the monuments that remained of the great "lost" civilizations of the Near East. This outlook can be ludicrously inappropriate when applied to tropical environments. The philosophy, outlook, and values of tropical cultures tend to be radically different with respect to expectations of, and strategies for, conservation. Rebirth and renewal are much more the norm than conservation and immobility. To see this we have only to observe the difference between a medieval European cathedral, rated as to value in terms of its intactness, and a Buddhist temple, rated as to value in terms of its spiritual vitality, most often expressed by change and development.

These issues are closely connected to the important question of "restoration" or "conservation" techniques. Should physical conservation be a role reserved for specialists—a task consigned to an elite equipped with the latest scientific methodology—or should it arise

from traditional practices of use and replacement? Standards of traditional workmanship and conceptualization are high and exacting—as indicated by the traditional Indian measure of good masonry: "An ant should not be able to climb it." Yet modern "scientific" conservation is often necessary, because the process of development and displacement has destroyed traditional crafts. The question we must address, then, is where to place our priorities—whether in the high-tech conservation of a valuable cultural icon, or in the gradual encouragement and restoration of traditional cultural skills and crafts. Here we return to the question of what is desirable for the future—and when the issue is phrased in this way, it seems obvious that, over the long term, only continued traditional use and renewal will conserve the fragile and valuable fabric and spirit of the world's various cultures.

It follows that conservation options must suit the society for which they are designed. This relates not only to the issue of traditional cultural practices and mores, but also to what is actually practical and achievable in a society where the priority afforded cultural conservation is often, perforce, fairly low. High-tech solutions often prove to be short-lived. Even more noticeable to the objective observer is that such measures are often not targeted to the most pressing and simplest of problems. The case of Australian rock-art conservation provides a good example. This body of art is probably the greatest and largest in the world. Many high-tech solutions for its conservation have been proposed. It is certainly true that this art is in an unstable medium, and that it is threatened by natural elements over time.

Complete prevention of natural weathering is almost impossible, and many of the proposed solutions are intensive (with a five- to ten-year lead time), site-specific, and too costly for most conservation authorities. In their effort to discover and document this state of affairs, the researchers proposed very extravagant schemes. However, many overlooked another obvious point: Most of the damage was occurring, dramatically and irrevocably, as a result of the actions of unmanaged or poorly managed visitors. It proved relatively easy, and low-tech, to study visitor behavior and to devise methods to modify it. Often, the simplest and most obvious management tech-

niques are overlooked, even though they return the largest conservation bonus, and require only the simplest methods and technology.

Some Key Elements for the Success of Conservation Planning

It follows from what I have said that conservation planning and conservation practice must be practical and applicable to the local situation. There are numerous models from which to choose. I have discussed some of the options and some of the elements that I consider to be essential. Outside these technical guidelines there are others that relate to the appropriateness of the whole process to the society in which it exists. In brief:

■ Conservation planning must be realistically suited to the cultural and social conditions of the society.

■ Conservation planning must be designed and written with the involvement and agreement of the key players—conservation professionals, local staff, local interest groups, politicians, and so on.

■ Conservation planning and practice must be realistic in terms of cost, technical feasibility, and the ongoing management structure and funding.

■ Conservation planning never takes place in the ideal situation—one that would allow us to contemplate cultural value divorced from proposed use, or to carry out regional assessment prior to site assessment. In the real world, cultural conservation planning is generally carried out under crisis conditions, relating to visitor pressure, to political agendas, and to ongoing social disruption and disempowerment. The key is to operate within this environment to find the most realistic and authentic solution to a complex and exciting problem.

In summary, the major point I have made here about conservation policy delivery is that the conservation policy must evolve from the society whose heritage it seeks to conserve. In this region, we have a unique opportunity and responsibility to develop a new set of such policies, which are an integral part of our developing societies and which respond sensitively to their needs. Furthermore, we have the opportunity to enrich and reinvent the ethos of heritage conservation, and hence to contribute significantly to the ongoing development of the discipline and its practice.

Acknowledgments

I am indebted to many people for the development of the ideas expressed here. I would like to thank my Australia ICOMOS colleagues, and in particular Denis Byrne, for many lively and thought-provoking discussions.

Biography

Sharon Sullivan is Executive Director of the Australian Heritage Commission, the national agency responsible for developing a comprehensive register of areas of cultural and natural significance and for promoting their conservation. She previously served as Deputy Director of the National Parks and Wildlife Service of New South Wales.

References

Adouasio, J. M., and R. C. Carlisle
1988 Some Thoughts on Cultural Resource Management Archaeology in the United States. *Antiquity* 62:234.

Bowdler, S.
1988 Repainting Australian Rock Art. *Antiquity* 62:517–23.

Byrne, D.
1991 Western Hegemony in Archaeological Heritage Management. *History and Anthropology* 5:269–76.

Cleere, H.
1989 Introduction: The Rationale of Archaeological Heritage Management. In *Archaeological Heritage Management in the Modern World*, H. Cleere (ed.). London: Unwin Hyman.

Domicelj, J., and S. Domicelj
1990 *A Sense of Place: A Conversation in Three Cultures.* Canberra: Australian Heritage Commission.

Kerr, J.
1985 *The Conservation Plan.* Canberra: National Trust of Australia (NSW).

Layton, R. (ed.)
1989 *Conflict in the Archaeology of Living Traditions.* London: Unwin Hyman.

Lewis, D., and D. Rose
1988 *The Shape of the Dreaming.* Canberra: Aboriginal Studies Press.

Mowaljarlai, D., and C. Peck

1987 Ngarinyin Cultural Continuity: A Project to Teach the Young People the Culture, Including the Repainting of Wandjina Rock Art Sites. *Australian Aboriginal Studies* 2:71–78.

Sullivan, S.

1985 The Custodianship of Aboriginal Sites in South-eastern Australia. In *Who Owns the Past?*, I. McBryde (ed.). Oxford: Oxford University Press.

Trigger, B.

1985 The Past as Power: Anthropology and the North American Indian. In *Who Owns the Past?*, I. McBryde (ed.). Oxford: Oxford University Press.

Wang Gungwu

1985 Loving the Ancient in China. In *Who Owns the Past?*, I. McBryde (ed.). Oxford: Oxford University Press.

Ward, G., and S. Sullivan

1989 The Australian Institute of Aboriginal Studies Rock Art Protection Program. *Rock Art Research* 6:1.

Wei, C., and A. Aass

1989 *Heritage Conservation East and West.* ICOMOS Information 3.

Legal and Policy Issues in the Protection of Cultural Heritage in South Asia and the Pacific

Cathy Lynne Costin

The cultural heritage is a largely nonrenewable resource. Although new items can and will be added, they cannot replace existing treasures. Neither replicas nor reproductions can take the place of lost or irreversibly damaged property. Cultural property is threatened by dangers of both natural and human origin. Although we can combat many threats with our rapidly developing conservation technology, preventing damage and destruction is preferable to attempting to salvage endangered sites or damaged and defaced property. To avoid problems in the first place, nations need adequate legal and administrative means for protecting their cultural heritage.

The discussion that follows addresses current legislation, administrative procedures, and public policy related to the safeguarding of cultural property in the tropical Asian and Pacific states participating in this symposium.

The Value of the Cultural Heritage

The cultural heritage matters to individuals, ethnic groups, nations, and the international community (Cleere 1989:5–10; Lipe 1984; Prott and O'Keefe 1984, 1989). The values of cultural property are various: symbolic, historic, informational, aesthetic, and economic.

Symbolic Value. Cultural property provides awareness of and pride in cultural identity. In the postcolonial world, the idea of a national cultural heritage is of particular importance to emerging nations, and the protection of cultural property is a highly political issue (Williams 1978:138).

Historic Value. The cultural heritage represents eras and sometimes civilizations that have passed.

Much of this heritage symbolizes a florescence of a region's traditions and cultures. Heritage is often of particular importance to nonliterate societies and to segments of literate societies often ignored in conventional "historical" documents. In countries such as Australia, we see the implications of cultural heritage in connecting Aboriginal communities with their past and with the continuation of traditional lifestyle (Creamer 1983:11).

Informational Value. The cultural heritage is essential to both public education and scholarly research. Archaeologists, historians, and ethnographers use material culture to study ancient and traditional cultures. Information about how other cultures met challenges to their existence can help us as we meet the demands of our own world. The study of other cultures can also lead to new intellectual achievements. For scholars, the greatest informational value comes in studying cultural property within its original context.

Aesthetic Value. The cultural heritage can provide an aesthetic, emotional experience for the viewer, leading to personal growth and development. Moreover, these buildings, artworks, and artifacts can serve as a creative inspiration for contemporary artists, both those working within traditional forms and those working in a modern style.

Economic Value. Cultural property — comprising archaeological sites, monuments, historic buildings and quarters, and archaeological and ethnographic materials in museums — is an important focus of tourism in many nations. As such, this tourism, which can be local, national, or international, generates employment and revenue.

Given the values of cultural property, many problems are created when such material is damaged, destroyed, or removed from its context. These losses include the damage or loss of buildings of historical importance, archaeological sites, monuments, and objects; the loss of traditional knowledge and "scientific" information; the loss of access to objects of cultural or national importance; and the alienation of people from their culture or the loss of national pride.

Threats to Cultural Property

The protection of cultural property involves safeguarding it from willful as well as unintentional damage and destruction. It has been suggested that greed and violence are the two greatest threats to cultural property (Baxter, in Williams 1978:vii). Add to these apathy and ignorance of the value and the irreplaceable nature of cultural property, and we have summarized the key threats of human origin. However, to protect cultural property effectively, we must address the specific hazards it faces, as each threat must be countered with particular strategies.

Movable cultural property is threatened by the following human actions:

- Improper storage and display environments
- Improper maintenance and repair
- Theft
- Vandalism
- War and violence
- Culture change
- Illegal export

Immovable cultural property can be damaged or destroyed by a large number of human actions. These include:

- Neglect, lack of maintenance, and improper repair and rehabilitation
- Demands of industrialization, such as the construction of roads, tunnels, and hydroelectric dams, as well as pollution
- Rural land modification and development, including earthmoving and landform modification for agricultural expansion, mining, quarrying, irrigation projects, dam construction, expansion of rural settlements, and road and highway construction

- Urbanization, including improper alteration for reuse, damage caused by installation and operation of "modern" amenities such as electricity and indoor plumbing, demolition for new construction, and deterioration caused by pollution
- Excessive or underregulated visitation
- Willful damage from vandalism and unauthorized or clandestine excavation/looting
- War and violence
- Culture change

The appropriate physical care of cultural property is covered in this volume by King and Pearson and in the articles and books in the annotated bibliography on the preservation of immovable cultural property. In this paper, I will address the key threats of urban and rural development, underregulated visitation, clandestine excavation, theft, and illegal export.

What Should Be Preserved?

Individuals and agencies charged with the protection of cultural property are faced with the dilemma of deciding what to protect. In practical terms, it is impossible to save everything. Yet one cannot always predict what will be of value or interest in the future. Standards, needs, and interests change over time and tend to reflect the current political, social, and economic climate (Daifuku 1968, Kristiansen 1989, Lipe 1984). For example, a generation ago, archaeologists were most interested in large, complex sites; small sites were not considered interesting or important. Today, however, it is recognized that all sites, large and small, contribute to our understanding of the past. It is from the small sites that we gain information about the daily life of the peasants, fisherfolk, herders, and craftspeople who sustained great cultures. Similarly, changing tastes and research in art history may bring a new focus on previously unknown or underappreciated artists or periods.

At some time the heritage of a given cultural group may be suppressed by the group in power. Traditional objects and structures are sometimes labeled as "savage" or "primitive," and therefore not worth saving (Daifuku 1972). Religious change can also threaten cultural heritage. For example, in Papua New Guinea, recent converts to Christianity occasionally

destroy traditional cult houses and objects. The identification of these traditional structures as protected cultural heritage is now used to intervene in conflicts between missionaries and guardians of the traditional cult houses (Swadling 1983:92).

Research technology has also changed over time, so that scientists can garner increasing amounts of useful data from objects and sites. Forty years ago, undecorated pottery was not collected from archaeological sites or curated because it was thought to contain little information. Today, chemical characterization studies allow us to identify the sources of materials used, and thus permit the reconstruction of exchange networks. Objects and sites that are preserved are available for future study and appreciation; those that are destroyed or discarded are obviously not. As Kristian Kristiansen (1989:27), a Danish archaeologist, has argued:

> *Since each age has its own conception of what is important, and since science is constrained by its own history and by the limitations of methodology, protection should never be assessed either on the basis of research priority or on political considerations. The basic principle in all protection should be that monuments and sites are to be protected in their own right and in all their variety, as far as possible.*

The need, however difficult, is to develop a rational policy that is as free of bias as possible. The Australian National Parks and Wildlife Service has instituted a program of acquisition and preservation of archaeological sites by adopting a set of "themes" (e.g., art, technology) and subthemes. The policy is to balance site acquisition in each category (Buchan 1979:69).

Most countries, however, base their protection policies on today's standards of "importance." For example, the focus in preservation of cultural property is often on objects or places of high monetary value or aesthetic preeminence. Yet mundane objects, structures, and sites that illustrate technology and culture are necessary for a well-rounded view of traditional culture, and if this is the goal of preservation, they too must be saved (cf. Specht 1979).

The challenge in the preservation of a given piece of cultural property is to save as much of its various types of value—symbolic, historic, informational, aesthetic, and economic—as possible for the broadest audience possible. However, the different functions of cultural property meet different interests, and the needs of one group may differ from—and perhaps even conflict with—the needs of other groups (Cleere 1989:11). For example, there may be conflict between the development of an archaeological site for tourism and its preservation for future study or use. Similarly, the desire to put a particularly fragile but significant object on museum display for public appreciation and education may conflict with the curatorial responsibility to safeguard the object—through isolation, if need be. Some cultural resource managers argue that certain objects and sites must be sacrificed to public display and visitation in order to protect others for researchers, the appreciation of future generations, and even posterity. In this case, the issue becomes choosing the "sacrificial" site or object. Again, the relative weight of different needs may have to be evaluated. Individuals concerned with public education or appreciation may wish to display the most handsome or spectacular example, while cultural resource managers argue that a previously affected site or a redundant object should be chosen, knowing that its display will cause it to deteriorate even further.

When cultural property officials choose to preserve something, they must recognize that the function of that object, building, or urban quarter will almost certainly change. As de Varine (1983) points out, most items labeled as cultural property already have been stripped of their traditional context and their functional utility. Cultural heritage officials must often decide what the new function of preserved property will be. For example, objects may be taken out of everyday use and placed on display in a museum. Their traditional, utilitarian function is lost, and they begin to function primarily as objects for aesthetic appreciation. Or these objects may be kept in a museum storeroom and preserved primarily for their scientific or informational value. Similarly, a historic building may be preserved, but converted to a new use, becoming, for example, an office, an inn, or a shopping arcade. Finally, a preserved urban quarter may be converted from a residential neighborhood or industrial complex into a living museum.

Policies and Strategies in the Protection of Cultural Heritage

A number of strategies for protecting cultural property are currently in use in Asia and the Pacific. These include legislative controls on ownership and transfer of both immovable and movable cultural property. There is also a growing body of legislation regulating activities, such as urban development, that directly impact cultural property.

A second set of controls consists of normative attitudes or values. Most important is national recognition of the significance of cultural heritage and public commitment to the stewardship of cultural property. The protection of cultural heritage is constitutionally mandated in some nations (Pakistan is one). In some countries, such as Japan and the People's Republic of China, there is a strong tradition of interest in preservation. This leads to a high degree of compliance with the goals of preservation and protection. Such success seems to be linked to high public interest, education, and strong cultural identity (Sayre 1986).

Nafziger (1983:330) has written an interesting essay in which he explores the roles of "law" (legislation) and "culture" (values and attitudes) in the legal protection of cultural property. Using Italy as a case study, he argues that there have been few studies of the actual efficacy of protective laws. He raises a series of interesting questions that must be answered:

> Have laws facilitated or handicapped the resolution of political and bureaucratic conflicts that have delayed effective responses? Have legal controls contributed to an image of stability as a premise for fund raising? Do the UNESCO agreements and recommendations have any substantial effect? Have criminal penalties deterred thefts, intentional despoliation, and corrupt practices in applying funds?

Ultimately, he argues, cultural property laws will be effective only in conjunction with supportive public opinion and social policy.

A Brief History

Japan and India have the longest history of modern protective legislation in Asia and the Pacific, having passed their first laws concerning the protection of cultural property in the late nineteenth century. Many nations in the region did not pass significant protection legislation until they gained independence. Unfortunately, in many cases legislation was proposed and implemented only after undesirable activities (such as the demolition of historic buildings, clandestine excavation of archaeological sites, or excessive export of movable property) had reached crisis levels.

While those countries with a relatively long history of protective legislation have benefited from the protection they provided, there is a drawback to some of the older legislation. Specifically, this legislation did not anticipate many of the modern issues and problems in cultural heritage protection—and probably could not have done so. Some areas not addressed in this legislation are pollution control, industrialization, and urban development (Thapar 1989a:167). Moreover, interests and ideas about what is "important" and therefore deserving of protection have changed; some types of cultural property now regarded as important (e.g., vernacular architecture) are not covered in early legislation.

Definitions of Cultural Property

Unesco (1970: Article 1) has defined cultural property as property which, on religious or secular grounds, is specifically designated by each state as being of importance for archaeology, prehistory, history, literature, art, or science and which belongs to the following categories:

■ Rare collections and specimens of fauna, flora, minerals, and objects of paleontological interest

■ Property relating to history, including the history of science and technology and military and social history, to the national leaders, thinkers, scientists, and to events of national importance

■ Products of archaeological excavations (including regular and clandestine) or of archaeological discoveries

■ Elements of artistic or historical monuments or archaeological sites that have been dismembered

■ Antiquities more than one hundred years old, such as inscriptions, coins, and engraved seals

■ Objects of ethnological interest

■ Property of artistic interest such as:

 • Pictures, paintings, and drawings produced entirely by hand on any support and in any

material (excluding industrial designs and manufactured articles decorated by hand)

- Original works of statuary art and sculpture in any material
- Original engravings, prints, and lithographs
- Original artistic assemblages and montages in any material

■ Rare manuscripts and incunabula, old books, documents, and publications of special interest (historical, artistic, scientific, literary, etc.) singly or in collections

■ Postage, revenue, and similar stamps, singly or in collections

■ Archives, including sound, photographic, and cinematographic archives

■ Articles of furniture more than one hundred years old and old musical instruments

The protective legislation in the tropical Asian and Pacific states involved in this symposium does not use definitions as detailed as the one cited above. Some use a single term (such as "antiquity" or "national cultural property") to refer to both movable and immovable property. Other countries distinguish legally between immovable and movable cultural property (e.g., between "monuments" and "antiquities" or "relics").

Cultural property can be defined in legislation by delimiting specific categories of objects (e.g., sculptures, paintings, coins, manuscripts, tools), structures (ancient dwellings, temples), and formations (caves). Japan is unique in including intangibles (demonstrated skill in drama, music, the applied arts, and manners and customs) among its four defined types of cultural property. Some nations (India, Indonesia, Malaysia, Myanmar, Nepal, and Singapore) include in the definition of a cultural property the site or land on which the item exists or is believed to exist, thereby extending protection to the land at that site.

A further defining characteristic is date of manufacture or age. Some states use a fixed date. For example, in Malaysia, antiquities are objects made or modified before 1850. The laws of Sri Lanka cover all objects that date from 1815 or earlier. Pakistani law covers objects dating from 1857 or earlier. Other states use a moving date. For example, in both India and the Philippines, "antiquities" means all objects more than one hundred years old. India distinguishes between antiquities and art treasures; the latter are

individually designated works that are less than one hundred years old.

Another defining characteristic is the source of the cultural property. Some legislation (including that of Micronesia, Malaysia, and Pakistan) specifies that to be cultural property, materials or objects must have been manufactured or modified by human activity. Other jurisdictions (Australia, Japan, New Zealand, Papua New Guinea, and the Philippines) include natural places (mountains, geological features) or objects (trees, fossils, minerals) as cultural property if they are of cultural, historic, or scientific significance. New Zealand, Papua New Guinea, and the Philippines specifically include type specimens of native flora, fauna, and minerals as cultural property.

Often, legislation specifies that to qualify as cultural property, material must hold a particular interest or significance, whether archaeological, artistic, scientific, or historical.

Some legislation defines cultural property quite broadly. For example, the People's Republic of China includes all objects of revolutionary, historical, or cultural interest to the state. Other states with broad definitions are the Philippines and Thailand. One drawback to such broad definitions is that they are so vague that they become difficult to interpret (Henson 1989:112).

The remainder of this paper will deal with the protection of cultural property, focusing primarily on antiquities, artworks, ethnographic materials, monuments, sites, historic buildings, and historic urban centers. Specific issues surrounding the preservation of other types of cultural property—including archives, coins, rare books, and natural history specimens—will not be addressed.

DEGREES OF PROTECTION

Rarely are all items of cultural property afforded equal protection in heritage legislation. Two basic strategies are available for designating certain items for special protection. They are (1) categorical classification or enumeration, and (2) individual declaration. In either case, particular cultural property may be referred to as "proclaimed," "designated," or "declared" property.

Some jurisdictions enumerate specific types of objects or categories for protection. The categories may be named in the initial legislation, or heritage authori-

ties may be responsible for determining and publishing the categories. In other cases, particular examples of types or categories may be singled out for special protection. Usually, this is an administrative procedure. Objects or places may be nominated for special protection, or they may be selected from an inventory or survey catalogue.

In addition to making the distinction between designated and nondesignated items or classes of cultural property, there may be a ranking system that defines the degree or type of protection given. For example, Indonesia classes historic buildings into three categories of importance, each of which is afforded a different priority in protection (Suselo 1988:200). Japan distinguishes between national treasures and important cultural property. Undesignated property also receives some protection. For example, two months' notice is required before construction on any inventoried archaeological site. The government has the right to order excavation before the site is destroyed (Tanaka 1984:83). In New Zealand, European buildings are inventoried and classified into one of four categories. The levels of importance range from "meriting recording" (with no mention of preservation) to "permanent preservation considered essential" (McKinlay and Adams 1983:73–76).

Often, only designated resources will be eligible for certain types of preservation grants. For example, inclusion in the Australian Register of the National Estate is a prerequisite for many types of grants in that country (Bourke and Freeman 1983:23).

RESPONSIBILITY FOR PROTECTION
A variety of ministries and agencies are responsible for the protection of cultural property in tropical Asia and the Pacific (see Appendix B for a partial listing of relevant ministries and agencies in the participating countries). Most often, these are ministries of culture or education. Ministries of planning and development may have secondary responsibility, especially for the protection of immovable cultural property.

Many countries assign responsibility for protection to different levels of government. For example, in the People's Republic of China, archaeological sites may fall under national, provincial, regional, or local protection. Usually, monuments are protected at the jurisdictional level at which they are declared important. As of 1989,

more than 500 places were under national protection, more than 3,000 under provincial or regional protection, and about 10,000 under local protection (Zhuang 1989:107). In India, responsibility is divided between the Union government and states. The Union is responsible for all cultural property (ancient, historical, and archaeological) declared by Parliament to be "of national importance." The states are responsible for all other ancient historical monuments and records. The Union and the states have concurrent responsibility for all other archaeological sites and remains (Thapar 1984:65). As of 1989, there were almost 5,000 monuments under central protection and nearly 1,500 under state protection, although Sundaram (1989:262) estimates there are 32,000 ancient monuments without federal or state protection.

Movable Cultural Property

DEFINITIONS AND COVERAGE UNDER CURRENT LEGISLATION
The types of movable property covered by protective legislation vary from nation to nation. Tropical Asian and Pacific countries define movable cultural heritage most broadly to include items of ethnological, archaeological, historic, literary, and scientific value. Countries with such broad definitions include Australia (Hassall 1986:493). Some nations are concerned with objects that have reached a particular age. Indian law covers both antiquities (items more than one hundred years old) and declared "art treasures" produced by designated artists (works of living artists are exempted; Prott and O'Keefe 1988:104). New Zealand is particularly concerned with the protection of ethnographic (i.e., Maori) materials (Prott and O'Keefe 1984:68–69). Papua New Guinea has a heritage law that covers all objects connected with traditional culture, whether archaeological or ethnographic (Prott and O'Keefe 1988:166). Protective legislation in Australia does not cover the works of living artists (Prott and O'Keefe 1989:30). Some countries also differentiate among objects made by various ethnic groups. In Australia, some legislation treats "historical" (by which is meant European) objects differently from Aboriginal "relics," even though all are archaeological materials (Ward 1983:18). Singapore's legislation does not cover movable

cultural property (Duboff 1977). Some legislation enumerates which specific kinds of objects are covered. Materials protected under legislation in countries in Asia and the Pacific include: artifacts, arms, carvings, coins, epigraphs, fossils, inscriptions, jewelry, manuscripts, mineral specimens, ornaments, paintings, sculptures, statues, and tools.

Ownership and Possession

An issue all countries have faced is that of sanctioned ownership of cultural property. Most Asian and Pacific countries have legislation aimed at bringing some or all movable cultural property into government possession. There are four basic means to accomplish this end: (1) government declaration of ownership, (2) compulsory acquisition, (3) government right of preemption under certain conditions, and (4) selective purchase.

In Sri Lanka, all known and undiscovered antiquities, including those in private possession, are the property of the state (Duboff 1977:1061). However, finders of antiquities are entitled to some compensation, provided the discovery is reported within a prescribed period (Prott and O'Keefe 1988:199).

The People's Republic of China, Malaysia, New Zealand, and the state of Western Australia have passed legislation whereby the state claims ownership of undiscovered relics (Prott and O'Keefe 1984:191, Ward 1983:19). Known objects in private possession before the passage of heritage laws usually remain with current private possessors. However, their transfer and sale are often regulated (see below). Malaysia has a mechanism whereby the state can renounce its ownership (Prott and O'Keefe 1984:195). In New Zealand, ownership is vested in the Crown when Maori ownership is unclear, that is, when the traditional owners are unknown (Greenfield 1989:170).

Australia, India, Indonesia, Pakistan, and Papua New Guinea have the power to compulsorily acquire all "relics" (archaeological objects) once they have been discovered (Prott and O'Keefe 1984:196). The Nepalese government may compulsorily purchase an object considered to be in danger of damage or loss (Prott and O'Keefe 1988:152). India's Ancient Monuments and Archaeological Sites and Remains Act, 1958, provides for government purchase at "market value." But, as with many developing countries, there are rarely suffi-

cient funds available for such purposes (Prott and O'Keefe 1989:503).

Bangladesh, Japan, and Pakistan have national legislation allowing the private ownership of archaeological objects, but giving the state the right of preemption if the owner wishes to sell (Prott and O'Keefe 1984:113,197). The Sri Lankan government may preempt a sale only if the object is to be exported (Prott and O'Keefe 1989:503).

In Japan, ownership of objects recovered in an excavation on private land is usually split between the landowner and the discoverer/excavator. If the government wishes to acquire a specific piece, it must fully reimburse the owner(s). Private holders are encouraged to donate their share to a local museum (Tanaka 1984:84).

Some countries, such as Papua New Guinea, strive to keep objects in their traditional functional contexts in local communities (Prott and O'Keefe 1989:46,95). When they cannot be protected in this way, they are moved to other, more secure locations, such as museums.

Australia is trying to balance the need to protect items of Aboriginal origin that have been repatriated to the Aboriginal communities—often with the stipulation from the returning museum or authorities that they be "professionally curated"—and traditional attitudes and needs regarding the handling, accessibility, and viewing of traditional objects. Cultural heritage authorities developed two strategies midway between standard museum storage and retention in traditional locations. The first strategy uses special storage areas within conventional museums. Access to such collections is regulated according to the traditional rules of the Aboriginal "owners" and keepers. The second strategy involves the designation of special, secure "keeping places." These range from small, protective shelters in the bush to European-style buildings in local communities that may function as community museums in addition to storage places (Sampson 1988).

Japan and New Zealand require that private owners of certain cultural resources make them available for study and public display (Prott and O'Keefe 1989:118,213).

Inventory and Registration

Several of the nations represented at this symposium have policies of inventorying or registering movable cul-

tural works. These include Australia, India, Indonesia, Japan, Malaysia, Nepal, New Zealand, Pakistan, Papua New Guinea, the Philippines, and Thailand (Burnham 1974, Duboff 1977, Williams 1978:153). The Papua New Guinea National Museum is working to catalogue *in situ* movable cultural property still in traditional use. In India, the government publishes categories of antiquities and art treasures that must be registered. These include sculpture, paintings, and painted manuscripts (Prott and O'Keefe 1988, 1989). The registration procedure includes the photographing of the object (Thapar 1984:66). In New Zealand, newly discovered objects are registered when they are found, and objects recovered before protective legislation was passed are registered when they change hands.

One problem in establishing or creating an inventory of movable cultural property is that—unlike large-scale immovables—many small items of cultural heritage are relatively easy to conceal. Thus, the discoverers and possessors of such objects are often given incentives to register their collections, especially if the state regulates the transfer of movable cultural property.

Although the primary goal of most inventories of movable cultural property is to regulate and track their movement, cataloging is especially useful in cases of their disappearance (Williams 1978:109).

RESTRICTIONS ON SALE, TRANSFER, AND EXPORT

Federal and state policies on the movement of cultural property vary widely among the participating nations. Policies range from tight restrictions on internal as well as external movement to a virtual "free trade" in movable cultural property.

It is necessary to determine the objective of any laws that control the movement, sale, or transfer of movable cultural property. This is a philosophical issue each nation must decide. For example, is the goal of the legislation to keep the cultural patrimony in the country, regardless of whether it is in public or private possession? Or is the goal to move cultural property or to keep it in the public domain?

Papua New Guinea prohibits the transfer or acquisition of certain types of cultural property (Prott and O'Keefe 1988:166), although field collectors representing scientific, educational, and other cultural institutions may be licensed to make ethnographic collections. Indonesia, Japan, Nepal, New Zealand, Pakistan, and Thailand allow certain items of movable cultural property to remain in private possession and to be traded among individuals, but require that a government agency or registering body be notified when their possession or ownership changes (Burnham 1974, Duboff 1977, Prott and O'Keefe 1989). The Philippine government must approve all transfers of national cultural treasures through sale or inheritance (Prott and O'Keefe 1988:171).

Bangladesh, the People's Republic of China, India, New Zealand, Pakistan, and Thailand control the sale and transfer of movable cultural property by licensing dealers and requiring that they report transactions (Prott and O'Keefe 1989:330, Williams 1978:109). In Papua New Guinea, dealers are licensed, while living artists who sell artifacts of their own manufacture are not subject to controls (Williams 1978:110). New Zealand places restrictions on to whom cultural property can be sold. Specifically, dealers may sell only to licensed auctioneers, licensed secondhand dealers, public museums, or registered private collectors (Prott and O'Keefe 1988:156). Registered private collectors must be residents of New Zealand. Thailand requires prior approval for sale to foreigners (Burnham 1974:144).

Another means of controlling the transfer of movable property is the right of preemption, which permits the government to buy any object offered for sale. Nations with rights of preemption include Bangladesh, Japan, Pakistan, Papua New Guinea, and the Philippines.

Singapore is the only country represented at this symposium that places no restrictions on the export of cultural property or works of art. The others control or prohibit outright the export of antiquities and ethnographic materials. A few prohibit export of most classes of cultural property, except for exhibition or scientific work. Bangladesh prohibits the export of anything more than one hundred years old. India prohibits the export of all antiquities and art treasures. The People's Republic of China maintains an extensive list of cultural property subject to export control (Prott and O'Keefe 1988:47).

Most countries require a permit or license to export cultural property. These include Indonesia, Malaysia, Nepal, New Zealand, Pakistan, Sri Lanka, and Thailand. In most of these countries, permission

can be denied if the object is considered to be of national importance. In Sri Lanka, the National Museum has two months to purchase the item following the time of application for an export permit. After this, the permit cannot be denied (Prott and O'Keefe 1989:503). New Zealand will exempt certain classes of objects from the general export prohibition if "sufficient" examples are already held in public museums in the country (Prott and O'Keefe 1989:481).

Australia uses a control list system for regulating export. Under the 1986 Protection of Movable Cultural Heritage Act, a permit is required to export any item on the National Cultural Heritage Control List/Prohibited Export List. Permits can be denied if the object is deemed important enough (Greenfield 1989:241–42).

Some countries allow the export of certain kinds of cultural property with a permit, while prohibiting outright the export of particular objects or categories of objects. The Philippines does not allow the export of property designated as cultural treasures; permits are required for the export of all other items of cultural heritage. Similarly, no item registered as national cultural property in Papua New Guinea may be exported (Duboff 1977). In Japan, items designated as national treasures or important cultural property can leave the country only for temporary cultural exchange. Other cultural property can be exported with a special license (Sayre 1986:866).

Penalties for the breach of export laws vary among the participating states. Most impose some fine or jail term, the severity of which varies greatly. Also important are provisions for the forfeiture (Australia, New Zealand, and Papua New Guinea) or confiscation (People's Republic of China, India, Malaysia, Nepal, and Pakistan) of the objects involved. The Philippine legislation specifies confiscation and forfeiture to the National Museum (Burnham 1974).

Several Asian and Pacific nations use other means in addition to legislated controls to discourage the export of cultural property. For example, in Australia, Japan, and New Zealand, tax incentives (including those pertaining to donations to universities, museums, and other cultural institutions) have been legislated to encourage people to keep cultural property in the country. Some feel that permitting private collecting within the country functions to keep the cultural heritage within the country (Bator 1983).

CONTROLLING ILLEGAL EXPORT

The question of how to stem the illicit flow of cultural property from the art-rich regions of the world to the art-importing countries has been the subject of numerous books, articles, and symposia (e.g., Bator 1983, Greenfield 1989, Messenger 1989, Meyer 1973, Nafziger 1983, O'Keefe 1983, Prott 1983a, Prott and O'Keefe 1984, Williams 1978).

There is a general debate as to whether the demand for cultural property stems primarily from private collectors or from museums. De Varine (1983) argues that museums account for only a small part of the international demand, but Williams (1978:139) argues that the collecting practices of many First World museums are responsible for the plundering of archaeological sites and the illegal export of cultural property. Ascertaining who wants cultural property and why they collect it is necessary to develop creative and effective solutions to controlling the demand.

Recommendations for ending the unwanted export of cultural property range from cultural to legal solutions (UNESCO 1970, O'Keefe 1983, Prott and O'Keefe 1989). These include the recommendations that countries:

Draft and implement effective national laws and regulations. Before drafting legislation, it is useful to pose questions clarifying the goals of the legislation. For example, is a total ban on all exports desired, or merely the ability to decide which objects will leave the country? Is the desire to keep singularly important objects in the country? Does the government wish the ban on export to be limited in duration, allowing cultural heritage managers the opportunity to build a comprehensive national collection, after which the export of redundant or lesser pieces might be permitted? Legal codes must be drafted precisely. Specifically, the relationships among ownership (whether state or private), export, and recovery (whether by forfeiture or confiscation) must be made clear (see O'Keefe 1983:369).

Establish an inventory of regulated property. Lists and catalogues that explicitly record property that cannot be exported make smuggling more difficult. Detailed records help immensely when a government seeks to recover illegally exported materials. Illustrated registers are the most effective.

Control excavations. The illicit excavation and illicit export are closely linked, since the former provides much of the material for the latter. Well-protected archaeological sites will yield fewer objects for unauthorized export.

Use education, media coverage, and public opinion. The public must be educated about the value of cultural heritage and the losses that are incurred when items of cultural property are illicitly removed from their archaeological contexts or countries of origin. Such education needs to take place in exporting and importing countries alike. The media should not glamorize "treasure hunters" and illicit collections. People need to be informed of the legal restrictions on excavations in their own countries and the countries they visit.

Discourage the collection of illicit materials. Museums and other cultural and educational institutions should be prevented from acquiring illegally exported cultural property from other countries. The prohibition should include both illegally excavated and stolen goods.

Control the transfer of cultural property. Antique and art shops and dealers should be licensed and monitored to make sure they are not trafficking in illicitly exported or imported cultural property.

Redirect or meet the demand. There are a number of ethical and legal ways to accomodate the demand for authentic art. However, research has not been done on the direct relationship between the increase or decrease in illegal trafficking and other ways to satisfy the interest of many people in owning authentic art. It is suggested that a serious look be taken at the possible implications of offering replicas or a compromise position on artifact sales before national policy is developed.

Japan, in particular, is often cited for its "balanced" approach in the management of movable cultural heritage. Selective prohibition of export keeps works deemed most important within the country. Redundant or less important items can be sold or traded internationally. This supposedly satisfies public and private demand abroad (Duboff 1977:78, Griffin 1981:9). However, it must be stressed that Japan is a wealthy, art-importing country. Whatever treasures accidentally slip beyond its borders can be repurchased in the open market, an option that is not available to poorer, developing countries (Prott and O'Keefe 1989:468, Sayre 1986).

Opinions vary on whether this "world art pool" should be geared toward traveling museum exhibitions (e.g, Williams 1978), permanent loans to museums and other cultural institutions (Duboff 1977:118), or being made available for purchase in an open market to museums and private individuals. In the most positive view, such a practice could potentially generate large amounts of revenue for the exporting nation. These monies could be reinvested in the further protection of the cultural heritage (cf. Duboff 1977:126). However, this suggestion sidesteps the issue of keeping collections—especially well-provenienced, scientifically excavated or collected assemblages—together for scholarly purposes. If research is an important objective of the preservation policy, requiring researchers to travel to several locations to study a single assemblage will be extremely costly and time consuming.

Pursue effective international cooperation. Despite the range of national laws aimed at controlling the export of cultural property, there has been relatively little international litigation of illegal export. O'Keefe (1983) argues that there are three reasons for this. First, until recently, this "victimless crime" received little attention from authorities. Second, the high cost of legal action in foreign jurisdictions has deterred many governments. Third, there may be problems in positively identifying materials, especially archaeological objects, as to their country of origin.

While this third issue seems to constitute a "problem" for legal experts, judges, and administrators, it is often no such thing for experts in a particular field of ethnography, archaeology, or art history. For example, art historians can place a painting in a particular epoch and school (and even attribute it to a particular artist or workshop). So, too, can archaeologists identify the time and region of origin of an archaeological object. Although it is true that some objects may be less distinctly attributable to a particular place and time, such items are rarely the focus of international smuggling and theft. The cultural heritage items that circulate on the international art market are the most elaborate and distinctive wares. These are precisely the types of goods that are easiest to identify as to culture and date.

O'Keefe (1983) suggests two areas in which international cooperation can combat the illegal export of cultural property. First, he calls for an international

convention to regulate issues of international law that currently make it difficult to obtain the return of cultural property. These problems include different definitions of bona fide purchase, time limitations on claims, and the reluctance of certain jurisdictions to recognize and enforce foreign laws (cf. Prott and O'Keefe 1989:80). Second, he urges states to enter into reciprocal agreements for the return of cultural property.

MAINTENANCE AND RESTORATION

Most countries require that cultural property—especially when designated as a national treasure or somehow unique—be maintained in good condition by private owners or possessors. Many states can exercise their rights of confiscation or expropriation in cases where cultural resources are not being maintained properly by private owners.

THE ROLE OF MUSEUMS

Museums play a role as educators about cultural heritage and—as discussed above—as repositories of cultural property. Their role is especially critical for states where at least some buildings or artifacts no longer serve their traditional functions, either because the traditions have become extinct or because the specific elements in question were removed from their original context and cannot be reintegrated into ongoing traditions.

Most museums include the preservation of movable art and artifacts as part of their mandate. Charters and enabling legislation for national museums usually contain language specifying responsibilities and restrictions. Most often, museums are restrained from selling or discarding objects from their collections except under extraordinary circumstances.

Several dilemmas are faced by museums because of cultural differences in attitudes toward the collection, public display of certain objects, and scientific research on them. Nowhere is this more current than in the worldwide debate on the repatriation and reburial of indigenous skeletal materials held in museums and universities. For example, Tasmanians have sought the return of skeletal materials housed in museums worldwide, including Australia. Some returned materials were cremated by the Tasmanians to prevent further treatment, which they regard as desecration (Greenfield 1989:157, Prott and O'Keefe 1989:70). This

cremation—destruction in the eyes of Western curators—is counter to the curatorial mandate to preserve and protect, yet was the most appropriate choice of action from the Tasmanian point of view.

A second issue facing regional museums is respect for the wishes of traditional communities regarding objects that are not supposed to be viewed or handled by certain groups, such as women or community outsiders. A third area for consideration is the reconciliation of traditional practice—which may include allowing perishable objects to disintegrate over time—and the contemporary technology and ethos of preservation.

Immovable Cultural Property

DEFINITIONS AND COVERAGE UNDER CURRENT LEGISLATION

The Burra Charter (in Bourke et al. 1983:34) specifically refers to "site(s), area(s), building(s) or other work(s), group(s) of buildings or other works ... [that have] cultural significance [i.e.,] aesthetic, historic, scientific or social value for past, present or future generations." Most states minimally protect archaeological sites and monuments of a certain age. Indian legislation does not cover buildings less than one hundred years old. Recent buildings of historical or architectural importance are not legally protected and are subject to damage or loss (Thapar 1989b:167). Some states specify particular kinds of buildings or structures—such as ancient dwellings, castles, churches, earthworks, monoliths, palaces, shell mounds, temple, and tombs—in their legislation.

OWNERSHIP

As with movable cultural property, a fundamental issue regarding immovable cultural property is question of permissible and preferred ownership. Several countries—the People's Republic of China, Malaysia, New Zealand, and Sri Lanka—and the state of Western Australia have passed legislation establishing state ownership of all known and unrecorded archaeological sites (Burnham 1974, Prott and O'Keefe 1984, Ward 1983). Australia, India, Indonesia, Pakistan, and Papua New Guinea have the power to compulsorily acquire archaeological sites once they have been discovered (Prott and O'Keefe 1984:196). The Singapore government may compulsorily acquire any protected historic building; it

must acquire any protected building used as a dwelling within a year of the issuing of a preservation order.

The Indian law of eminent domain requires the government to compensate the owner at fair market value. There are two problems with this: First, it is difficult to determine the monetary value of something (a monument or archaeological site) for which there is no market; and second, given India's other economic needs, funds are seldom available to pay for the sites (Rao n.d.:13). The Japanese government has a policy of gradually acquiring all protected archaeological sites. The national government makes grants of up to 80% of the cost to local governments and public agencies to purchase privately held cultural resources (N. Ito 1983:61, Tanaka 1984:83).

In Australia, sites on private land can remain the property of the owners, but artifacts cannot be collected and the sites cannot be tampered with or destroyed without the written permission of the appropriate heritage officials. These officials may require salvage archaeology to be conducted before any development can take place there (Flood 1989:81).

Graeme Ward (1983) argues that state ownership makes protection and management easier. In large measure this is because controls on the use and disposal of cultural heritage may conflict with private property rights in some countries. The need to balance these rights in such countries can present inconsistencies in the law. For example, private owners who violate protective laws on their own possessions are sometimes treated less harshly than are individuals who damage or destroy public property or property belonging to another (this is the situation in Japan).

The difficulty of protecting cultural property in private ownership is recognized in many states. In India and Nepal, the state is considered the guardian or custodian of protected immovable cultural property. Some states have the power to expropriate monuments that are not being well cared for by their owners. These states include India, Indonesia, Nepal, Pakistan, Singapore, Sri Lanka, and Thailand.

SURVEY, INVENTORY, AND REGISTRATION
Before items of immovable property can be effectively protected, they must be known to protection authorities. The methods for compiling a record of immovable property are survey, inventory, and registration. Survey is a procedure for systematically locating places of significance. Inventory and registration are procedures for recording information on known property. The result is a catalogue of significant places. The important issues in any survey or inventory program are: (1) what gets listed; (2) who is responsible for the program; and (3) who has access to the information.

Survey, inventory, and registration are valuable tools in the identification, management, and protection of immovable cultural property. Common uses of the resulting catalogues of immovable property include administration, research, documentation, publicity, preparation for legal designation under protective legislation, notification to developers, and as infrastructure in a master preservation plan (Bourke 1983, Sanday 1983, Sykes 1984:21).

The whereabouts of inventoried or registered locations may be reported by surveyors, researchers, the public, government authorities, mining crews, and the like. Many nations and their constituent states require that newly discovered sites be reported to the appropriate authorities. Governments with such requirements include most Australian states, India, Indonesia, Japan, Malaysia, Pakistan, Papua New Guinea, Sri Lanka, and Thailand (Burnham 1974).

Systematic surveys are especially useful because they have as their goal the identification of all sites, monuments, and buildings of a particular class. Surveys afford planners information that can be used to set priorities and make informed decisions about preservation.

Surveys eventually record huge quantities of data. For example, it is expected that the current government program in the People's Republic of China to record immovable cultural property will contain more than 100,000 entries when the project is finished (Zhuang 1989:107).

Countries with large-scale inventory or registration projects under way include Australia, India, Japan, Nepal, New Zealand, Papua New Guinea, and Thailand.

Some nations keep two or more listings that include one documenting all reported significant places, and a second listing only places with special protection. For example, Australia has a federally coordinated plan to inventory Aboriginal and archaeological sites. In theory, all known and newly discovered places are recorded in a central databank. The government

also maintains a Register of the National Estate, which includes sites deemed to be of "significance." Not all inventoried archaeological and Aboriginal sites are on the Register. Nominations for inclusion in the Register can come from a number of sources, including the general public, experts (e.g., anthropologists, art historians), or government authorities. Similarly, Japan maintains a Ledger of Designated Cultural Property, which lists all national treasures and important cultural features. Of the 263,946 Japanese archaeological sites inventoried as of 1984, only 1,163 were designated under the Law for the Protection of Cultural Properties (Tanaka 1984:83).

Some countries record only protected places. India's inventory is the Record of Protected Monuments and Sites, which is maintained by the Archaeological Survey of India. Only sites of importance that have been centrally protected are included. Information is recorded at the Regional Circle level, with a central file for the whole country maintained in the capital. In Malaysia, under the 1976 Antiquities Act, the federal government can declare a place an "ancient monument and historic site" subject to the approval of the government of the state in which the place is found (Buyong 1983:70).

In some participating countries, inventories may be compiled at the state, provincial, or local level rather than the federal or national level. In Australia, each state has set up a separate inventory system for archaeological and Aboriginal sites. A problem with a nonfederal program is that databanks compiled by local authorities are not entirely comparable (S. Sullivan 1983:1). For example, in Japan, there is no unified national policy for registration of sites more recent than the sixth century C.E. (Kofun period). Local boards of education are responsible for site registry. Some boards follow the national policy and record only sites from the sixth century and earlier. Others also register medieval sites or all premodern sites. Some jurisdictions record only castles, shrines, and temples, while small "commoner" villages are rarely recorded (Tanaka 1984:82). Such inconsistencies make the databanks less useful for research. The lack of a unified policy also means that recording will be based on a local subjective decision about what is deemed "important" (see discussion under "What Should Be Preserved," above). Many heritage managers call for

the standardization of the types of data recorded on sites throughout the nation.

The degree of public access to the information in inventories of immovable cultural property varies. There are some valid reasons for not making site information—especially exact location—available to the public on demand, including: (1) sites may not have adequate protection and will be subject to vandalism and unauthorized excavation; (2) indigenous groups may not want the sites visited because they continue to function as secret/sacred places; and (3) private owners may not want uninvited visitors (S. Sullivan 1983). In Australia, site information is classified as open, restricted, or closed. The Australian National Site Register is not considered a public facility (Ward 1979). The number of copies of the records maintained is strictly limited to provide security.

Unfortunately, goals for the use of the information in a catalogue or inventory may conflict. For example, one goal of creating an inventory is to have a master file that identifies sites to help in development and planning. It is often useful to maintain an accessible file of site locations so that planners and developers can research the locations of significant places in areas scheduled for construction or development and plan for appropriate salvage or preservation work. However, public access to site location information puts many sites at risk of vandalism and unauthorized excavation.

MAINTENANCE AND RESTORATION
Virtually all countries have legislation that, at a minimum, makes it illegal to knowingly deface, disturb, or destroy archaeological, cultural, or historic property. Furthermore, many can order private owners to maintain or repair protected monuments. These countries include India, Japan, and Myanmar. India, Indonesia, Nepal, Pakistan, Singapore, Sri Lanka, and Thailand all retain the right to assume guardianship or expropriate monuments if they are not being well cared for by their owners. In Japan, the government will subsidize repairs of registered cultural property owned by private individuals (Daifuku 1972:35). Some countries require official permission or approval before any maintenance or restoration work on protected cultural property can commence.

DEVELOPMENT

The need to emphasize the positive aspects of the compatibility of preservation and economic development is increasingly recognized by cultural heritage managers and development officials alike:

> Conservation of cultural and natural heritage is not an impediment in the struggle for better conditions of human existence. On the contrary, it will enhance and enrich existence, and create economic benefits through the preservation and improvement of tourist attractions. Conservation does not demand large investments. Rather, it is a matter of appropriate planning and legislation, administrative coordination, prevention, maintenance, and educating the people (Pradhan 1988:212, cf. Sundaram 1989).

Preservation can be viewed as a form of economic development. Certainly, cultural property is an important element in the development of a tourist industry (see, for example, Salleh 1988). Archaeological sites, historical monuments, and historically or artistically interesting communities can become the focal points for an incipient tourist industry in developing countries (Daifuku 1972:47). Cultural tourism is important because it generates funds and provides employment opportunities for the local population. Indeed, it has been suggested that Nepal enjoys a 14% return on the investment made in conserving Kathmandu Valley because of increased visitor revenues (Sanday 1983:103).

Other forms of economic revitalization are also associated with conservation. For example, traditional skills and crafts are necessary for the proper conservation and reconstruction of cultural property. Large projects may put many underemployed craftspeople to work. Others will learn new skills that will form the basis of future employment (Feilden 1986, Sanday 1986).

Tax incentives, such as exemptions from property tax, can be used to encourage preservation. Unfortunately, this strategy is often seen as a drawback by local governments in developing countries. Tax-exempt buildings do not generate tax revenues, but their residents and users demand costly city services. Cities may oppose preservation in the conviction that unrestricted development will raise the tax base and therefore raise revenues.

Many jurisdictions control private owners' rights to alter or build on or near designated, proclaimed, or declared historic buildings and monuments. These countries include India, Japan, Nepal, Pakistan, Papua New Guinea, Singapore, and Thailand. In the People's Republic of China, all construction plans must have protective measures for cultural property that would otherwise be damaged or destroyed. There are special procedures for development in protected zones (Prott and O'Keefe 1984:325). Japan similarly regulates construction in areas with known archaeological sites. Authorities can suspend and even stop construction to study or excavate impacted cultural property. They can also require that plans be changed to protect or preserve threatened cultural property (N. Ito 1983:60).

The protection of urban sites and historic quarters has a series of special and sometimes complicated requirements. First, a certain amount of flexibility is required, because people often continue to live and work in these areas. Second, multiple public or private ownership of structures within the zone necessitates special kinds of coordination and cooperation. More generally, urban quarters require a philosophical decision on the goal of protection and preservation: Is the area to be an "open-air museum" that will remain static and unchanging, or is it to be a viable community that must continue to grow and change even if slowly and in a controlled way?

Nowhere is the need to balance economic development and conservation more clear than in the preservation of historic urban areas. Several factors are involved in the successful integration of economic development and conservation in the preservation of historic cities:

■ Public participation in the planning and implementation stages is crucial (de Andrade 1968, Kinoshita 1988). It is especially important where traditionally decisions were made through community discussion and consensus (Sumintardja 1983, Suselo 1988). In such societies, decisions made by outside planners may appear arbitrary and will not be embraced by the local community (Mendis 1988b:xvii).

■ Political stability is necessary for continuity in the planning and implementation processes.

■ A long-term perspective allows for planning beyond expectations of immediate (and often short-term) gains

and permits a more integrated, overall planning process to proceed.

■ A policy on the goals of redevelopment is necessary. A sociological study of current and traditional occupations of the residents is necessarily a part of the decision-making process (Japanese National Commission for Unesco 1971:3). Most often, adaptive reuse will be the most viable economic alternative.

■ It is necessary to coordinate the actions of various public agencies, to keep them from conflicting with one another (de Andrade 1968, Sanpaolesi 1972). For example, those charged with development and those charged with conservation may both claim jurisdiction over an area, each with a different program for its future. Sometimes, there is no formal contact between cultural heritage officials and officials responsible for development (e.g., Swadling 1983:93). The Japanese National Commission for Unesco (1971:8) suggests that an education program be established to familiarize those responsible for planning and protection with the goals and methods of each other's fields. Better understanding should lead to cooperation.

■ It is necessary to include a buffer or protective zone around urban monuments and historic quarters to regulate development that might obstruct an important view or interfere with the atmosphere of the place (Sanpaolesi 1972). Chinese legislation expressly calls for such a buffer zone around protected sites (Zhuang 1989:105), as does the Indian Ancient Monuments and Archaeological Sites and Remains Act, 1958 (Rao n.d.:14).

■ There is a whole series of issues specific to urban areas that also must be addressed. These include zoning, vehicular traffic, parking, utility poles and wires, and the placement of electric street lights and neon advertising signs.

Archaeological sites are often protected from development through official designation of the areas around them. Malaysia provides for the protection of archaeological sites through the creation of "archaeological reserves." On these reserves, no cultivation, building, or destruction of trees is permitted (Prott and O'Keefe 1984:200). Other nations that provide for the designation of protected archaeological areas are India, Papua New Guinea, and the People's Republic of China (Prott and O'Keefe 1984:200–1). Some states protect their archaeological sites within a broader system of national parks and reserves. These include states in Australia and New Zealand.

In the case of archaeological sites where damage or destruction is inevitable, sites must be professionally excavated to salvage the maximum amount of information available.

Excessive or Underregulated Visitation

Undercontrolled or excessive human visitation— especially at poorly developed cultural heritage sites—can lead to damage caused by repeated touching or climbing, erosion, deliberate vandalism, deposit disturbance and compaction at archaeological sites, and dust stirred up by human walking (Herrmann 1989, Walsh 1984).

Cultural tourism is an important and desired activity for both visitors and hosts. The challenge to cultural resource managers is to mitigate the amount of damage visitors can cause to sites. The following issues emerge as principles of visitor management for cultural resource sites (see Flood 1979a, K. Sullivan 1984, Walsh 1984):

■ Choose sites for cultural tourism deliberately. Sites already visited or threatened should be selected over unvisited and unthreatened sites. Chosen sites can be promoted and publicized to draw public attention away from other sites. Many cultural resource managers argue that information about the location of some sites should be withheld from the general public to discourage unsupervised visitation (e.g., Walsh 1984:10).

■ Consider and minimize the negative impact on the local population. Work with the local population during the selection and development phases. Pay specific attention to cultural differences and traditional attitudes toward sites.

■ Have a detailed management plan prepared and implemented before opening the site for public visitation. This plan should include a survey of the surrounding region to ensure adequate knowledge of other cultural resources that may require special protection. It is also necessary to understand the impact of infrastructural services such as roads, food purveyors, and camping grounds.

■ Determine and enforce the carrying capacity of the site. It may be necessary to require that visitors make reservations. Practices such as requiring visitors to book

camping spaces near remote sites in advance may also help to limit the number of visitors.

■ Physically keep cars away—to reduce pollution and to maintain the ambience.

■ Develop adequate protective measures to keep visitors away from sensitive parts of the monument, building, or site. Options include boardwalks and trails, protective screening, low guidance fences, and high protective fences. Although some or all of these may detract aesthetically from the site, they are essential for protecting the resources. Studies show that "well-defined barriers and carefully marked signs and routes greatly reduce unintentional, if not willful" damage (Gale 1984:33).

■ Education, presentation, and interpretation are important. People are less likely to damage sites when they understand what they are viewing and feel satisfied with the level of information presented. A high standard of presentation should be attained. There should be several levels of information available to visitors, ranging from basic general education information to in-depth interpretive material. There is some disagreement as to the effectiveness of guided interpretive walks and chaperoned visits in relation to preventing unintentional damage, vandalism, and graffiti (cf. Walsh 1984).

■ Channel the "acquisitive instinct" through the sale of souvenirs, postcards, and the like. The opportunity to purchase high-quality color photographs and slides will also discourage people from breaching walkways and barriers to take photographs.

■ Discourage graffiti but give visitors an opportunity to "leave their mark" or react to the site in some way. A visitors' book will allow tourists to express their comments and reduce graffiti (K. Sullivan 1984). Should any defacement occur, remove it immediately.

■ Discourage vandalism and remove or repair its effects immediately; visible vandalism encourages more vandalism (K. Sullivan 1984).

LEGAL AND ILLEGAL EXCAVATION

Clandestine excavations are conducted to discover relics or antiquities that are buried in archaeological sites. The illicit excavator may keep these objects for a personal collection or may sell them for profit. Whatever the goal, this activity destroys sites and the information they contain. Such excavations are conducted in a careless, unscientific fashion. Unwanted objects (such as sherds, plant remains, bones, and plainwares) are broken and left scattered or piled in heaps on the site surface. Walls may be torn down and buildings destroyed. Information and historic, aesthetic, and economic value are lost.

Virtually all nations define and prohibit unauthorized excavations. Bangladesh, India, Indonesia, New Zealand, Pakistan, and Thailand have general laws prohibiting archaeological excavation on public or private lands for the purpose of discovering or recovering relics without government permit. Malaysia and Sri Lanka expressly forbid private owners from excavating on their own land (Prott and O'Keefe 1984:225).

Bona fide archaeological investigations include survey, surface collection, and excavation. Most nations regulate some, if not all, aspects of legitimate archaeological investigation. Most nations (Australia, People's Republic of China, India, Indonesia, Malaysia, Nepal, Pakistan, Papua New Guinea, the Philippines, Singapore, Sri Lanka, and Thailand) require researchers to obtain permits for their work. Japan requires that researchers report their intent to excavate. The government may issue instructions or prohibit the excavation (Burnham 1974:99).

India and Pakistan further regulate the conduct of the excavations (for example, no structures can be disturbed or dismantled without permission) and the kinds of analysis that may be run on recovered objects (Prott and O'Keefe 1984:243–300). Pakistan also regulates the staffing on archaeological projects, including specifying the types of experts that must be included on the team (Prott and O'Keefe 1984:248).

There are other regulations of archaeological research as well. Malaysia, New Zealand, and Pakistan all require archaeologists to receive the permission of private landowners before a permit for excavation (or exploration) will be granted (Prott and O'Keefe 1984:251). Some states in Australia require that archaeologists consult with local Aboriginal communities before or during their research (Creamer 1983:10). Similarly, New Zealand requires the consent of the appropriate Maori association before the excavation of certain sites (Prott and O'Keefe 1984:251). Clearly, a combination of legal controls and public policies is necessary to eliminate the illicit excavation of archaeological sites:

■ Require authorization for all archaeological explorations and excavation.

- Require all fortuitous discoveries of archaeological sites to be reported to appropriate authorities in a timely fashion.
- Promote public education and media coverage. The public must be educated about the destructive nature of clandestine excavations and the merits of scientific excavation. Treasure hunting must not be glamorized.
- Encourage public participation in legal excavations.
- Channel the urge to dig and to collect into a volunteer program that allows the public to participate in controlled, supervised excavations.
- Control illicit export. As discussed above, there is a link between illicit excavation and illicit trade in antiquities. The demand for antiquities and relics is the root cause of looting and plundering of archaeological sites.

The World Heritage Convention
The Convention Concerning the Protection of the World Cultural and Natural Heritage (Unesco 1990) is a means by which countries can voluntarily commit themselves to protecting immovable cultural property of exceptional importance. States that are party to the Convention nominate significant places for inclusion on the World Heritage List. An international committee then evaluates the nominations and selects from among the nominees. Criteria for inclusion on the list include:

- The uniqueness of the achievement of the site
- The influence the site once exercised
- The amount of evidence the site provides for reconstructing an extinct civilization
- The historical significance of the period represented by the site
- The site's significance as an example of a traditional way of life
- The association of the site with ideas and beliefs that are universally significant

Appendix C shows the current roster of Asian and Pacific nations that are parties to the World Heritage Convention. Appendix D shows the sites now listed officially as World Heritage sites. Their inclusion on the list obligates these nations to take responsibility for them and make sure they are adequately protected. It also makes them eligible for help with fund raising and obtaining training, equipment, and technical assistance for conservation and management. Designation on the World Heritage List does not automatically and perpetually guarantee preservation.

Planning for the Future

Safeguarding Cultural Heritage on the National Level
In a recent paper, Florante Henson (1989) made several specific recommendations for the upgrading of cultural resource management in the Philippines. Her comments allow us to identify six key areas for policy and legislation (cf. the recommendations of the director of the British National Trust for urban preservation in India, as summarized in Sundaram 1989:267).

Prevention. Agencies and governments can take an active role in the prevention of damage to and destruction of places or features of cultural importance, rather than relying on curative measures once damage or loss has occurred. There should be statutory measures for the safeguarding of important movable and immovable cultural heritage. The system for designating protected features should be clear.

Coherent Policy and Planning. Rational preservation policies can make explicit the goals of the protection program and should make explicit the criteria and strategies for selecting cultural property. Inventorying can be a critical tool in planning and administering the policies and procedures. Salvaging threatened sites is not the ideal response; a more sound course is to undertake planning policies that anticipate threats and find alternative solutions.

Clarity in the Bureaucratic Structure. The roles of implementing agencies must be clear, and these agencies should be encouraged to share resources and expertise.

Heritage Management Training and Qualifications. The qualifications of the professional community in heritage protection should be maintained at the highest possible level. This can be accomplished through continuing education for existing staff and the development of in-country and regional postgraduate courses. Sufficient salaries, incentive programs, and adequate facilities help to attract and retain highly qualified staff.

Public Education. Because human factors pose such a great threat to cultural heritage, public interest in heritage material and sites and public support for their protection are indispensable. The educational sys-

tem and the media can be used to inform the public of the value of cultural heritage and the legal provisions for its protection.

Adequate Funding. New sources of revenue need to be identified to permit implementing agencies to carry out their mandates successfully. Economic inducements—such as grants and tax incentives—for the repair and maintenance of important cultural heritage can be used if national policy permits the national heritage to remain in private hands. Financial support by industry, business, and individuals can be developed (Silva 1989).

REGIONAL COOPERATION

In addition to the above recommendations, which can be pursued on a national level, there are great opportunities for regional cooperation and coordination in the safeguarding of cultural property. There are preservation issues that are common to nations in tropical Asia and the Pacific, and regional cooperation is therefore a key strategy for protecting the cultural heritage. These issues are both philosophical and technical.

Some of the specific areas in which regional cooperation will yield high results are outlined below.

Controlling Illegal Traffic in Movable Cultural Property. In Asia and the Pacific, regional cooperation to protect cultural property—especially the illegal transport of movable cultural heritage—has been less important than protection measures at the national level (Niec 1976). One of the few examples of regional cooperation is the Australian legislation that prohibits the importation of objects from Papua New Guinea that have been illegally exported (Prott and O'Keefe 1989:533). Many of the public museums in Australia have established stringent policies regarding the authentication and valuation of improperly acquired cultural property (Greenfield 1989:244). More museums should follow their lead. Another area of cooperation has been the regional repatriation of cultural property. A notable example is the practice of the national museums of New Zealand and Australia to return objects to Papua New Guinea (Greenfield 1989:5).

Addressing the Rights and Interests of Racial and Ethnic Minorities. In Asia and the Pacific, many countries face problems balancing the needs of populations that may still be using cultural treasures with the desire to scientifically and legally preserve and protect these materials and places. In Australia, the Aboriginal populations' right to use traditional objects and sacred sites must be reconciled with laws that mandate the protection and preservation of "relics" and important places. As Lewis (1983:4) has remarked:

> *It is still very difficult, and to some extent quite inappropriate, to try to treat sites of Aboriginal significance according to principles developed for European-type monuments and places. Many of the sites are still of religious or mythological significance today. Visits by the uninitiated may defile the site, or visits by the uncaring may literally destroy it. There may be a real conflict between the significance which an archaeologist might attach to the site and consequent conservation policies, on the one hand, and on the other the views of the present-day Aboriginal community. Similarly, in New Zealand there are occasional Maori objections to excavation and conservation, especially where tapu is violated (McKinlay and Adams 1983:77).*

Other issues to be addressed include repatriation of objects and skeletal materials, and appropriate storage and display of secret, sacred, and ceremonial objects. Museums in the region clearly face ethical concerns in balancing divergent, culturally determined attitudes toward research and curation.

Determining the Values of the Colonial Heritage. The colonial "heritage" presents a complicated set of issues to the inhabitants and authorities of emerging nations (Lewis 1983:4). The debate surrounding the "value" of this part of the past brings out two issues outlined at the beginning of this paper. First, it underscores the political nature of protection decisions. Second, it forces cultural heritage managers to recognize that what is considered unimportant now may later be found to be important, before—one hopes—it is completely lost.

Technology. Many of the materials and conditions found in tropical Asia and the Pacific are not found in the West, and therefore have not been a key focus of western research. For example, the silk, bamboo, and lacquer objects that are coming out of archaeological excavations in the People's Republic of China need specialized conservation measures and treatment (Zhuang 1989:108).

INTERNATIONAL COOPERATION

The Repatriation of Cultural Property. The issue of returning cultural property to its country of origin has been debated widely during the past two decades or so (e.g., Greenfield 1989, *Museum* 1979). Prott and O'Keefe (1989) summarize the cases for and against the repatriation of objects. They argue that failure to appreciate the emotional as well as legal factors that enter into the debate will lead to proposals that fail to achieve the desired results.

There are several international agreements and procedures for the return of cultural property. The most important is the 1970 UNESCO Convention on the Means of Prohibiting and Preventing the Illicit Import, Export, and Transfer of Ownership of Cultural Property. This convention sets principles and standards for the safeguarding of movable cultural heritage and procedures for the recovery and return of stolen cultural property. As of August 1991, only six states participating in this Symposium had ratified, accepted, or acceded to the Convention (Appendix C). We should note here that the United States is also a signatory and is the only major art-importing nation to have ratified this Convention.

ICOM has prepared a report on the Principles, Conditions, and Means for the Restitution or Return of Cultural Property in View of Reconstituting Dispersed Heritages. While this document may not have universal application, it does provide guiding principles for the return of cultural property. Its success depends on the development of appropriate legal mechanisms within the country facing the possibility of losing its cultural property.

Civil Suits in the United States. Other countries have successfully recovered cultural property in the U.S. by bringing civil suits before courts. A recent example is the recovery by Cyprus of some sixth-century mosaics that were illegally removed from the apse of a church in Kanakaria. The mosaics entered the international art market and were purchased by an American dealer. The Republic of Cyprus and the religious authorities of Cyprus brought a suit before the Federal District Court in Indiana, and the court ruled in their favor.

Any country has the legal right to pursue the recovery of its cultural property in the United States, provided that it can be proven that a violation of U.S. law has occurred.

Ratification of the 1970 UNESCO Convention on Illicit Trade. The United States urges all countries that suffer from pillage and the unauthorized export of their cultural property to ratify the 1970 UNESCO Convention on illicit trade. Although the United States cannot enforce the export laws of other countries, it can—within the framework of this Convention and the U.S. Cultural Property Implementation Act of 1983—impose import controls on certain categories of archaeological or ethnographic material. Such import controls have the effect of recognizing the export controls of other countries, but are available only to individual states that are party to the 1970 Convention. A country must submit a formal request to the United States under Article 9 of the 1970 UNESCO Convention. A decision follows a process of review and evaluation. So far, no Asian or Pacific country eligible to make such a request of the United States has yet used this mechanism. The nations of Peru, El Salvador, Bolivia, and Guatemala have already requested and received protection for their property under this procedure. (Please see Appendixes F and G for further information.)

Summary and Conclusions

The purpose of this paper has been to raise issues of policy and legal protection of cultural property in tropical Asia and the Pacific. Several principles have been brought into focus:

■ States should develop and maintain a consistent and comprehensive philosophy guiding their legislation, policy, and management of cultural property.

■ Legal controls, administrative procedures, and favorable public opinion are all necessary for a successful protection program.

■ The prevention of damage is preferable to salvage and restoration.

■ Long-range planning is essential, especially in the preservation of immovable cultural property.

■ Protection at the national level is a necessary step, but there is a strong need for, and potentially great benefit from, international cooperation and coordination.

As was stated at the beginning of this paper, the cultural heritage is an irreplaceable resource. Every effort must be taken to safeguard it, for all the purposes it serves in our lives and will serve in future generations.

Biography

Cathy Lynne Costin is a Research Associate with the Institute of Archaeology, University of California at Los Angeles. She earned the Ph.D. in Anthropology, with a special interest in South America, at UCLA. She teaches courses in anthropology at UCLA and California State University at Northridge, and continues to develop her interest in law and cultural heritage, and in economic archaeology.

References

Allchin, F. R.
1989 Threats to the Conservation of the Cultural Heritage in Rural and Urban Areas. In *Conservation of the Indian Heritage;* B. Allchin, F. R. Allchin, and B. K. Thapar (eds.); pp. 245–50. New Delhi: Cosmo Publications.

Bator, Paul
1983 *The International Trade in Art.* Chicago: University of Chicago Press.

Bourke, Max
1983 National Surveys and Records. In *Protecting the Past for the Future: Proceedings of the UNESCO Regional Conference on Historic Places,* Sydney, 22–28 May 1983; M. Bourke, M. Lewis, and B. Saini (eds.); pp. 122–30. Canberra: Australian Government Publishing Service.

Bourke, Max, and Peter Freeman
1983 Australia. In *Protecting the Past for the Future: Proceedings of the UNESCO Regional Conference on Historic Places,* Sydney, 22–28 May 1983; M. Bourke, M. Lewis, and B. Saini (eds.); pp. 22–44. Canberra: Australian Government Publishing Service.

Bourke, Max, Miles Lewis, and Bal Saini (eds.)
1983 *Protecting the Past for the Future: Proceedings of the UNESCO Regional Conference on Historic Places,* Sydney, 22–28 May 1983. Canberra: Australian Government Publishing Service.

Buchan, Rosemary
1979 The Significance of Land Tenure to the Management of Aboriginal Sites in New South Wales. In *Archaeological Resource Management in Australia and Oceania,* J. R. McKinlay and K. L. Jones (eds.), pp. 67–72. Publication 11. Wellington: New Zealand Historic Places Trust.

Burnham, Bonnie
1974 *The Protection of Cultural Property: Handbook of National Legislation.* Paris: International Council of Museums.

Buyong, Kamarul Baharin Bin
1983 Malaysia. In *Protecting the Past for the Future: Proceedings of the UNESCO Regional Conference on Historic Places,* Sydney, 22–28 May 1983; M. Bourke, M. Lewis, and B. Saini (eds.); pp. 67–70. Canberra: Australian Government Publishing Service.

Challis, A. J.
1979 New Zealand Register of Archaeological Sites. In *Archaeological Resource Management in Australia and Oceania,* J. R. McKinlay and K. L. Jones (eds.), pp. 25–26. Publication 11. Wellington: New Zealand Historic Places Trust.

Cleere, Henry
1984 *Aproaches to the Archaeological Heritage: A Comparative Study of World Cultural Resource Management Systems.* Cambridge: Cambridge University Press.
1989 Introduction: The Rationale of Archaeological Heritage Management. In *Archaeological Heritage Management in the Modern World,* H. Cleere (ed.), pp. 1–19. One World Archaeology 9. London: Unwin Hyman.

Creamer, Howard
1983 Contacting Aboriginal Communities. In *Australian Field Archaeology: A Guide to Techniques,* G. Connah (ed.), pp. 10–17. Canberra: Australian Institute of Aboriginal Studies.

Daifuku, Hiroshi
1968 The Significance of Cultural Property. In *The Conservation of Cultural Property, with Special Reference to Tropical Conditions,* pp. 19–26. Museums and Monuments 11. Paris: UNESCO.
1972 Monument Conservation Programmes. In *Preserving and Restoring Monuments and Historic Buildings,* pp. 31–48. Museums and Monuments 14. Paris: UNESCO.

de Andrade, Rodrigo M. F.
1968 The Conservation of Urban Sites. In *The Conservation of Cultural Property, with Special Reference to Tropical Conditions,* pp. 153–68. Museums and Monuments 11. Paris: UNESCO.

de Silva, P. H. D. H.
1979 Sri Lanka. *Museum* 31(1):22–25.

de Varine, Hugues

1983 The Rape and Plunder of Cultures: An Aspect of the Deterioration of the Terms of Cultural Trade Between Nations. *Museum* 35(3):152–58.

Domicelj, Joan

1983 Planning, Legislation and Financial Incentives for the Conservation of Historic Places. In *Protecting the Past for the Future: Proceedings of the UNESCO Regional Conference on Historic Places,* Sydney, 22–28 May 1983; M. Bourke, M. Lewis, and B. Saini (eds.); pp. 150–56. Canberra: Australian Government Publishing Service.

Duboff, Leonard D.

1977 *The Deskbook of Art Law,* 1st ed. Washington, D.C.: Federal Publications.

Feilden, Sir Bernard

1986 Challenges to Heritage Preservation in Industrially Developed Countries. In *The Challenge to Our Cultural Heritage: Why Preserve the Past,* Yudhishthir Raj Isar (ed.), pp. 41–49. Washington, D.C.: Smithsonian Institution Press.

Flood, Josephine

1979a Cultural Resource Management and Tourism: A National Perspective with Particular Reference to Archaeological Sites. In *Archaeological Resource Management in Australia and Oceania,* J. R. McKinlay and K. L. Jones (eds.), pp. 51–56. Publication 11. Wellington: New Zealand Historic Places Trust.

1979b The Register of the National Estate: Policy and Problems (with Special Reference to Aboriginal Sites). In *Archaeological Resource Management in Australia and Oceania,* J. R. McKinlay and K. L. Jones (eds.), pp. 20–24. Publication 11. Wellington: New Zealand Historic Places Trust.

1984 Interpretation of Rock Art and Archaeological Sites. In *Visitors to Aboriginal Sites: Access, Control and Management,* H. Sullivan (ed.), pp. 78–85. Proceedings of the 1983 Kakadu Workshop. Canberra: Australian National Parks and Wildlife Service.

1989 "Tread Softly for You Tread on My Bones": The Development of Cultural Resource Management in Australia. In *Archaeological Heritage Management in the Modern World,* H. Cleere (ed.), pp. 79–101. One World Archaeology 9. London: Unwin Hyman.

Gale, Fay

1984 The Protection of Aboriginal Rock Art from Tourists at Ubirr, Kakadu National Park. In *Visitors to Aboriginal Sites: Access, Control, and Management,* H. Sullivan (ed.), pp. 32–40. Proceedings of the 1983 Kakadu Workshop. Canberra: Australian National Parks and Wildlife Service.

Greenfield, Jeanette

1989 *The Return of Cultural Treasures.* Cambridge: Cambridge University Press.

Griffin, Gillet

1981 Collecting Pre-Columbian Art. *Art Research News* 1(2):7–10.

Hassall, Douglas

1986 Australian Legislation for the Protection of Movable Cultural Property. *Australian Law Journal* 60(9):492–93.

Henson, Florante G.

1989 Historical Development and Attendant Problems of Cultural Resource Management in the Philippines. In *Archaeological Heritage Management in the Modern World,* H. F. Cleere (ed.), pp. 109–17. One World Archaeology 9. London: Unwin Hyman.

Herrmann, Joachim

1989 World Archaeology—The World's Cultural Heritage. In *Archaeological Heritage Management in the Modern World,* H. Cleere (ed.), pp. 30–37. One World Archaeology 9. London: Unwin Hyman.

Isar, Yudhishthir Raj (ed.)

1986 *The Challenge to Our Cultural Heritage: Why Preserve the Past.* Washington, D.C.: Smithsonian Institution Press.

Ito, Nobuo

1983 Japan. In *Protecting the Past for the Future: Proceedings of the UNESCO Regional Conference on Historic Places,* Sydney, 22–28 May 1983; M. Bourke, M. Lewis, and B. Saini (eds.); pp. 59–62. Canberra: Australian Government Publishing Service.

Ito, Teiji

1971 Historical Review of the Cultural Conservation in Japan. In *Proceedings of the Symposium on Preservation and Development of Historic Quarters in Urban Programmes,* pp. 46–51. Kyoto and Nara: Japanese National Commission for UNESCO.

Japanese National Commission for UNESCO

1971 *Proceedings of the Symposium on Preservation and Development of Historic Quarters in Urban Programmes.* Kyoto and Nara.

Joshi, Jagat Pati

1983 India. In *Protecting the Past for the Future: Proceedings of the UNESCO Regional Conference on Historic Places,* Sydney, 22–28 May 1983; M. Bourke, M. Lewis, and B. Saini (eds.); pp. 49–53. Canberra: Australian Government Publishing Service.

Kari, Michael

1979 The Future of the Papua New Guinea Archaeological and Traditional Sites Registry. In *Archaeological Resource Management in Australia and Oceania,* J. R. McKinlay and K. L. Jones (eds.), pp. 27–29. Publication 11. Wellington: New Zealand Historic Places Trust.

Keokuungwal, Chalerm

1988 Bangkok Metropolitan Area: Policy Perspective and Strategies on Planning for Development and Conservation. *Regional Development Dialogue* 9(3):136–44.

Kinoshita, Hiroo

1988 New Challenges for City Planning in Kyoto: The Integration of Metropolitan Development and Conservation. *Regional Development Dialogue* 9(3):87–107.

Kristiansen, Kristian

1989 Perspectives on the Archaeological Heritage: History and Future. In *Archaeological Heritage Management in the Modern World,* H. Cleere (ed.), pp. 23–37. One World Archaeology 9. London: Unwin Hyman.

Lewis, Miles

1983 Keynote Address: Conservation, a Regional Point of View. In *Protecting the Past for the Future: Proceedings of the UNESCO Regional Conference on Historic Places,* Sydney, 22–28 May 1983; M. Bourke, M. Lewis, and B. Saini (eds.); pp. 3–11. Canberra: Australian Government Publishing Service.

Lipe, William D.

1984 Value and Meaning in Cultural Resources. In *Approaches to the Archaeological Heritage: A Comparative Study of World Cultural Resource Management Systems,* H. Cleere (ed.), pp. 1–11. Cambridge: Cambridge University Press.

McKinlay, James, and Patricia Ann Adams

1983 New Zealand. In *Protecting the Past for the Future: Proceedings of the UNESCO Regional Conference on Historic Places,* Sydney, 22–28 May 1983; M. Bourke, M. Lewis, and B. Saini (eds.); pp. 73–86. Canberra: Australian Government Publishing Service.

Mendis, M. W. J. G.

1988a Colombo Metropolitan Region: Planning Strategies for Development and Conservation of Assets and Resources. *Regional Development Dialogue* 9(3):173–85.

1988b Editorial Introduction: Management of Urban Assets and Resources. *Regional Development Dialogue* 9(3):xv–xvii.

Messenger, Phyllis (ed.)

1989 *The Ethics of Collecting: Whose Culture? Whose Property?* Albuquerque: University of New Mexico Press.

Meyer, Karl

1973 *The Plundered Past.* London: Hamish Hamilton.

Misra, Bijayanand

1988 Delhi: Policy Perspectives and Strategies on Planning for Development and Conservation. *Regional Development Dialogue* 9(3):162–72.

Monreal, Luis

1979 Problems and Possibilities in Recovering Dispersed Cultural Heritages. *Museum* 31(1):49–57.

Morton III, W. Brown

1986 Saving Indonesia's Borobudur: A High-tech Triumph in International Cooperation. In *The Challenge to Our Cultural Heritage: Why Preserve the Past,* Yudhishthir Raj Isar (ed.), pp. 113–21. Washington, D.C.: Smithsonian Institution Press.

Museum

1979 Return and Restitution of Cultural Property. *Museum* 31(1).

Musigakama, Nikom

1983 Thailand. In *Protecting the Past for the Future: Proceedings of the UNESCO Regional Conference on Historic Places,* Sydney, 22–28 May 1983; M. Bourke, M. Lewis, and B. Saini (eds.); pp. 109–16. Canberra: Australian Government Publishing Service.

Nafziger, James

1983 Comments on the Relevance of Law and Culture to Cultural Property Law. *Syracuse Journal of International Law and Commerce* 10(2):323–32.

Niec, Halina

1976 Legislative Models of Protection of Cultural Property. *Hastings Law Journal* 27:1089–1122.

O'Keefe, Patrick J.

1983 Export and Import Controls on Movement of the Cultural Heritage: Problems at the National Level. *Syracuse Journal of International Law and Commerce* 10(2):352–70.

Perdon, Renato

1983 Philippines. In *Protecting the Past for the Future: Proceedings of the UNESCO Regional Conference on Historic Places,* Sydney, 22–28 May 1983; M. Bourke, M. Lewis, and B. Saini (eds.); pp. 98–105. Canberra: Australian Government Publishing Service.

Pott, Peter H., and M. Amir Sutaarga

1979 Arrangements Concluded or in Progress for the Return of Objects: The Netherlands–Indonesia. *Museum* 31(1):38–42.

Pradhan, Shanker M.

1988 Kathmandu: Metropolitan Development and Conservation. *Regional Development Dialogue* 9(3):203–21.

Prott, Lyndel V.

1983a International Control of Illicit Movement of Cultural Heritage: The 1970 UNESCO Convention and Some Possible Alternatives. *Syracuse Journal of International Law and Commerce* 10(2):333–51.

1983b International Penal Aspects of Cultural Protection Law. *Criminal Law Journal* 7(4):207–17.

Prott, Lyndel V., and Patrick J. O'Keefe

1984 *Law and the Cultural Heritage,* Vol. 1: *Discovery and Excavation.* London: Professional Books.

1988 *Handbook of National Regulations Concerning the Export of Cultural Property.* Paris: UNESCO.

1989 *Law and the Cultural Heritage, Vol. 3: Movement.* London: Butterworths.

Ranjitkar, Hari Ratna

1983 Nepal. In *Protecting the Past for the Future: Proceedings of the UNESCO Regional Conference on Historic Places,* Sydney, 22–28 May 1983; M. Bourke, M. Lewis, and B. Saini (eds.); pp. 71–72. Canberra: Australian Government Publishing Service.

Rao, G. B. Krishna

n.d. [India] Legislation on Conservation and Management of Ancient Monuments and Archaeological Sites and Ruins. Unpublished manuscript on file at ICCROM, Rome.

Salleh, Ghani Bin

1988 Penang Metropolitan Area: Innovative Planning Strategies for Metropolitan Development and Conservation. *Regional Development Dialogue* 9(3):145–59.

Sampson, Cliff

1988 Aboriginal Keeping Places. *Bulletin of the Conference of Museum Anthropologists* 20:20–23.

Sanday, John

1983 Conservation of Historic Places: A Regional Perspective. In *Protecting the Past for the Future: Proceedings of the UNESCO Regional Conference on Historic Places,* Sydney, 22–28 May 1983,; M. Bourke, M. Lewis, and B. Saini (eds.); pp. 12–20. Canberra: Australian Government Publishing Service.

1986 Science and Technology in Architectural Conservation: Examples from Nepal and Bangladesh. In *The Challenge to Our Cultural Heritage: Why Preserve the Past,* Yudhishthir Raj Isar (ed.), pp. 99–112. Washington, D.C.: Smithsonian Institution Press.

Sanpaolesi, Piero

1972 The Conservation and Restoration of Historic Quarters and Cities. In *Preserving and Restoring Monuments and Historic Buildings,* pp. 245–51. Museums and Monuments 14. Paris: UNESCO.

Sayre, C. Franklin

1986 Cultural Property Laws in India and Japan. *UCLA Law Review* 33(3):851–90.

Sekino, Masaru

1971 National Protection of the Monuments and Sites in Japan. In *Proceedings of the Symposium on Preservation and Development of Historic Quarters in Urban Programmes,* pp. 71–77. Kyoto and Nara: Japanese National Commission for UNESCO.

Sekler, Eduard F.

1977 *Summary of the Master Plan for the Conservation of the Cultural Heritage in the Kathmandu Valley.* Harvard Graduate School of Design Publication Series in Architecture. Paris: UNESCO.

Silva, Roland

1983 Sri Lanka. In *Protecting the Past for the Future: Proceedings of the UNESCO Regional Conference on Historic Places,* Sydney, 22–28 May 1983; M. Bourke, M. Lewis, and B. Saini (eds.); pp. 106–8. Canberra: Australian Government Publishing Service.

1989 The Cultural Triangle of Sri Lanka. In *Archaeological Heritage Management in the Modern World,* H. F. Cleere (ed.), pp. 221–26. One World Archaeology 9. London: Unwin Hyman.

Specht, Jim

1979 The Australian Museum and the Return of Artefacts to Pacific Island Countries. *Museum* 31(1):28–31.

Sullivan, Hilary (ed.)

1984 *Visitors to Aboriginal Sites: Access, Control and Management.* Proceedings of the 1983 Kakadu Workshop. Canberra: Australian National Parks and Wildlife Service.

Sullivan, K. M.

1984 Monitoring Visitor Use and Site Management at Three Art Sites: An Experiment with Visitors' Books. In *Visitors to Aboriginal Sites: Access, Control and Management,* H. Sullivan (ed.), pp. 43–53. Proceedings of the 1983 Kakadu Workshop. Canberra: Australian National Parks and Wildlife Service.

Sullivan, Sharon

1983 Making a Discovery: The Finding and Reporting of Aboriginal Sites. In *Australian Field Archaeology: A Guide to Techniques,* G. Connah (ed.), pp. 1–9. Canberra: Australian Institute of Aboriginal Studies.

Sumintardja, Djauhari

1983 Indonesia. In *Protecting the Past for the Future: Proceedings of the UNESCO Regional Conference on Historic Places,* Sydney, 22–28 May 1983; Bourke, M., M. Lewis, and B. Saini (eds.); pp. 54–58. Canberra: Australian Government Publishing Service.

Sundaram, P. S. A.

1989 The Future Shape of Urban Conservation in India. In *Conservation of the Indian Heritage;* B. Allchin, F. R. Allchin, and B. K. Thapar (eds.); pp. 259–72. New Delhi: Cosmo Publications.

Suselo, Hendropranoto

1988 Indonesia: Innovative Planning Strategies for Metropolitan Development and Conservation. *Regional Development Dialogue* 9(3):189–202.

Swadling, Pamela

1983 Papua New Guinea. In *Protecting the Past for the Future: Proceedings of the UNESCO Regional Conference on Historic Places,* Sydney, 22–28 May 1983; M. Bourke, M. Lewis, and B. Saini (eds.); pp. 87–95. Canberra: Australian Government Publishing Service.

Sykes, Meredith H.

1984 *Manual on Systems of Inventorying Immovable Cultural Property.* Museums and Monuments 19. Paris: UNESCO.

Tanaka, Migaku

1984 Japan. In *Approaches to the Archaeological Heritage: A Comparative Study of World Cultural Resource Management Systems,* H. Cleere (ed.), pp. 82–88. Cambridge: Cambridge University Press.

Thapar, B. K.

1984 India. In *Approaches to the Archaeological Heritage: A Comparative Study of World Cultural Resource Management Systems,* H. Cleere (ed.), pp. 63–72. Cambridge: Cambridge University Press.

1989a Agencies for the Preservation of Cultural Heritage of India. In *Conservation of the Indian Heritage;* B. Allchin, F. R. Allchin, and B. K. Thapar (eds.); pp. 163–68. New Delhi: Cosmo Publications.

1989b Policies for the Training and Recruitment of Archaeologists in India. In *Archaeological Heritage Management in the Modern World,* H. F. Cleere (ed.), pp. 285–91. One World Archaeology 9. London: Unwin Hyman.

UNESCO

1968 *The Conservation of Cultural Property, with Special Reference to Tropical Conditions.* Museums and Monuments 11. Paris.

1970 Convention on the Means of Prohibiting and Preventing the Illicit Import, Export, and transfer of Ownership of Cultural Property.

1972 *Preserving and Restoring Monuments and Historic Buildings.* Museums and Monuments 14. Paris.

1984 *The Protection of Movable Cultural Property: Compendium of Legislative Texts.* Vols. 1–2. Paris.

1990 The World Heritage Convention: A New Idea Takes Shape. *UNESCO Courier,* October:42–43.

Walsh, Graeme L.

1984 Archaeological Site Management in Carnarvon National Park: A Case History in the Dilemma of Presentation or Preservation. In *Visitors to Aboriginal Sites: Access, Control and Management,* H. Sullivan (ed.), pp. 1–14. Proceedings of the 1983 Kakadu Workshop. Canberra: Australian National Parks and Wildlife Service.

Ward, Graeme K.

1979 The Australian National Site Register: Review and Prospect. In *Archaeological Resource Management in Australia and Oceania,* J. R. McKinlay and K. L. Jones (eds.), pp. 12–19. Publication 11. Wellington: New Zealand Historic Places Trust.

1983 Archaeology and Legislation in Australia. In *Australian Field Archaeology: A Guide to Techniques,* G. Connah (ed.), pp. 18–42. Canberra: Australian Institute of Aboriginal Studies.

Williams, Sharon A.

1978 *The International and National Protection of Movable Cultural Property: A Comparative Study.* Dobbs Ferry, N.Y.: Oceana Publications.

Zhuang, Min

1989 The Administration of China's Archaeological Heritage. In *Archaeological Heritage Management in the Modern World,* H. F. Cleere (ed.), pp. 102–8. One World Archaeology 9. London: Unwin Hyman.

Appendix A

National Legislation on the Protection of Cultural Heritage

AUSTRALIA

Protection of Movable Cultural Heritage Act 1986

Protection of Movable Cultural Heritage Regulations 1988

Customs Regulations (Prohibited Exports)

Customs Regulations (Prohibited Imports)

Aboriginal and Torres Strait Islander Heritage Protection Act 1984

World Heritage Properties Conservation Act 1983

Museum of Australia Act 1980

Historic Shipwrecks Act 1976, amended 1980

Australian Heritage Commission Act 1975, amended 1976

National Parks and Wildlife Conservation Act 1975

(New South Wales) Heritage Act 1977

(New South Wales) National Parks and Wildlife Act 1974

(New South Wales) National Trust of Australia Act 1960

(Northern Territory) Native and Historical Objects and Areas Preservation Ordinance 1955

(Northern Territory) Aboriginal Sacred Sites Act 1978

(Queensland) Aboriginal Relics Preservation Act 1967, amended

(South Australia) Aboriginal Heritage Act 1979

(South Australia) Historic Shipwrecks Act 1981

(South Australia) History Trust of South Australia Act 1981

(South Australia) South Australian Heritage Act 1978, amended 1979

(South Australia) Second-Hand Dealers Act 1919, amended

(Tasmania) Museums (Aboriginal Remains) Act 1984

(Tasmania) Aboriginal Relics Act 1975

(Tasmania) National Parks and Wildlife Act 1970

(Victoria) Archaeological and Aboriginal Relics Preservation Act 1972, amended 1980

(Victoria) Historic Shipwrecks Act 1981

(Victoria) Second-Hand Dealers Act 1958

(Western Australia) Aboriginal Heritage Act 1972, amended 1980

(Western Australia) Maritime Archaeology Act 1973

BANGLADESH

Antiquities Act 1968, amended 1976

CHINA, THE PEOPLE'S REPUBLIC OF

Regulations on Preservation of Cultural Relics, 19 November 1982

Provisional Regulation for the Prohibition of Export of Valuable Cultural Relics and Books, 24 May 1950

INDIA

Antiquities and Art Treasure Act 1972

Notification of 2 July 1976 concerning the Antiquities and Art Treasures Act

Notification of 1 December 1976 concerning the Antiquities and Art Treasures Act

Ancient Monuments and Archaeological Sites and Remains Act 1958, amended 1972

Ancient Monuments and Archaeological Sites and Remains Rules, ca. 1950

Indian Treasure Trove Act 1878

INDONESIA

Ordinance on the Protection of Monuments 1931

JAPAN

Law No. 214, 30 May 1950, for the Protection of Cultural Property, amended 1975

MALAYSIA

Antiquities Act 1976

(Sabah) Antiquities and Treasure Trove Enactment 1977

(Sarawak) Antiquities Ordinance 1954

MICRONESIA

Title 67 (Historical Sites and Antiquities) of the Trust Territorial Code, chapter 11 amended by Public Law No. 1-48

(Kosrae) Public Law No. 1-45 Kosrae Historic Preservation Act

(Yap) State Law No. 1-58 State Historic Preservation Act

NEPAL

Ancient Monuments Preservation Act 1956, amended 1964, 1970

Notification of the Ministry of Education concerning the exportation and movement of historical, archaeological, or artistic objects, 7 April 1969

NEW ZEALAND
Antiquities Act 1975
Reserves Act 1977
Historic Places Act 1980
National Parks Act 1980
National Art Gallery, Museum, and War Memorial Act 1972
Secondhand Dealers Act 1963
Auctioneers Act 1928

PAKISTAN
Export of Antiquities Rules 1979
Antiquities Act 1975, amended by Antiquities (amendment) Act 1976
Archaeological Excavation and Exploration Rules 1977

PAPUA NEW GUINEA
National Cultural Property (Preservation) Act 1965
Conservation Areas Act 1978

THE PHILIPPINES
The Cultural Properties Preservation and Protection Act 1966, amended by Presidential Decree No. 374, 10 January 1974
Rules and Regulations for the Implementation of Presidential decree No. 374 amending Republic Act No. 4846, 20 February 1974

SINGAPORE
Preservation of Monuments Act 1970

SRI LANKA
Antiquities Ordinance 1940, amended

THAILAND
Act on Ancient Monuments, Antiques, Objects of Art, and National Museums B.E. 2504 (1961)
National Executive Council Announcement No. 189, 23 July B.E. 2515 (1972) Prohibiting the Search for Archaeological and Historical Objects in Areas Designated by the Minister of Education
Act on the Control of Auction Sale and the Sale of Antiquities B.E. 2474 (1931)

Appendix B

Government Ministries and Agencies Responsible for Administering, Protecting, and Preserving Cultural Properties

AUSTRALIA
Australian Institute of Aboriginal Studies
Australian Heritage Commission
(Australian Capital Territory) Conservation and Agriculture Section
New South Wales Heritage Council
New South Wales National Parks and Wildlife Service
 Aboriginal and Historic Resources Section
(Northern Territory) Aboriginal Sacred Sites Protection Authority
(Northern Territory) Museums and Art Galleries of the Northern Territory
(Queensland) Department of Aboriginal and Islander Advancement
 Archaeology Branch

(South Australia) Department of the Environment and Planning
 Heritage Conservation Branch
 Aboriginal Heritage Section
Tasmanian National Parks and Wildlife Service
(Victoria) Ministry for Conservation
 Victoria Archaeological Survey
(Victoria) Victorian Historic Buildings Council
Western Australian Museum
 Department of Aboriginal Sites

CHINA, THE PEOPLE'S REPUBLIC OF
Ministry of Culture
 Administrative Bureau of Cultural Relics and Archaeological Data

Institute of Archaeology of the Chinese Academy of
 Sciences

INDIA
Archaeological Survey of India
Ministry of Education and Culture
State Departments of Archaeology

INDONESIA
Ministry of Education
 Directorate General of Culture
 Directorate of Museums
 Directorate of Fine Arts
 Directorate of Archaeological and Cultural
 Monuments
 Directorate for the Protection and
 Development of the Historical and
 Archaeological Heritage
 Directorate of Traditional Values
 Directorate of Spiritual Affairs
Archaeological Service

JAPAN
Ministry of Education
 Agency for Cultural Affairs
 National Commission (Council) for the Pro-
 tection of Cultural Properties
 Cultural Affairs Division
(local) Boards of Education

MALAYSIA
Museums Department
 Antiquities Division
Sabah Museum
Sarawak Museum

NEPAL
Ministry of Education
 Department of Archaeology
Department of Housing and Physical Planning

NEW ZEALAND
Department of Internal Affairs

Cultural Section
New Zealand Historic Places Trust
Department of Lands and Survey
New Zealand Forest Service

PAKISTAN
Ministry of Education and Provincial Coordination
 Department of Archaeology and Museums
Ministry of Culture, Sports, and Tourism
Ministry of Finance
Central Board of Revenues (Customs)

PAPUA NEW GUINEA
National Museum
 Anthropology Department
 Contemporary History Department
 Aviation, Maritime, and War Branch
Minister of Science, Tourism, and Culture
Minister of Physical Planning

THE PHILIPPINES
National Historical Institute
 Monuments and Heraldry Division
National Museum
 Division of Cultural Properties
Ministry of Tourism

SINGAPORE
Preservation of Monuments Board

SRI LANKA
Archaeological Department
Urban Development Authority

THAILAND
Ministry of Education
 Fine Arts Department
 Division of Archaeology

Appendix C

Ratification and Acceptance of UNESCO Conventions

Participating states that have ratified, accepted, or acceded to the Convention on the Means of Prohibiting and Preventing the Illicit Import, Export, and Transfer of Ownership of Cultural Property[1]

Australia
People's Republic of China
India
Nepal
Pakistan
Sri Lanka

Participating states that have ratified, accepted, or acceded to the Convention Concerning the Protection of the World Cultural and Natural Heritage[2]

Australia
Bangladesh
People's Republic of China
India
Indonesia
Malaysia
Nepal

New Zealand
Pakistan
The Philippines
Sri Lanka
Thailand

Participating states that have ratified, accepted, or acceded to the Convention and Protocol for the Protection of Cultural Property in the Event of Armed Conflict [the Hague Convention][3]

Australia (Convention only)
India
Indonesia
Malaysia
Pakistan
Thailand

1. as of August 1991
2. as of January 1990
3. as of June 1987

Appendix D

Cultural Properties Currently Included on the World Heritage List[1]

AUSTRALIA
Kakadu National Park (N/C)[2]
Great Barrier Reef (N)
Willandra Lakes Region (N/C)
Western Tasmania Wilderness National Parks (N/C)
Lord Howe Island Group (N)
Australian East Coast Temperate and Subtropical Rainforest Parks (N)
Uluru National Park (N/C)
Wet Tropics of Queensland (N)

BANGLADESH
Historic Mosque City of Bagerhat (C)
Ruins of the Buddhist Vihara at Paharpur (C)

CHINA, THE PEOPLE'S REPUBLIC OF
Mount Taishan (N/C)
The Great Wall (C)
Imperial Palace of the Ming and Qing Dynasties (C)
Mogao Grottoes (C)
The Mausoleum of the First Qin Emperor (C)
Peking Man Site at Zhoukoudian (C)

INDIA
Ajanta Caves (C)
Ilora Caves (C)
Agra Fort (C)
Taj Mahal (C)
Sun Temple, Konarak (C)

Group of Monuments at Mahabalipuram (c)

Kaziranga National Park (N)

Manas Wildlife Sanctuary (N)

Keoladeo National Park (N)

Churches and Convents of Goa (c)

Khajuraho Group of Monuments (c)

Group of Monuments at Hampi (c)

Fatehpur Sikri (c)

Group of Monuments at Pattadakal (c)

Elephanta Caves (c)

Brihadisvara Temple, Thanjavur(c)

Sundarbans National Park (N)

Buddhist Monuments at Sanchi (c)

NEW ZEALAND

Westland and Mount Cook National Park (N)

Fiordland National Park (N)

NEPAL

Sagarmatha National Park (N)

Kathmandu Valley (c)

Royal Chitwan National Park (N)

PAKISTAN

Archaeological ruins at Moenjodaro (c)

Taxila (c)

Buddhist ruins of Takht-i-Bahi and neighboring city remains at Sahr-i-Bahlol (c)

Historical Monuments of Thatta (c)

Fort and Shalimar Gardens in Lahore (c)

SRI LANKA

Sacred City of Anuradhapura (c)

Ancient City of Polonnaruwa (c)

Ancient City Sigiriya (c)

Sinharaga Forest Reserve (N)

Sacred City of Kandy (c)

Old Town of Galle and its fortifications (c)

1. as of September 1990

2. c-Cultural; N-Natural

Appendix E

International Agreements, Conventions, and Resolutions on the Protection of Cultural Property

1954 Convention for the Protection of Cultural Property in the Event of Armed Conflict

1956 UNESCO Recommendation on International Principles Applicable to Archaeological Excavations, New Delhi

1962 UNESCO Recommendation Concerning the Safeguarding of the Beauty and Character of Landscapes and Sites, Paris

1968 UNESCO Recommendation Concerning the Preservation of Cultural Property Endangered by Public or Private Works, Paris

1970 Convention on the Means of Prohibiting and Preventing the Illicit Import, Export, and Transfer of Ownership of Cultural Property

1972 Convention Concerning the Protection of the World Cultural and Natural Heritage

1972 UNESCO Recommendation Concerning the Protection, at the National Level, of the Cultural and National Heritage, Paris

1976 UNESCO Recommendation Concerning the Safeguarding and Contemporary Role of Historic Areas, Nairobi

1978 UNESCO Recommendation Concerning the Protection of Movable Property

Appendix F

U.S. Implementation of the UNESCO Convention on the Means of Prohibiting and Preventing the Illicit Import, Export, and Transfer of Ownership of Cultural Property

The Convention was adopted by UNESCO in 1970 in response to the growing concern of the international community that the high demand for cultural objects is generating rampant pillage of significant archaeological and ethnological materials.

The Convention promotes international cooperation in curbing the market for stolen art and looted artifacts. There are seventy state parties to the convention, listed below.

In 1983, the United States became the first major art importing country to implement the Convention. Enabling legislation for the Convention is the Convention on Cultural Property Implementation Act (Public Law 97-446) as amended. The United States implements the Convention in the following way:

■ It prohibits the entry of inventoried articles of cultural property stolen from public collections after the date the Convention went into effect for the state party for the U.S.

■ It prohibits the entry of uninventoried archaeological and ethnological materials that are in jeopardy from pillage and illegal export from a state party. To obtain U.S. restrictions, a state party must officially request U.S. import restrictions under Article 9 of the Convention.

Requests for U.S. import restrictions are transmitted through diplomatic channels to the Director of the U.S. Information Agency who is responsible for determining whether the U.S. should impose the restrictions. He is advised by the Cultural Property Advisory Committee, a Presidential board of archaeologists, anthropologists, ethnologists, art dealers, and representatives of the museum community and the general public.

The U.S. Commissioner of Customs is responsible for enforcing U.S. import restrictions and for recovering stolen cultural property.

The United States has received requests for U.S. import restrictions from five countries: Canada, El Salvador, Bolivia, Peru, and Guatemala. To date, emergency U.S. import restrictions have been imposed on:

■ Pre-Hispanic ceramic and stone artifacts form El Salvador's Cara Sucia archaeological region. (Effective date: September 11, 1987)

■ Antique ceremonial textiles from the Andean community of Coroma, Bolivia. (Effective date: March 14, 1989).

■ Moche archaeological material from the Sipan region of Peru. (Effective date: May 7, 1990).

■ Maya artifacts originating in the Peten region of Guatemala (Effective date: April 15, 1991)

State Parties to the UNESCO Convention on the Means of Prohibiting and Preventing the Illicit Import, Export, and Transfer of Ownership of Cultural Property:

Algeria
Argentina
Australia
Bangladesh
Belize
Bolivia
Brazil
Bulgaria
Burkina Faso
Byelorussian SSR
Cameroon
Canada
Central African Republic
Colombia
China, The People's Republic of
Cote d'Ivoire
Cuba
Cyprus
Czechoslovakia
Democratic Kampuchea
Democratic People's Republic of Korea
Dominican Republic
Ecuador
Egypt
El Salvador

Greece
Guatemala
Guinea
Honduras
Hungary
India
Iran
Iraq
Italy
Jordan
Kuwait
Libyan Arab Jamahiriya
Madagascar
Mali
Mauritania
Mauritius
Mexico
Mongolia
Nepal
Nicaragua
Niger
Nigeria
Oman
Pakistan
Panama

Peru
Poland
Portugal
Qatar
Republic of Korea
Saudi Arabia
Senegal
Spain
Sri Lanka
Syrian Arab Republic
Tunisia
Turkey
Ukrainian SSR
Union of Soviet Socialist Republics
United Republic of Tanzania
United States of America
Uruguay
Yugoslavia
Zaire
Zambia

Prepared by USIA's Cultural Property Staff, 301 Fourth Street, S.W., Room 247, Washington, D.C. 20547 (Telephone 202/619-6612, Fax 202/619-5177).

Appendix G

Laws Pertaining to the Recovery of Cultural Property of Another Country in the United States

U.S. CUSTOMS LAWS

There are basic Customs laws that, if violated, could result in the recovery of cultural property. These violations include smuggling, false declaration, and false entry. Persons committing these violations have committed a felony. The goods (such as cultural property) are subject to seizure by Customs. Usually Customs will notify the appropriate embassy of the seizure. The country of origin, however, must make a claim of ownership in writing for the property in order for Customs to make the return.

NATIONAL STOLEN PROPERTY ACT (NSPA)

Under this law, criminal action can be brought against a person(s) who engages in the international or interstate transport of stolen property having a value of $5,000 or more or who knowingly receives or acquires such property. For many years, this was routinely applied to stolen automobiles, refrigerators, etc., but not to artifacts. Then in the late 1970s, in the *McClain* Case, the U.S. Court of Appeals for the Fifth Circuit found that Pre-Columbian artifacts from Mexico had been smuggled

by individuals who had knowledge of the Mexican law that clearly claimed ownership of excavated and unexcavated materials for Mexico. The court, in its decision, found the defendants guilty of transporting stolen property under the NSPA. Since the NSPA is a criminal statute, it does not, in and of itself, guarantee seizure, forfeiture, or return of objects. How can the country of origin recover the material? Usually the NSPA is applied in conjunction with a technical Customs violation. In this case, the goods smuggled in violation of a Customs law are subject to detention by Customs. Under these circumstances, the material is not automatically returned to the country of origin. The country must make a claim in writing for the return of the property. A brief letter to the U.S. Customs by the country's Ambassador to the U.S. will enable U.S. Customs to arrange for the material's return.

Civil Action by a Foreign Government in U.S. Courts. A foreign government may bring suit in U.S. courts to recover stolen cultural property whose rightful ownership is claimed by a person or institution in the United States. The country must hire its own legal counsel.

U.S. Import Controls. Articles of cultural property illegally exported from another country may be seized by U.S. Customs under the following laws:

Pre-Columbian Monumental or Architectural Sculpture or Murals Statute. This law (1972) prohibits the entry into the United States of pieces of sculpture or murals, including stelae, taken from a Pre-Columbian monument. Under this law, articles of immovable cultural property that are not accompanied by an export permit issued by the country of origin are subject to seizure, forfeiture, and return to that country by the U.S. Customs Service. This law pertains to Pre-Columbian monumental pieces from Mexico, Central and South America, and the Caribbean Islands.

CONVENTION ON CULTURAL PROPERTY IMPLEMENTATION ACT (1983)

This law implements the 1970 UNESCO Convention on the means of prohibiting and preventing the illicit import, export, and transfer of ownership of cultural property. It provides special assistance to the other 69 countries that are party to the Convention in following manner:

■ It prohibits the entry into the United States of any article of cultural property stolen from a museum, monument, or other public institution after April 12, 1983, or the date the country of origin implemented the Convention, whichever date is later.

■ It provides a special mechanism whereby the United States may respond to a request from a nation party to the Convention whose cultural patrimony is in current jeopardy from the loss of its archaeological and ethnographic materials. In response to a request, made to the Director of the U.S. Information Agency in Washington, the United States may impose import restrictions on specific types of categories of artifacts. Artifacts that are not accompanied by an export permit issued by the country of origin are subject to seizure, forfeiture, and return to that country by the U.S. Customs Service. To date, the United States has imposed emergency import restrictions on Pre-Columbian artifacts from the Cara Sucia region of El Salvador; on antique ceremonial textiles of Bolivia; on Moche artifacts from the Sipan region of Peru; and on Maya artifacts from the Peten region of Guatemala. A request from Canada is pending a final decision.

Prepared by USIA's Cultural Property Staff, 301 Fourth Street, S.W., Room 247, Washington, D.C. 20547 (Telephone 202/619-6612, Fax 202/619-5177).

Annotated Bibliography

Allchin, B., F. R. Allchin, and B. K. Thapar (eds.)

1989 *Conservation of the Indian Heritage*. New Delhi: Cosmo Publications.

This volume is a collection of symposium papers on the conservation of both natural and cultural heritage. There are informative papers on the history and modern administration of conservation in India, the need to balance development and tourism with protection, and conservation and protection in urban environments.

Bourke, Max, Miles Lewis, and Bal Saini (eds.)

1983 *Protecting the Past for the Future: Proceedings of the UNESCO Regional Conference on Historic Places*, Sydney, 22–28 May 1983. Canberra: Australian Government Publishing Service.

This volume contains thirty-six papers by participants in a symposium sponsored by the Australian National Commission for UNESCO on the protection of historic cultural property in Asia and the Pacific. The fourteen countries represented were Australia, the People's Republic of China, Fiji, India, Indonesia, Japan, the Republic of Korea, Malaysia, Nepal, New Zealand, Papua New Guinea, the Philippines, Sri Lanka, and Thailand. Primary sections include a regional overview, documentation, protection, and implementation. Each participant presenting a country overview was given a questionnaire covering issues such as documentation, protection, and implementation; answers to these questionnaires formed the outline of many of the discussions.

Cleere, Henry

1984 *Approaches to the Archaeological Heritage: A Comparative Study of World Cultural Resource Management Systems*. Cambridge: Cambridge University Press.

This volume contains articles on cultural resource management (CRM) in twelve countries around the world. Topics covered include the history of CRM in each country, current legislation, administrative structure, the organization of survey and inventory, training for

CRM professionals, and public attitudes toward the preservation of cultural heritage. The introductory essay by Lipe discusses the value of cultural resources.

Cleere, Henry (ed.)

1989 *Archaeological Heritage Management in the Modern World*. One World Archaeology 9. London: Unwin Hyman.

This volume contains papers on the management of archaeological property originally presented at the World Archaeological Congress in Southampton, 1987. Themes are both substantive and philosophical. The theoretical and philosophical issues raised by many of the participants are clearly relevant to all cultural property management—archaeological, historic, and contemporary. The papers provide excellent comparative material on topics such as protection policy and philosophy, protection legislation, training, general management issues, problems encountered in trying to develop management plans, and joint projects with UNESCO.

Duboff, Leonard D.

1977 *The Deskbook of Art Law*, 1st ed. Washington, D.C.: Federal Publications.

This is a textbook designed for a one-semester course on laws—primarily those of the United States of America—relating to all forms of movable art. It does, however, contain chapters on the international movement of art (focusing on problems of illicit movement), wartime destruction of works of art, and the special legal and ethical problems of museums. Contains an excellent, albeit somewhat out-of-date, chart summarizing legislation pertaining to cultural property in 137 countries.

Greenfield, Jeanette

1989 *The Return of Cultural Treasures*. Cambridge: Cambridge University Press.

The book opens with an emotional description of the return of two early manuscripts to Iceland from Denmark. Following a review of the Elgin Marbles contro-

versy, the book provides excellent discussion of several of the most well-known cases of attempted and achieved repatriation, including the Koh-i-noor diamond, the throne of Rajit Singh, Sri Lankan manuscripts, Aboriginal skulls from Australia, the Aurel Stein collection of Chinese manuscripts, the "Ortiz" Taranaki panels from New Zealand, the Pathur Sivanpuram Nataraja, and many Pre-Columbian cases. She also provides a list of many examples of the successful instances of return, primarily from museum collections.

Houdek, Frank G.
1988 *Protection of Cultural Property and Archaeological Resources: A Comprehensive Bibliography of Law-related Materials.* New York: Oceana Publications.

This bibliography includes materials published in English related to legal aspects of protection. The focus is primarily on secondary sources. U.S. legislation is covered fully; other countries are dealt with less thoroughly. The volume covers materials published through March 1987.

Isar, Yudhishthir Raj (ed.)
1986 *The Challenge to Our Cultural Heritage: Why Preserve the Past.* Washington, D.C.: Smithsonian Institution Press.

This volume contains the proceedings of a conference on cultural preservation sponsored by a variety of international organizations in 1984. The conference was organized to inform North American journalists of the issues and problems of cultural heritage management. The papers are targeted for a broader readership than most preservation and conservation literature. There are excellent discussions of preservation philosophy, alternative approaches in balancing preservation and development, funding, the science and technology of preservation, and illicit movement of cultural property.

McKinlay, J. R., and K. L. Jones
1979 *Archaeological Resource Management in Australia and Oceania.* Publication 11. Wellington: New Zealand Historic Places Trust.

This edited volume contains papers presented at two sessions at the Congress of the Australian and New Zealand Association for the Advancement of Science on archaeological site registers and the management of archaeologi-

cal sites. There are useful, pragmatic discussions of site registry programs (goals, structure, problems), as well as more general discussion of cultural resource management and its relationship to tourism and development.

Museum 31(1)
1979 Special Issue: The Return and Restitution of Cultural Property.

This entire issue of *Museum* is devoted to the issues surrounding the return of dispersed cultural property to their countries of origin. Articles include statements from representatives of several countries actively seeking the return of key cultural property and analyses of several international arrangements for their return. Finally, there is a discussion of the UNESCO Intergovernmental Committee for Promoting the Return of Cultural Property to its Countries of Origin or its Restitution in Case of Illicit Appropriation, and an insightful study on restitution and return by an ICOM subcommittee.

Prott, Lyndel V., and Patrick J. O'Keefe
1984 *Law and the Cultural Heritage.* Volume 1, *Discovery and Excavation.* Oxford: Professional Books.

This volume analyzes national legislation and international agreements concerning the discovery of archeological sites and regulation of archaeological investigations. The volume provides a detailed comparative study of antiquities legislation, covering ownership, possession, legal and clandestine excavation, and enforcement of legal controls. There is an excellent analysis of the value of cultural property, the various interests in cultural property, and the reasons why cultural property should be protected.

1988 *Handbook of National Regulations Concerning the Export of Cultural Property.* Paris: UNESCO.

This handbook is intended as a "quick reference guide on rules governing the export of cultural property" (p. i). It provides a brief, country-by-country summary of relevant legislation and administrative procedures. Topics covered in each section include property subject to export control, types of export controls, restrictions on transfer of ownership, penalties, and sanctions.

1989 *Law and the Cultural Heritage.* Volume 3,
 Movement. London: Butterworths.

This volume analyzes national legislation and international agreements concerning the movement—legal and illegal—of cultural property between cultures and between countries. It deals with works of "fine art" as well as archaeological, historical, and ethnographic objects. Key topics include types of transfer of ownership, controls on exports and imports, and the question of recovery and repatriation. It places more emphasis on North America, Western Europe, and Australia/New Zealand than did the first volume *(Discovery and Excavation),* in large part because these are the primary countries marketing and importing cultural property. There is a detailed discussion of the 1970 UNESCO Convention on the Means of Prohibiting and Preventing the Illicit Import, Export, and Transfer of Ownership of Cultural Property.

Russell, John
1978 Conservation in Monsoon Asia: The Conservation of Immovable Cultural Property in Southeast Asia. Ph.D. dissertation, Architecture, Heriot-Watt University, Edinburgh.

This dissertation covers the conservation and protection of immovable cultural property in nine southeast Asian countries: Burma (Myanmar), Indonesia, Khampuchea, Laos, Malaysia, the Philippines, Singapore, Thailand, and Vietnam. Data are based on a detailed questionnaire and interviews with heritage-protection officials in these countries, as well as library research. Topics covered are the historical background, an overview of the cultural heritage of each nation, discussions of the causes (environmental and human) of decay, and conservation policy, programs, and framework. There is a general overview followed by a detailed profile of each nation.

Sayre, C. Franklin
1986 Cultural Property Laws in India and Japan. UCLA *Law Review* 33(3):851–90.

The author argues that the "adequate protection of a nation's cultural patrimony ultimately depends on the socioeconomic conditions that exist within each national and the political power of that nation in the international community" (p. 857). He compares India and Japan to demonstrate that legislation alone is inadequate. These countries have similar laws and approaches to protection

but very different results. India (an example of a developing country) must rely on the good faith of the international community, while Japan (which is developed and financial strong) has the financial and human resources to *prevent* problems. Sayre argues that the international community should establish a fund to assist countries lacking sufficient funding to finance domestic protection policy and legislation, underwritten in part by assessments against nations that violate the 1970 UNESCO Convention.

Sullivan, Hilary (ed.)
1984 *Visitors to Aboriginal Sites: Access, Control and Management.* Proceedings of the 1983 Kakadu Workshop. Canberra: Australian National Parks and Wildlife Service.

This volume contains many short, useful case studies in site management, cultural tourism, and visitor education. Several case studies on the impact of tourism and the effects of various management strategies are most informative. The section on Aboriginal Peoples' Perspectives is especially welcome. Common points are made by several of the papers are: (1) in order to protect sites, visitors may not always be allowed complete freedom to explore sites on their own; (2) isolation cannot be considered a guarantee of protection for remote sites; (3) the need to involve—not merely consult—Aboriginal peoples in all aspects, including site management and interpretation to visitors.

Sykes, Meredith H.
1984 *Manual on Systems of Inventorying Immovable Cultural Property.* Museums and Monuments 19. Paris: UNESCO.

This volume is an attempt to bring together simple and effective techniques for the inventorying of immovable cultural property, specifically monuments and sites. The first section is a methodological introduction, which includes instructions for using a worksheet to develop an inventory procedure. This is followed by the comparison of eleven specific inventory systems (Argentina, Canada, France, India, Italy, Japan, Mexico, Morocco, New York City, Poland, and Zambia). The third section compares the types of data collected in each system topically. There are several useful summarizing charts and an appendix consisting of reproductions of many of the original survey forms.

United Nations Centre for Regional Development

1988 Innovative Planning Strategies for Metropolitan Development and Conservation, a special issue of *Regional Development Dialogue* 9(3).

This issue of the journal published by the UNCRD contains some of the papers presented at the International Symposium on Innovative Planning Strategies for Metropolitan Development and Conservation, sponsored by the UNCRD and the City of Kyoto in 1987. The focus of the conference was the need to balance growth and change with conservation and preservation of historic areas. Participants represented both East and West, but the presenters and audience were by and large Asian. Participants grappled with the challenge of realistically balancing "proper conservation" with the need to accommodate almost overwhelming population growth. Four key conservation themes for consideration in development plans were: "(a) What needs conserving; (b) integration of conservation and preservation objectives; (c) an adequate legal support system; and (d) provision of incentives for private sector participation in conservation efforts" (p. xvi). The discussions of development are presented within a framework of building on and preserving the past. Therefore, they are informative and useful for stimulating a dialogue between individuals charged with protecting cultural heritage and those in charge of development. The papers on Kyoto and Katmandu illustrate particular emphasis on the preservation of cultural heritage as a highly valued component of planning.

UNESCO

1968 *The Conservation of Cultural Property, with Special Reference to Tropical Conditions*. Museums and Monuments II. Paris.

This collection of papers describes simple and well-known techniques for the conservation of cultural property, especially under tropical conditions. Topics include the conservation of movable property made of specific materials (including stone, pottery, glass, metals, organic materials), problems and solutions in the protection of immovable property, and guidelines on setting up a national service for the protection of cultural property, which covers both administrative needs and technical needs (e.g., setting up a laboratory).

1972 *Preserving and Restoring Monuments and Historic Buildings*. Museums and Monuments 14. Paris.

This is a manual covering typical problems and techniques in the conservation of immovable cultural property. Basic principles of conservation and preservation are discussed. Practical topics include survey, photogrammetic methods, and basic conservation techniques.

1984 *The Protection of Movable Cultural Property: A Compendium of Legislative Texts* (2 vols.). Paris.

This two-volume compendium contains detailed information on national regulations on the protection of cultural property. It is organized by country. Relevant national legislation is cited by topic within each country. Topics include: definitions, systems of ownership and use, extent of protection, discovery and excavation, sanctions and penalties, and authorities responsible for protection. Footnotes are used for interpretation.

Williams, Sharon A.

1978 *The International and National Protection of Movable Cultural Property: A Comparative Study*. Dobbs Ferry, N.Y.: Oceana Publications.

This volume gives a history of obligations and attitudes toward the protection of cultural property. The author analyzes the 1954 Hague Convention for the Protection of Cultural Property in the Event of Armed Conflict in addition to peacetime international agreements, including major UNESCO resolutions and recommendations and the 1970 UNESCO Convention. The book presents a decidedly Western perspective throughout, including the choice of case studies, the emphasis on "fine art" rather than (non-Western) archaeological and ethnographic materials, and a general emphasis on the "common heritage of mankind" as a critical factor, rather than recognizing cultural diversity and each cultures right to determine what is important to it. Detailed discussion of export policies of France, Italy, Mexico, United Kingdom, and Canada may provide guidance to countries now formulating policies. Appendices reprint major international treaties, conventions, and samples of Canadian legislation, regulations, and permits controlling ownership, import, and export of cultural property.

Issues That Affect Cultural Property, Specifically Objects, in South Asia and the Pacific

■

Colin Pearson

Countries in South Asia and the Pacific range from very large land masses with large populations to small islands with only a few hundred inhabitants. These countries contain a significant component of the world's cultural heritage; in many of these areas, certain arts traditions carry on uninterrupted. While most of the countries have facilities for caring for their movable cultural property—museums, galleries, libraries, archives, or cultural centers—many are at a very basic level. In most cases, a small number of people with limited facilities and resources are responsible for the care of the nation's cultural heritage.

The environment of the region is generally quite harmful to movable cultural property. The climate can be hot and humid, or hot and arid; both climates can be damaging if not controlled. Insects, rodents, and air pollution all endanger museum collections. What is being done, and what can be done, to ensure that this important part of our cultural heritage is preserved for posterity?

When considering the conservation needs of movable cultural property, the entire situation should be examined in context. It is a waste of time and money to train conservators if no conservation facilities are available, and to build facilities when trained conservation personnel are lacking. It is just as wasteful to spend time restoring an important artifact only to store or display it in an adverse environment.

This paper first discusses the need to define and legislate for the protection of movable cultural property. Next, the need for a code of ethics and guidance for conservation practice, designed to give the conservation profession a stable foundation, is addressed. The chal-lenges of conservation training, with particular attention to South Asia and the Pacific, are then discussed.

The second half of the paper addresses the specific effects of tropical environments on the deterioration of movable cultural property and suggests some alternative approaches to controlling or reducing these dangers.

The Definition and Protection of Movable Cultural Property

Before we can consider the various means of protecting movable cultural property, we must first define what it is. Whereas immovable cultural property is defined in the Venice Charter of 1966 (UNESCO 1966), no such international charters address movable cultural property. For this we look to national legislation or charters. A definition is given by the Australian Institute for the Conservation of Cultural Material (AICCM) in its *Code of Ethics and Guidance for Conservation Practice* (AICCM 1986) where movable objects comprise "works of art, artifacts, books, manuscripts, moving image and sound, and other objects of natural, historical or archaeological origin." A more extensive definition is given in Australia's Protection of Movable Cultural Heritage Act, 1986 (see Appendix). If nations in South Asia are considering this kind of protective legislation, they will probably come up with definitions that vary, depending on the nature of their own movable cultural property. However, all nations should establish a formal definition of this class of resource, along with a full list of places where such materials are housed. This list might include museums, art galleries, libraries, archives, historic

houses, cultural centers, archaeological sites (both land and marine), and private collections.

How is movable cultural property protected? Although covered in detail in the accompanying paper by Costin, this question is discussed here briefly. Whereas many countries have legislation to protect immovable buildings, monuments, and sites, movable property is often not given adequate legislative protection. If the artifacts are held in a museum, then the federal, state, or local legislation that established the institution will normally give it the legal right to protect the artifacts it houses. For example, a function of the National Museum of Australia as defined in its enabling act (Australian Government Publishing Service 1980) is "to develop and maintain a national collection of cultural material." But such legislation may not cover artifacts held by small historical societies and the like, nor does it protect artifacts held in private collections. Australia has legislation that covers all movable cultural property, but it is limited to controlling the import and export of such material (see Appendix).

In the language of the regulations, movable cultural property has always been separated from immovable cultural property. The definition of a significant place, I would argue, should include the building, its contents, the archaeological material on the site, the gardens around the building, and the surrounding landscape. The place needs to be considered as a whole—its history, usage, cultural significance, and its contents, both movable and immovable. In many instances, the artifacts, either natural or man-made, are what make a site culturally significant. For example, grinding stones and stone flakes may indicate a quarry and tool-making site; an arrangement of stones might indicate a ceremonial site; skeletal remains might denote a burial site. It is impossible to plan for the conservation of a place without considering all of its appurtenant objects. This caveat should be taken even further.

Perhaps new legislation or conservation plans should not separate movable from immovable cultural property. The proposed New Zealand Conservation of Cultural Property legislation (New Zealand 1983), which will cover movable and immovable property, defines cultural property as "physical items or the remains of such items, which provide evidence of human thought, activity or history, or have human

spiritual or emotional association, and which may include any associated physical or social environment contributing to the understanding or significance of that property."

Codes of Ethics and Guidance for Conservation Practice

Several international documents offer conservators and curators a guide to the handling of museum collections. The International Council of Museums (ICOM) has published a "Code of Professional Ethics" and in 1986 the Interim Meeting of the Working Group on Training in Conservation and Restoration of the ICOM Committee for Conservation published "The Conservator-Restorer: A Definition of the Profession," which attempts to define the conservation profession.

Around the world, a number of conservation organizations in different countries have developed their own codes of ethics. The earliest was formulated by the American Institute for Conservation (AIC), with Murray Pease's report in 1968 (Pease 1968), from which organizations such as the U.K. Institute for Conservation (UKIC), the International Institute for Conservation of Historic and Artistic Works-Canadian Group (IIC-CG), and the AICCM (1986) developed their own codes—each one borrowing from the other. AIC is currently reviewing its own Code of Ethics and Standards of Practice.

It is essential that a code of ethics and guidance for conservation practice be developed by those most involved. Such a document could regularize the standards for conservation, provide a useful statement of the current state of thinking within the regional conservation network, and strengthen communication and understanding among individuals in the various heritage professions. Perhaps either the ICOM Committee for Conservation or the International Centre for the Study of the Preservation and the Restoration of Cultural Property (ICCROM) could be persuaded to advise on this task.

Such a document might contain a glossary defining such terms as "movable cultural property," "conservator," "conservation," "restoration," "preservation," and "reconstruction." The definitions now used vary widely, and developing consensus is a good initial step toward agreement on normative standards of practice.

Developing the Conservation Profession

The state of professional conservation in the region varies widely from country to country. In some countries, including Japan, India, Australia, and New Zealand, the conservation profession is well established, and many of the cultural institutions have well-developed conservation facilities. In countries in Southeast Asia—for example, the Association of Southeast Asian Nations (ASEAN) countries of Brunei, Indonesia, Malaysia, the Philippines, Singapore, and Thailand—conservation facilities exist, but in the main they are limited to the national museums of each country (Norton and Pearson 1983). In the Pacific, the majority of countries either lack both conservators and conservation facilities (Norton and Pearson 1984) or have a single person serving as curator, conservator, exhibition designer, and cleaner.

For conservation to develop, a number of requirements must be in place: conservation training, laboratories, equipment and supplies, and literature. In any proposal for funding to support the development of this necessary infrastructure, one should not neglect any of these factors, as each has little value or utility without all the others.

CONSERVATION TRAINING

Most conservators in several countries in the region have received their training largely through short courses. This training has been provided through organizations such as ICCROM; National Research Laboratory for Conservation (NRLC) in Lucknow, India; Southeast Asian Ministers of Education Organization (SPAFA) in Thailand; and the Regional Conservation Centre at the University of Canberra. Although appropriate as a beginning, these brief courses are inadequate in the long term to train professional conservators. Formal academic training at the university level is necessary to achieve parity with other practitioners in the heritage professions, such as curators, museum directors, historians, archaeologists, librarians, and archivists. This subject is discussed in papers presented to the Interim Meeting of the Working Group on Training in Conservation and Restoration of the ICOM Committee for Conservation, held in the Netherlands in 1989 (Stanley Price 1990).

There are a number of problems with short courses (Pearson 1991). These include:

Duration. Many courses are only two to three weeks long and cannot provide in-depth training. Moreover, they usually concentrate on the practice of conservation and omit the theory that gives context and rationale to each practice.

Level of Course. Most courses are at a basic, introductory level, which again can be dangerous if they concentrate on the practice and only scan the theory. The maxim "a little knowledge can be a dangerous thing" is particularly applicable to conservation.

Relevance. The material covered in the course is not always relevant to the student's home situation, especially if the training is given in another country where the materials and conservation problems may be different.

Follow-up. There is generally too little follow-up to short conservation training courses, and when students return home, they often cannot practice the skills and techniques they were taught.

Certification of Attendance. It is standard practice to offer certificates of attendance to participants in short courses. Unfortunately, these are often used later as proof of qualification. Unless the participants are examined, however, such certificates are meaningless, as they do not ensure that anything was gained from the course. Language problems, lack of interest, inappropriate level, and other problems can easily obstruct learning. Perhaps certificates of attendance could be replaced by certificates of achievement when no examination is given.

There are only a few university-level courses currently available in the region. The University of Canberra in Australia offers degrees at the bachelor's, master's, and doctoral levels (the latter two by research) (Pearson 1986), and the Tokyo National University of Fine Arts and Music offers a Master of Arts degree in conservation science (Sugisita 1986). The University of Canberra takes students from various countries in the region, including New Zealand, Brunei, Malaysia, Fiji, Sri Lanka, and the Solomon Islands.

Like the short courses, the university training programs have significant shortcomings. For example, in the University of Canberra course, there are a number of problems in training students from overseas. The following summarizes the problems associated with university training courses:

Duration. A two- to three-year course is often too long for students to be away from their homes and families. They often suffer from climatic and cultural shock.

Funding. Overseas students must pay tuition fees (around u.s. $10,000 per annum), in addition to the costs of travel, accommodations, and living expenses. Some of the developed countries in the region have arrangements to provide training scholarships—in Australia, for example, students are assisted by the Australian International Development Assistance Bureau (AIDAB). Each country determines its own priorities regarding overseas training, and cultural heritage is invariably at the bottom of the list of priorities—preceded by health, education, agriculture, fishing, and so on.

Differences in Academic Preparation. The level of education received by students in different countries in the region can be quite uneven. A bachelor's degree from one country may be equivalent only to a secondary education in another country. Information concerning the equivalent levels of academic training in the region must be considered when deciding whether to accept foreign students into a conservation training program (this information is available through government departments of education). If a student has not reached a certain academic standard upon admission, the possibility for failure is higher. Such public failure causes problems for students when they return home, and wastes valuable funds. Proficiency in the language of the country where the training is carried out is essential.

Relevance. The training received by students must be relevant to the needs of their home nations. The religions, beliefs, and cultural values of the region must be considered in the development of appropriate training programs. The techniques and materials used in conservation training must be available or easily adaptable and when possible, foreign students should have some opportunity to work on artifacts and problems related to their own countries.

Since 1986, a training program has been in operation for the six ASEAN countries, organized by UNESCO and funded by the United Nations Development Program (UNDP), to train conservators from the national museums of each country. Its progress was reviewed at a workshop held in Bangkok in January 1991.

In the Pacific region, the University of Canberra and ICCROM carried out a survey to determine the con-

servation needs of Pacific states, with attention to training, facilities, and equipment. As a result, proposals will be prepared to assist with the development of conservation in the region.

CONSERVATION FACILITIES

Conservators need at least minimal facilities to carry out their work. These would include a conservation laboratory, equipment, chemicals, conservation materials, books, and journals.

Requests for sophisticated equipment such as scanning electron microscopes and other forms of analytical equipment should be treated with caution. These are sometimes "donated" by developed countries, but although they are impressive, they are rarely used or needed. Expensive to maintain, they require highly trained operators. It is usually much more efficient to "buy" the analysis from a university or government agency.

Basic laboratory equipment is necessary; international suppliers can ship equipment to any part of the world. Because of possible problems with currency exchange regulations, one should determine what equipment or equivalent is available in that country before orders are placed. The same reasoning applies to conservation materials, chemicals, and solvents.

One should also be aware of high duties on imported equipment and conservation supplies. In some cases, international organizations such as UNESCO and UNDP can approach government customs and excise departments to see if import duties can be waived for equipment and material to be used for conservation.

Although conservation books and journals can be costly and difficult to acquire for the same reasons as given above, it is important that trained conservators have access to the latest conservation literature. Conservation books can be obtained through international suppliers, while journals usually must be acquired by subscription.

ICCROM, through its Technical Assistance Program, can provide limited conservation literature (usually its own publications) and sometimes equipment and supplies. These may be available on request; there is, however, a greater chance of receiving material if the country concerned is a member of ICCROM. It costs countries such as Malaysia, the Philippines, and Thai-

land about U.S. $2,500 per annum to belong. Besides receiving technical assistance, member states have a say in the running of ICCROM through its General Assembly, and are also likely to receive preferential treatment compared with nonmember states in the awarding of training opportunities and consultancies. Countries are therefore encouraged to join ICCROM; details about membership can be obtained from the Director.

COMMUNICATION

An important matter for the development of conservation in the region is communication among countries, organizations, institutions, and individuals. Some countries have their own professional conservation organizations and publish journals and newsletters. Others do not, and as a consequence know very little about what is happening in their own region.

Electronic mail and the Conservation Information Network (CIN) offer rapid access to broad networks of information and practitioners. Information on services of this kind, specific to the conservation profession, is available from the Getty Conservation Institute and from the Canadian Heritage Information Network (365 Laurier Tower South, 12th floor, Ottawa, Ontario).

It should be noted that ICCROM, the Canadian Conservation Institute, and the Getty Conservation Institute will send their newsletters on request, free of charge, to any conservator or conservation organization.

The Influence of Tropical Environments on Objects

The climate of countries in South Asia and the Pacific can vary from hot and dry to hot and humid, depending on the location of the country. For example, tropical island climates are characteristic of the nations of the South Pacific. Heat, dryness, high relative humidity (particularly if coupled with high light levels), air pollution, and the presence of insects can all cause serious damage to works of art and artifacts held in museums, galleries, libraries, archives, cultural centers, and historic houses.

There have been several general publications on the problems of conservation in the tropics, presented as the proceedings of conferences and symposiums (UNESCO 1968, Thomson 1967, Agrawal 1972, Pearson 1980, IIC

1988). These publications address the common problems of high relative humidity, insects, mold growth, and the control of these problems, and include reports from different countries. These usually note the facilities, materials, and techniques used in each country and provide information about the issues facing the local conservators. The references listed cover the basic texts relevant to this field, including the latest bibliography published by New York University (Gerhard 1990). *The Museum Environment*, by Thomson (1986), is the standard reference book in this field.

TEMPERATURE AND RELATIVE HUMIDITY

Temperature and relative humidity (RH) are closely interrelated. In a closed space—a storeroom or display case—an increase in temperature will cause a decrease in relative humidity, and vice versa. Changes in temperature alone also affect reaction rates, with a general rule that for every 10 °C increase in temperature there will be a doubling of reaction rates, and if these are associated with deterioration processes, materials will break down much more quickly. This rule is also dependent on light levels. For example, the temperature of cellulose needs to rise only 5 °C—from 15 °C to 20 °C—to cause a 250% increase in reaction rates, whereas other materials, if stored in the dark, may be unaffected by changes in temperature as large as 30 °C (Thomson 1986).

Relative humidity changes are much more significant in deterioration processes. High relative humidity can cause corrosion of metals and weeping of glass and—if the temperature is above 65 °C to 70 °C—is ideal for mold growth on organic materials. Below 40% RH, most organic materials will begin to dry out, and shrinkage, warpage, or cracking may occur. In contrast, for metals, a low relative humidity is ideal for preservation.

When both temperature and relative humidity change, the effects on materials can be serious. If these changes are rapid, materials may suffer damage as they expand and contract. In organic materials, moisture moves in and out of the artifact, causing further swelling and contraction, and possibly resulting in serious damage. If changes take place slowly, organic materials have time to adjust. To ensure that artifacts remain stable, daily temperatures must not change by more than 5 °C, and the relative humidity by more than 5% (Zhong 1988). Artifacts can survive well in extreme con-

ditions, such as underwater or in desert environments, as long as the conditions are stable.

LIGHT

Light is a more potent cause of deterioration of museum artifacts than is heat (Thomson 1986:4). For degradation reactions to take place, materials must receive energy, which can take the form of light radiation. In light, minute bundles of energy called photons travel in a wave motion; the higher their frequency and shorter their wavelength, the more energy they contain. Higher energy levels increase damage to the artifact as "photochemical degradation."

The most damaging component of light is in the ultraviolet (UV) range. In visible radiation, the blue end of the spectrum is more harmful than the red. Radiation in the infrared (IR) portion of the spectrum is heat. All light sources, natural and artificial, contain various proportions of ultraviolet, visible, and infrared radiation, and all these must be measured to determine if a light source constitutes a potential hazard in the museum.

The annual total levels of outdoor light received by countries in South Asia and the Pacific are twice those received by countries far north or south of the equator (Thomson 1972). If this intense light is allowed to fall on museum artifacts, photochemical degradation will occur. Organic materials are particularly susceptible, as fibers are weakened and dyed material loses or changes color when exposed to excessive light. Although an obvious solution is to eliminate all natural daylight from within a museum, this can be difficult and can create an unpleasant, unnatural environment. Even with the use of artificial light sources, care must be taken to control ultraviolet and infrared radiation levels.

AIR POLLUTION

Air pollution varies widely in content and quantity from place to place. Some cities in the region have high levels of pollution from industry and motor vehicles. Airborne dust and salt (especially common on the Pacific islands) can damage works of art and artifacts.

Sulfur dioxide is the most common industrial pollutant, and "acid rain" is a well-known phenomenon that can degrade marble, limestone, frescoes, cellulose, silk, leather, parchment, wood, iron, steel, and many other natural and synthetic materials (Thomson

1986:147). The products of combustion of vehicle exhaust produce the strong oxidizing gas ozone, as well as nitrogen oxides, which can combine with water to form nitrous and nitric acids. Airborne salts, in certain forms, are particularly damaging to metals. Particulate matter may seem to be mere unsightly dust, but it can harbor moisture, oils, and acidity. These external air pollutants can enter a museum and damage the collections.

MUSEUM PESTS

Insects. A wide range of insects can be found in museums in the tropics. These include silverfish, cockroaches, bookworms, book lice, wood borers, termites, clothes moths, and carpet beetles, among others. Most insects favor high temperatures and high relative humidities, and are more active in the tropics than in temperate climates (Nair 1972). The damage caused depends on the insect type, its life cycle, and the material being attacked. Moth-eaten textiles, powdered wood resulting from borers or termites, and the stains from insect droppings are common occurrences in museum storerooms. Good housekeeping should be the first line of defense for controlling insects, but there has traditionally been an excessive reliance on the use of some potentially dangerous insecticides. Some new thinking on this subject promises to improve the situation. (See discussion of pest control, below.)

Mold. Fungal spores are always present in the atmosphere and will propagate and grow mold in the right environment. This causes staining and breaks down organic materials (Nair 1972, Strang and Dawson 1991). Molds can grow at temperatures below the freezing point, but they grow more readily at warm temperatures. A relative humidity between 65% and 70% is ideal for mold growth (Thomson 1986:86, Strang and Dawson 1991).

In many countries in the region, the relative humidity outdoors rarely falls below 65%, and remains above 80% for long periods. Unless some form of environmental control is used, similar conditions will prevail inside a museum, coupled with a daily temperature that seldom falls below 20 °C.

Rodents. Rodents, in particular rats and mice, are not uncommon in the region, and sometimes museum objects have been badly chewed. Again, good housekeeping is important. Rodent bait can help to confirm the presence of these pests and control them. Toxic

baits can, however, be a problem, though not as serious as that posed by insecticides.

Human Factors. As any museum professional knows, museum staff can be the cause of significant damage to works of art and artifacts. Not only can the lack of proper environmental conditions cause damage, but poor handling, inadequate support during transport, poor storage, and poor display techniques are also major contributing factors. All these kinds of damage are preventable.

The Reduction and/or Control of Environmental Factors

LIGHT

Light levels can be controlled quite easily. There are internationally accepted standards of illumination and ultraviolet radiation for materials with various degrees of susceptibility to damage caused by light (see Thomson 1986:23). These levels can be attained by using a few standard guidelines:

■ Never allow direct sunlight to enter a museum where light-sensitive objects are on display. This can be achieved through careful building design and sensible location of collections.

■ Rotate objects between dark, controlled-climate storage and display. Highly light-sensitive materials should not be kept on exhibition for more than three to six months at a time.

■ Use timed light switches or curtains for display cases containing highly sensitive material.

■ Levels of UV radiation can be reduced by reflecting light from painted surfaces. For example, white titanium dioxide will reflect only about 20% of the UV rays falling on it. By careful design, it is possible to control UV radiation and daylight entering a museum.

■ Use incandescent light for illuminating objects. Incandescent bulbs have low UV output, and the light levels can be controlled with a dimmer switch. One should take into consideration the heat that incandescent bulbs produce.

■ If fluorescent light is used, the tubes must have a low UV output, or UV filters must be used (LaFontaine and Wood 1980).

■ Several filter systems are available for reducing illumination and UV and IR radiation levels. Filtering materials are available as lacquers, thin plastic films, or sheets of clear, rigid plastic, such as Perspex or Plexiglas treated with a UV filter. Whichever system is used, it is essential to test the efficiency of the filter. Never simply accept the claims of the manufacturer.

It is also necessary to consider the color-rendering index and color temperature (Thomson 1986:48–60) of light sources, as these will affect the appearance of exhibited objects. This is particularly important for exhibition designers. By careful design and use of artificial light sources, it is possible to create a museum where all objects can be viewed easily, at light levels that will not cause harm.

CONTROLLING MUSEUM PESTS

Museum pests include insects, mold, rodents, and people. People can be controlled by means of education and the effective use of trained museum staff. Educational efforts should involve curators, conservators, exhibition designers, preparators (who move and handle works of art and artifacts), registrars, and directors.

A major problem in the region is the current practice of controlling insects by means of insecticides, many of which have been banned in Europe, North America, and Australia. In literature from as recently as six years ago, we see reference made to the use of DDT; Aldrin; dieldrin; chlordane; lindane; and insect repellents, such as naphthalene crystals and paradichlorobenzene (Agrawal and Dhawan 1985). The "British Museum Mixture" insect repellent, comprising equal portions of chloroform, creosote, and naphthalene is noted, along with another repellent formula that combines paradichlorobenzene, benzene, and creosote. Recent studies have shown that these chemicals are harmful to museum staff, to works of art, and to artifacts.

Until relatively recently, ethylene oxide was considered a safe fumigant for treating both insect and mold infestations. For safety purposes, users were cautioned to dilute it with carbon dioxide and to carry out treatment in a fumigation chamber. Today, however, ethylene oxide is being banned from museum use because of its toxicity, particularly since it can remain in an object for months after treatment (Florian 1987). It and other common fumigants, such as methyl bromide, are also known to damage certain materials.

It appears that virtually every insecticide or fumigant that has been used to control insects is eventually found

to be hazardous. The most recent research indicates that even Vikane, widely used in American museums, has problems (The Getty Conservation Institute 1990).

Fortunately, there is now a concerted move away from the use of insecticides. Even so, it may be many years before their residual effects disappear. Promising insect-control methods under current investigation include freezing at -20 °C for forty hours (Florian 1987), inert gases (low-oxygen atmospheres; Gilberg 1989), and nitrogen (Valentín 1989). Nitrogen atmospheres are also proving to be successful in treating mold growth (Valentín et al. 1990). Some techniques being developed in industry for control of insects in stored products are finding application in controlling museum pests.

The propagation of fungi and mold takes place in conditions of relative humidity above 65% to 70% and warm temperatures—conditions typical of the region. What factors can help to control mold growth?

Relative humidity in museums should be kept below 65% (Strang and Dawson 1991). Temperature alone has little effect on mold growth: Freezing will not kill fungal spores, and the use of very high temperatures would be detrimental to the artifacts. Various means of controlling relative humidity have been described above. Good air circulation keeps fungal spores from settling long enough for them to propagate (Strang and Dawson 1991).

Another means of controlling mold growth is the use of fungicides. Fungicides are invariably toxic, and none meets all the requirements for effective treatment of mold. Ideally, a fungicide suitable for museum use should be safe to use (for the artifact and for the user), effective on a broad classification of fungi, toxic to all growth stages, and nonstaining. Over the years, most of the common fungicides and fumigants, such as thymol, orthophenylphenol, pentachlorophenol, paradichlorobenzene, ethylene oxide, and others have been found to be harmful to both people and artifacts (McGiffing 1985, Strang and Dawson 1991, Green and Daniels 1987, Lewin 1986). The application of gamma radiation has been shown to damage cellulosic materials (Butterfield 1987).

Alternative nontoxic antifungal agents that may solve some of the above problems are being researched (Dersarkissian and Goodberry 1980). Of considerable interest is the recent work by Valentín et al. (1990), who are experimenting with nitrogen (low-oxygen atmospheres) to control mold in museum collections. This is

safe and effective on molds, particularly when coupled with the use of low relative humidity. The work to date indicates that low RH is more important than low oxygen concentrations, confirming that the best preventive measure is maintaining a low relative humidity.

The best approach now being taken for the overall control of insects, mold, and rodents is "integrated pest management," or IPM (Flint and Van den Bosch 1981; Story 1985; Zycherman and Schrock 1988), which is an ecosystems approach to controlling museum pests without harming staff or collections. IPM requires a thorough study of the pests likely to be present in a museum, their habits or life cycles, and the environments they prefer. Although site specific, it is adaptable in principle to any museum, and can provide a structure whereby responsible decisions concerning the control of pests can be made.

The goal of IPM for museum collections is the protection of the museum and its collections from damaging pests, and the reduction of pesticide use. The usual IPM procedures are as follows:

Establish a monitoring program for pests:

- inspect for wood-boring insects in structures
- observe particularly for signs of mold
- monitor for insects
- monitor for rodents
- analyze the data

Prevent infestations through nonchemical controls:

- environmental controls
- good housekeeping
- structural maintenance and repair
- closing/sealing possible entry points
- cultural controls
- administrative controls for collections
- proper storage and exhibitions

Deal with infestations (treatment strategies):

- determine the extent of the infestation
- consider all factors when choosing a treatment
- evaluate collections safety
- identify and minimize human health risks

A number of the IPM procedures relate to building design. Certain questions should be asked: How easy is it

for insects and rodents to gain entrance into storage and exhibition areas? Are preparation areas for the museum cafeteria close to object storerooms? Is there only one service entrance for objects, food, books, stationery, and the like? Are there problems with rising damp, or the occasional flood or leaking roof that will create high relative humidity and promote mold growth? Many of these problems can be avoided in the design stage.

The approach to pest control through IPM instead of toxic pesticides should be encouraged. This could improve the status not only of collections but also of the health of museum workers in the region.

Natural Disasters

The 42d Session of the United Nations General Assembly in December 1987 designated the 1990s as the International Decade for Natural Disaster Reduction. U.N. Resolution No. 42/169 states that:

> *The objective of this Decade is to reduce through concerted international actions, especially in developing countries, loss of life, property damage and social and economic disruption caused by natural disasters ... and that its goals are: (a) to improve the capacity of each country to mitigate the effects of natural disasters expeditiously and effectively, paying special attention to assisting developing countries in the establishment, when needed, of early warning systems; (b) to devise appropriate guidelines and strategies for applying existing knowledge, taking into account the cultural and economic diversity among nations; (c) to foster scientific and engineering endeavours aimed at closing critical gaps in knowledge in order to reduce loss of life and property; (d) to disseminate existing and new information related to measures for the assessment, prediction, prevention and mitigation of natural disasters; (e) to develop measures for the assessment, prediction, prevention and mitigation of natural disaster through programmes of technical assistance and technology transfer, demonstration projects, and education and training, tailored to specific hazards and locations, and to evaluate the effectiveness of these programmes.*

In the resolution, the General Assembly of the United Nations created a mandate for the International

Decade for Natural Disaster Reduction by calling on governments "to establish national committees, in cooperation with the relevant scientific and technological communities, with a view to surveying available mechanisms and facilities for the reduction of natural hazards, assessing the particular requirements of their respective countries or regions in order to add to, improve or update existing mechanisms and facilities and develop a strategy to attain the desired goals."

At its General Assembly in the Hague in 1989, ICOM created its Ad Hoc Committee for Disaster Reduction, which is attempting to coordinate activities on a global basis. How many countries in Asia and the Pacific have national committees to deal with natural disasters, and more important, how many cultural institutions have a disaster preparedness plan to deal with a calamity? Disaster plans need to be drawn up and then practiced, so that they can readily be put into effect if a disaster is imminent.

An excellent book by Sir Bernard Feilden (1987) provides specific guidelines for coping with earthquakes. There are other general procedures that can be followed to cope with most natural disasters. The majority of the literature refers to protecting library and archive material (Kemp 1983; Dixson Library, University of New England 1990) but more general information is available to cover the wide range of movable cultural property (Upton and Pearson 1978).

During and immediately following a disaster, panic is common. Persons who have practiced the emergency evacuation of buildings and have dealt with water-damaged material and similar challenges will be much better equipped to cope with the real situation. Besides such training, planning is required to identify potential sources of disasters (a process known as risk assessment). Many threats can be minimized by a program of inspection and maintenance.

First, it is necessary to inspect the buildings and collections to determine the potential risk if a disaster occurs. Are buildings prone to flooding? Are they close to the waterfront, where they could be affected by high tides or tidal waves? Is there a regular maintenance schedule for the building and its services? What fire detection and suppression systems are there? Do they function and are they tested regularly? Valuable advice is often available from local fire departments.

In the Pacific, the majority of cultural collections are housed in relatively small buildings that are prone to damage by typhoons (called hurricanes when formed east of the International Dateline, cyclones in the Indian Ocean) and tidal waves. Surveys of such buildings—especially the storage and exhibition areas—can help determine the potential risk to a building and its contents. For example, is the building large enough that it requires an evacuation procedure?

Typhoons, heavy rains, and strong winds are often predictable and allow time to take protective action. If a typhoon is imminent, special measures can be taken, including shuttering windows and covering collections with plastic, taking care not to create a microenvironment of high relative humidity. If the records of the collections are lost, the collections may become worthless. Have records been duplicated and copies held elsewhere for safekeeping?

Materials and equipment necessary for cleaning up after a disaster should be either readily available or accessible from known sources. After a disaster, there will not be time to research sources of plastic sheeting, fans, emergency generators, or other items, particularly when there will probably be competition from local residents for such materials. Small institutions can stock a storage cupboard with mops, buckets, sponges, and flashlights. These items must not be used for regular cleaning purposes; they should be reserved for emergency access only. What would be available from other similar institutions nearby? Can assistance be provided through the local fire department, police, or other emergency organizations? The availability of help will depend on the size of the town or city where the institution is located, but it is essential that prior contact be made with other emergency authorities.

Once disaster has struck, consider how to deal with the resultant damage. The most common problem is water from rain, floods, or firefighting procedures. In a hot, humid environment, mold will grow very rapidly unless quick action is taken. Anticipate what happens to books, coated papers, photographs, cinefilm, computer disks, metals, textiles, furniture, and other materials on exposure to water. Freezing waterlogged materials can be a useful first step—but will freezing facilities be available? What can and cannot be frozen? Once the situation is under control, the frozen object must be carefully dried out. Planning and training in procedures for dealing with damaged material are therefore essential components of any museum operation.

Training courses are required to ensure that every cultural institution has a plan for coping with disasters. Such a course should include the following topics:

- Principles of disaster planning
- Risk assessment
- Prevention/reduction of potential disasters
- Dealing with a disaster after the event
- Preparation of a disaster plan

All individuals and institutions responsible for the preservation of movable cultural property should be concerned about preparing for and coping with disasters.

Conclusions

There is much to be done in South Asia and the Pacific if the movable cultural heritage of the region is to be preserved. Whatever actions are taken, they must not be carried out in isolation, but rather as part of an overall conservation development plan for each country. The relative difficulty of enacting such legislation will vary from country to country. Writing an appropriate code of ethics for conservation, however, should be relatively easy.

Each country represented here should have a conservation development plan that takes into account the issues discussed in this paper. Any activity, such as a training scheme or building a new conservation laboratory, should be part of such a plan. It may be years before countries in the region are as well equipped as Western countries, but without long-term plans and goals, little will be achieved in the near future, and many activities, such as short courses or acquisition of conservation equipment, will be a waste of money.

Preserving cultural heritage rarely has a high priority for domestic funds or international aid. Without funds, it will be impossible to train conservators and provide them with adequate conservation facilities. Intensive lobbying at all levels will help to raise awareness about the dangers facing the preservation of movable cultural property.

Much can be done to lessen the physical effects of tropical environments on works of art and artifacts.

With the use of appropriate building design, insulation, air circulation, and passive environmental controls, a stable environment can be achieved quite economically. Integrated pest management that employs freezing and low-oxygen environments is a safe way to control pests. These inexpensive, environmentally sound approaches would benefit from further investigation and promotion in the region.

Communication among individuals in the museum professions in the region will ease the burden by distributing the work, and will help to set agendas and priorities that pertain directly to the concerns, challenges, and opportunities common to the area. Regional exchanges of technology, information, and individuals can enrich the professional practice of cultural property conservation, and can create a stronger voice more likely to capture the attention of international agencies and institutions. The long history of interest in conservation of cultural traditions in South Asia and the Pacific is recognized, and stands to gain substantially from stronger ties among the nations of the region.

Biography

Colin Pearson is Director and Associate Professor of the National Centre for Cultural Heritage Science Studies, at the University of Canberra, Australia. His degrees, including the Doctorate in Science Technology, were awarded by the University of Manchester. He is a consultant to Unesco/undp on conservation training in South Asia and the Pacific, a member of the Board of the icom Committee for Conservation, a Fellow and Council Member of the iic, and a Council Member and Academic Advisory Board Member of iccrom.

References

Agrawal, O. P. (ed.)

1972 *Conservation in the Tropics.* Rome: iccrom.

Agrawal, O. P., and S. Dhawan

1985 *Control of Biodeterioration in Museums.* Technical Note No. 2. Lucknow, India: National Research Laboratory for Conservation of Cultural Property.

aiccm (Australian Institute for the Conservation of Cultural Material)

1986 Code of Ethics and Guidance for Conservation Practice, for Those Involved in the Conservation of Cultural Materials in Australia. Canberra: aiccm.

Anonymous

1960 Climatology and Conservation in Museums. *Museum* 13(4).

Australian Government Publishing Service

1980 National Museum of Australia Act. Canberra.

Australia icomos

1987 The Australia icomos Charter for the Conservation of Places of Cultural Significance [known as the Burra Charter], including Guidelines to the Burra Charter: Cultural Significance, and Guidelines to the Burra Charter: Conservation Policy. Canberra: Australia icomos.

Baxi, S. J.

1972 Climate and Museum Architecture in the Tropics. In *Conservation in the Tropics*, pp. 69–73. Rome: iccrom.

Bhowmik, S.

1972 Design of a Museum Building and Preservation. In *Conservation in the Tropics*, pp. 74–80. Rome: iccrom.

Butterfield, F.

1987 The Potential Long-Term Effects of Gamma Irradiation on Paper. *Studies in Conservation* 32: 181–90.

Chiraporn, A.

1988 Control of Museum Climate in Thailand. In *Control of Museum Climate in Asia and the Pacific Area*, pp. 11–20. Kyoto: The Japanese Organising Committee of iic Kyoto Congress.

Dersarkissian, M., and M. Goodberry

1980 Experiments with Non-Toxic Anti-Fungal Agents. *Studies in Conservation* 25:28–36.

Dixson Library, University of New England

1990 *Disaster Response and Recovery Manual.* Biddeford, Maine: Dixson Library, University of New England.

Feilden, B. M.

1987 *Between Two Earthquakes: Cultural Property in Seismic Zones.* Rome/Marina del Rey, California: iccrom/The Getty Conservation Institute.

Flint, M. L., and R. Van den Bosch

1981 *Introduction to Integrated Pest Management.* Plenum Press.

Florian, M.-L.

1987 The Effect on Artifact Materials of the Fumigant Ethylene Oxide and Freezing Used in Insect Control. *ICOM-CC Preprints, 8th Triennial Meeting, Sydney,* pp. 199–208. Los Angeles: ICOM/The Getty Conservation Institute.

Freemantle, E.

1988 Humidity Control for Small Volumes. In *Control of Museum Climate in Asia and the Pacific Area,* pp. 35–39. Preprints of meeting held in Kyoto, Japan, 18 September 1988. Kyoto: Japanese Organising Committee of IIC Kyoto Congress.

Fry, M., and J. Drew

1956 *Tropical Architecture in the Humid Zone.* London: Batsford.

Fuji-Davison Chemical Ltd.

1986 *The Function of Art-Sorb.* Technical Bulletin 86–7. Tokyo.

Gerhard, C.

1990 *Preventive Conservation in the Tropics: A Bibliography.* New York: Conservation Institute of Fine Arts, New York University.

The Getty Conservation Institute

1990 Unpublished notes from the "Preventive Conservation: Museum Collections and Their Environment" Workshop, April 1990.

Gilberg, M.

1989 Inert Atmosphere Fumigation of Museum Objects. *Studies in Conservation* 34:80–84.

Green, L., and V. Daniels

1987 Investigation of the Residues Formed in the Fumigation of Museum Objects Using Ethylene Oxide. In *Recent Advances in the Analysis of Artifacts,* Proceedings of the Jubilee Conservation Conference, pp. 309–13. London: Institute of Archaeology, University of London.

ICOM (International Council of Museums)

1986 The Conservator-Restorer: A Definition of the Profession. *ICOM News* 39(1):5-6.

IIC (International Institute for Conservation)

1988 *Control of Museum Climate in Asia and the Pacific Area.* Preprints of meeting held in Kyoto, Japan, 18 September 1988. Kyoto: Japanese Organising Committee of IIC Kyoto Congress.

Kamba, N.

1988 Technical Report on the Result of Brief Survey Concerning Museum Climate. In *Control of Museum Climate in Asia and the Pacific Area,* pp. 1–10. Preprints of meeting held in Kyoto, Japan, 18 September 1988. Kyoto: Japanese Organising Committee of IIC Kyoto Congress.

Kemp, T.

1983 Disaster Assistance Bibliography: Selected References for Cultural/Historic Facilities. *Technology and Conservation* 2(83):25–27.

LaFontaine, R. H., and P. Wood

1980 *Fluorescent Lamps.* Technical Bulletin 7. Ottawa: Canadian Conservation Institute.

Lewin, R.

1986 Study Estimates Higher Risk from Ethylene Oxide Exposure. *Science* 23:31.

McGiffing, R.

1985 A Current Status Report on Fumigation in Museums and Historical Agencies. *AASLH Technical Report* 4:1–16. Nashville, Tennessee.

Nair, S. M.

1972 Biodeterioration of Museum Materials in Tropical Countries. In *Conservation in the Tropics,* O. P. Agrawal (ed.), pp. 150–58. Rome: ICCROM.

[New Zealand]

1983 The Conservation of Cultural Property Bill (Draft). Auckland: New Zealand Government.

Norton, R., and C. Pearson

1983 *Tour of Cultural Institutions in South East Asia.* Canberra: Regional Conservation Centre, University of Canberra.

1984 *Tour of Cultural Institutions in the Pacific.* Canberra: Regional Conservation Centre, University of Canberra.

Pearson, C.

1986 Training in the Conservation of Cultural Materials in Australia. In *The Training of Specialists in Various Fields Related to Cultural Properties,* 9th International Symposium on the Conservation and Restoration of Cultural Property, pp. 211–20. Tokyo: National Research Institute of Cultural Properties.

1991 Conservation Training for and in Countries of South East Asia and the Pacific. Presented at the Ferrara III Meeting: Education and Training in Conservation at International Level—Past Experiences and Future Need; Ferrara, November 1991.

Pearson, C. (ed.)

1980 *Regional Seminar on the Conservation of Cultural Material in Humid Climates.* Australian National Commission for UNESCO. Canberra: Australian Government Publishing Service.

Pease, M.

1968 *The Murray Pease Report: Code of Ethics for Art Conservators.* New York: American Institute for Conservation (International Institute for Conservation, American Group).

Stanley Price, N. (ed.)

1990 *The Graduate Conservator in Employment: Expectations and Realities.* Proceedings of the Interim Meeting of the Working Group on Training in Conservation and Restoration of the ICOM Committee for Conservation, Amsterdam and Leiden, 31 August–1 September 1989. Amsterdam: ICOM.

Stolow, N.

1985 Controlled Environment Travelling Cases and Their Monitoring. In *Conservation and Exhibitions*, p. 242. London: Butterworths.

Story, K.

1985 *Approaches to Pest Management in Museums.* Washington, D.C.: Conservation Analytical Laboratory, Smithsonian Institution.

Strang, T. J. K., and J. E. Dawson

1991 *Controlling Museum Fungal Problems.* Technical Bulletin No. 12. Ottawa: Canadian Conservation Institute.

Streten, N. A., and J. W. Zillman

1984 Climate of the South Pacific Ocean. In *Climates of the Oceans: World Survey of Climatology*, Vol. 15, pp. 263–429. Amsterdam: Elsevier.

Sugisita, R.

1986 Problems in the Practice of Training Conservation Scientists in Japan. In *The Role of Science in Conservation Training.* Proceedings of the Interim Meeting of the Working Group on Training in Conservation and Restoration of the ICOM Committee for Conservation, 6–10 October 1986, London, pp. 99–108.

Thomson, G.

1972 Climate in the Museum in the Tropics. In *Conservation in the Tropics*, pp. 37–52. Rome: ICCROM.

1986 *The Museum Environment.* 2nd ed. London: Butterworths.

Thomson, G. (ed.)

1967 *London Conference on Museum Climatology.* London: IIC.

UNESCO

1966 International Charter for the Conservation and Restoration of Monuments and Sites (known as the Venice Charter).

1968 *The Conservation of Cultural Property, with Special Reference to Tropical Conditions.* Museums and Monuments 11. Paris.

Upton, M. S., and C. Pearson

1978 *Disaster Planning and Emergency Treatments in Museums, Art Galleries, Libraries, Archives and Allied Institutions.* Canberra: Australian Institute for the Conservation of Cultural Material.

Valentín, N.

1989 Insect Control by Inert Gases on Artifact Materials. Report to the Getty Conservation Institute.

Valentín, N., M. Lindstrom, and F. Preusser

1990 Nitrogen Atmosphere for Microbial Control on Museum Collections. Report to the Getty Conservation Institute.

Zhong, B. Z.

1988 The Measures of Controlling the Environment Climate in Museums. In *Control of Museum Climate in Asia and the Pacific Area*, pp. 21–25. Preprints of meeting held in Kyoto, Japan, 18 September 1988. Kyoto: Japanese Organising Committee of IIC Kyoto Congress.

Zycherman, L. A., and J. R. Schrock (eds.)

1988 *A Guide to Museum Pest Control.* Washington, D.C.: American Association of Systematics.

Appendix

Protection of Movable Cultural Heritage Act, No. 11 of 1986

 Division 1 — Exports

Movable cultural heritage of Australia

7. (1) A reference in section 8 to the movable cultural heritage of Australia is a reference to objects that are of importance to Australia, or to a particular part of Australia, for ethnological, archaeological, historical, literary, artistic, scientific, or technological reasons, being objects falling within one or more of the following categories:

(a) objects recovered from

 (i) the soil or inland waters of Australia

 (ii) the coastal sea of Australia or the waters above the continental shelf of Australia; or

 (iii) the seabed or subsoil beneath the sea or waters referred to in sub-paragraph (ii);

(b) objects relating to members of the Aboriginal race of Australia and descendants of the indigenous inhabitants of the Torres Strait Islands;

(c) objects of ethnographic art or ethnography;

(d) military objects;

(e) objects of decorative art;

(f) objects of fine art;

(g) objects of scientific or technological interest;

(h) books, records, documents or photographs, graphic, film, or television material or sound recordings;

(j) any other prescribed categories

(2) The generality of paragraph (1j) is not limited by any of the other paragraphs of sub-section (1).

Building for Conservation: Appropriate Design for Environmental Control in the Tropics

Steve King

In 1968, UNESCO published *The Conservation of Cultural Property, with Special Reference to Tropical Conditions*, as part of its Museums and Monuments series. Together with *Preserving and Restoring Monuments and Historic Buildings*, a subsequent title in the same series, it has served as the standard handbook for the review of preventive conservation problems connected with a diverse range of materials. For issues affecting historic buildings, urban settings, monuments, and sites, either generally or with special emphasis on the tropics, it is difficult even today to surpass the material in those two volumes.

One issue, however, was not adequately addressed. This is the problem of how to create suitable building environments for the safekeeping of movable cultural property. Since that time, every symposium and workshop on the problems of conservation in tropical climates has included a short review of this problem and an overview of some general principles. Each paper presented has affirmed that, to a large extent, the preservation of objects that form part of our cultural heritage depends on the quality of the environment in which we store and display those objects. And on every occasion, the authors have lamented that the buildings they work in fall short of the ideal.

Unfortunately, architects, the professionals who should best understand the principles that determine the suitability of buildings for both climate and purpose, know far too little about the special requirements of preventive conservation. Worse, as Sir Bernard Feilden, an architect himself, points out, architects seem to have a "latent desire to put architectural expression before research into the client's needs" (1979).

Clients, for their part, often consider it beyond their competence to understand these aspects of the buildings they commission and, therefore, decline to participate meaningfully in their design. Ultimately, it is the responsibility of those charged with the preservation of our cultural heritage to advise on the best environments for achieving that end. To do that effectively, they must be competent to brief architects or other consultants and to review their advice. This paper is intended as a practical guide for policymakers and conservation professionals who may commission or operate buildings as repositories of cultural heritage materials in the tropics.

It is taken for granted that readers are familiar with the major problems of preventive conservation in their region. Nevertheless, certain long-held assumptions may be cast in doubt when environmental variables are discussed at the scale of buildings, rather than of exhibition cases or individual objects. The second section clarifies the scope of this paper and its bias, which is to avoid reliance on air conditioning in cultural institutions, in spite of the difficult climatic conditions of the region. The third section briefly sets out the context of different climates and microclimates in the tropics, including the general siting concerns for public buildings in those contexts.

The fourth section is the core of the discussion. It reviews in more detail the major environmental variables and the building issues that arise from them. In a number of cases, ambiguities in the literature are noted, and readers may even note some differences in interpretation from those offered by Pearson (this volume). In the area of humidity control, in particular, conventional views are challenged. Some of the issues highlighted

may offer hope for successful approaches to the "passive" control of museum environments.

A resumé of the behavior of the most common contemporary building materials in use in the tropics follows. Although far from comprehensive, it does include, however briefly, some material that may be beneficial for a clearer understanding of the final sections of this paper.

The sixth section discusses "passive" environmental control strategies, offering guidance on how best to avoid the need for air conditioning in cultural institutions. The seventh section reviews some suggestions for making air conditioning most effective where its use is unavoidable.

The threat of disasters and extreme events is discussed in the Appendix. The principle of "protective construction" is introduced, as well as its importance during preliminary design stages, to minimize additional costs.

Throughout the paper, there is a distinct bias toward discussion of the problems associated with hot, humid climates. The combination of unrelieved high temperature and excessive humidity appears to be the most challenging set of conditions for preventive conservation. The conclusion is that, although some conservation requirements can be met only by air conditioning to high standards, preventive conservation in many cultural institutions would be better served by good building design and management, avoiding overly sophisticated construction methods or services and equipment that require highly skilled staff for their installation, maintenance, and operation.

Buildings for Conservation

When discussing the conservation of cultural heritage, a distinction is conventionally made between movable and immovable cultural property. The former refers to objects, whether natural history samples, ethnographic artifacts, works of art, or documents. The latter includes historic buildings or places adapted to current uses, and archaeological sites or other monuments that may no longer serve the purpose for which they were built.

The protection of objects is usually identified with cultural institutions such as museums, art galleries, libraries, and archives. These institutions are often the major civic monuments in contemporary society, and as such have the potential to exemplify the preservation of

regional diversity and to reinforce the cultural integrity of a nation or region. The most important single factor in the effective preservation of the objects for which these institutions serve as repositories, however, is the maintenance of appropriate conditions of storage and display, largely by providing proper environmental conditions. This specialized but conventional architectural task—inadequately understood by both the conservation and architecture professions—is the subject of this paper.

In contrast, architectural conservation itself is effectively a discipline in its own right, with its own well-developed literature. The conservation of buildings and sites may take place in the context of preserving living environments of contemporary relevance, such as in existing cities of historical character. Where we seek to preserve monuments whose uses are no longer sustained, conservation, in the words of Piero Gazzola (1972), "ceases to be a matter of practical necessity, and becomes a purely cultural task." As exemplified by the Borobudur project, this usually—though not always—involves large-scale interventions and considerable expenditures.

To encourage such conservation, Unesco has long promoted the economic value of historic monuments as the primary impetus for so-called cultural tourism. "The assumption is that, if such economic value exists, the measures taken for the preservation of monuments will not compete with economic development, but will actually form part of it" (Maheu 1970). Too few authors, however, sound the necessary notes of caution about the effects of such outside pressures, such as the following:

> Tourists do bring much needed currency into the country and favour the restoration and maintenance of areas of historical character. But they also tend to exploit local resources to the fullest and expect the host to adapt to Western values and ideals, distorting the fragile balance of the more closed culture. [In the long term] only when legislation, control mechanisms, development plans and guidelines are based on an economic autonomy of the country can there be a sound foundation for continuous interest in conservation (Kervanto 1988).

Archaeological, architectural, and urban conservation remain pressing issues for most nations. These issues are, however, outside the scope of this paper.

Building in the Tropics

Tropical climatic zones are defined as those between the tropics of Cancer and Capricorn at latitudes 22.5° north and south. They account for some 40% of the globe's surface area. In spite of this, the special problems of planning and building in the tropics have received little attention in the technical literature of architecture. Tropical climates have long been considered challenging for building design only in terms of efficiency and comfort for the people rather than survival of objects. Perhaps that is why they appear to have been less thoroughly investigated than other climates, and tropical islands have been given particularly superficial attention.

Casual perusal of the bibliography will show that in spite of the existence of several departments of tropical architecture in respected universities, and of even more experimental research establishments, most of the literature is quite old and based far too closely on a small number of seminal works. In addition, much of this extant literature relates to low-cost housing. With recent advances in commercial activity and industrialization in the tropics, there has been some attention paid to office and manufacturing buildings, but other public buildings, particularly cultural institutions with a conservation function, have virtually escaped investigation.

The advent of supposedly practical and reliable refrigerative air conditioning was welcomed by many as the shortcut solution to human discomfort caused by heat and humidity and to the problem of maintaining stable environments for artifacts. As it turns out, the use of air conditioning has itself introduced problems peculiar to these regions. Sophisticated systems are expensive to install and require expert maintenance and other backup resources for efficient operation, but these resources and backup technology are lacking in developing countries and geographically remote regions. Worse, the discontinuous operation of "high-tech" controls can jeopardize artifacts by subjecting them to extreme and sudden environmental changes. Ultimately, air conditioning rarely compensates for inadequate planning or building design.

Garry Thomson, concluding the second edition of his seminal *The Museum Environment* (1986), warns of the dangers of assuming that the "mass of machinery" built into modern museums is actually doing the work it was designed to do:

Nothing should be installed which cannot be maintained, and seen to be maintained. There is something inelegant in the mass of energy-consuming machinery needed at present to maintain constant RH and illuminance, something inappropriate in an expense which is beyond most of the world's museums. Thus the trend must be towards simplicity, reliability, and cheapness.

In short, with respect to building design for conservation in the tropics, this paper emphasizes minimal reliance on mechanical equipment.

Climate and Siting

Climatic Zones

Tropical climates are characterized by excessive heat. Within that generalization, six types are usually distinguished (Miller 1961:28–31).

Hot, Dry Desert Climates. These are found from latitudes 15° to 30° north and south of the equator. The climate is characterized by two seasons: a hot period and a cooler one. In both, the diurnal range is 17 °C to 22 °C, reaching 43 °C to 49 °C in the hot season and a more temperate 27 °C to 32 °C during the cool season. Relative humidity (RH) is low, ranging from 55% in the early mornings to 10% in the afternoons. Solar radiation is extreme and night skies are clear. Winds tend to be hot and local, and often carry dust and sand.

Hot, Humid Equatorial Climates. These climates are found in the region between latitudes 15° north and 15° south of the equator. There is little seasonal variation, with air temperatures between 27 °C and 32 °C during the day and 21 °C and 27 °C at night. Relative humidity is high, at around 75% throughout the year. Solar radiation is often diffuse, but remains strong. Wind is generally low and from the east or northeast, but strong gusts can occur at times. Precipitation is high throughout the year.

Composite, Monsoon Climates. These occur in the large land masses near the tropics of Cancer and Capricorn. A hot, dry period—similar to that described above—lasting two-thirds of the year, is followed by a warm, humid period for the remainder. Temperatures, diurnal ranges, and solar radiation are similar to those

described for the hot/dry and hot/humid climates, though humidity in the wet season is somewhat more variable. Winds are strong and steady during the monsoon, and precipitation reaches 200 to 250 mm during the wettest month.

Hot, Dry Maritime Desert Climates. These climates are located where hot, dry land masses meet the sea. Temperatures in both hot and cool seasons are marginally more moderate, as is the diurnal range. Humidity, in contrast, varies over a broader range, from 50% to 90%, because of strong solar radiation causing evaporation from the sea. Winds are local, onshore during the day and offshore at night.

Tropical Upland Climates. These are found near the equator, at elevations above about 900 m. They are characterized by greater diurnal variation, owing to clear sky radiation at night. Humidity ranges from 55% to 99%. Solar radiation is very strong, winds are variable and moderate, and precipitation is variable, averaging about 1,000 mm per annum.

Warm, Humid Island Climates. These climates occur on islands within the equatorial belt and in the trade wind zones. Examples include the islands of the Caribbean and Indonesia and the Pacific islands. Seasonal variations are almost negligible, mean monthly temperatures varying by 1 °C to 3 °C throughout the year. Dry bulb air temperature ranges from between 29 °C and 32 °C during the day to between 18 °C and 24 °C at night. The diurnal range seldom exceeds 8 °C. Humidity varies between 55% and 100%. Solar radiation is strong and mainly direct, but with some diffuse radiation from occasional cloud cover. The predominant east-by-north-easterly trade winds blow at a steady 7 m per second. Precipitation is high, between 1250 mm and 1800 mm per annum. Tropical rain can fall suddenly with extraordinary intensity and is usually accompanied by a strong wind. Some areas are within the hurricane/cyclone (typhoon) belt, which can result in wind velocities of 45 to 70 m per second from any direction.

At a slight risk of oversimplification, one can tailor siting and building responses to two fundamentally different climate types: hot/humid and hot/arid. As will become quickly apparent, of these, the hot, arid climate lends itself to vernacular traditions of building for human comfort. But for conservators and curators, the problem of a hot, humid climate remains much more intractable.

MICROCLIMATE

The brief descriptions above may be considered typical of entire regions, whereas the microclimate of a particular site may be determined by local factors such as topography (hills, mountains, etc.), surface characteristics (vegetation), and local obstructions.

A reduction in air temperature of up to 3 °C may be expected for every 100 m elevation above sea level. Larger ranges of hills can create distinct daily winds, as cool air drains down valleys at night. Hills more than 300 m high will modify the rainfall pattern, with windward sides receiving more rain than regional averages, and leeward sides generally receiving significantly less. Times of sunrise and sunset, and hence the amount of solar radiation, will be influenced by topography, as well as by local obstructions such as other buildings.

Wind velocity and direction are both altered by local topographical features. Wind speed is lowest near the ground and increases rapidly with height over unobstructed ground. This rate of increase is significantly reduced over built-up areas.

Crests of hills receive, on average, stronger winds than do lower slopes or leeward sides. Vegetation, being porous, tends to dissipate wind energy, whereas urban landscapes redistribute and redirect airflow, often causing higher velocities and turbulence. It may be crudely estimated that wind speeds are influenced by local topographical details by a factor of three.

Buildings and hard surfaces absorb more solar radiation than vegetation does. This results in a typical urban "heat island," with temperatures elevated as much as 8 °C above the countryside, most of this effect occurring at night.

Hard surfaces cause rain to drain away, rather than being absorbed and later reevaporated by transpiration from plants and direct evaporation from the soil. In the hot, humid zones this can reduce the relative humidity in urban settings by as much as 5% to 10% (Baker 1987:207–9). Conversely, in hot, arid climates, vegetation in enclosed gardens can raise the humidity under the canopies by up to 40%, while lowering the ground-surface temperature by more than 20 °C (Lesiuk 1983).

GEOLOGY AND SOILS

Although there are some aspects of building on "tropical soils" that can be considered characteristic of the

region, their variability and technical complexity are beyond the scope of this paper. It is perhaps sufficient to alert readers to the fact that the combined effects of prolonged rainfall, possible seismic activity, and the widespread incidence of deeply weathered so-called residual soils threaten the stability of slopes in hot, humid zones more than the stability of slopes in most other regions (Blight 1988). The design of foundations of buildings, and especially the detailed design of excavations associated with roadworks on sites, should be undertaken only with expert geotechnical advice.

SURFACE WATER CONTROL

Tropical rain can fall suddenly with extraordinary intensity and is usually accompanied by a strong wind. Rainwater drains are often inadequate to cope with the sudden accumulation of water, and there is always the risk of flood damage. To a degree, this occurs in both hot/humid and hot/arid regions. In the former, flooding occurs because of the frequency and quantity of rain; in the latter, it occurs because the sun hardens the ground, increasing initial runoff, and because of the absence of ground-covering vegetation to bind soil and impede the flow of water.

The destructive power of flowing water can cause soil erosion. It can undermine streets and foundations that are inadequately anchored and can ruin parks and gardens. Great attention should be paid to the siting of a building on a slope to avoid channeling surface run-off. Roads running down the slope add to the velocity of the flowing water and thus increase its erosive power. In extreme cases the foundations can become exposed and buildings can collapse. It is preferable to set buildings in parallel rows across the slope, rather than along the slope, provided that water is collected in suitable conduits and the eroded material is intercepted.

Wind-blown spray, caused by severe, driving rain striking the ground in front of buildings, can saturate and soil the lower parts of such structures.

Building Issues

Human beings have been using shelter to modify environmental extremes for a very long time. Strategies of building design to maximize human comfort in a wide variety of climates have been developed by many cul-

tures. Since the time of Socrates, simple rules of thumb have been codified for the layout of cities, for sun control and wind protection by the orientation of houses, and for the apt use of materials. Vernacular architecture has taken on refined and characteristic forms to mitigate the extremes of heat and dryness of the desert, to maximize the use of cooling breezes on tropical islands, and to utilize the heat and light of the sun in cool temperate zones.

Beginning in the late 1960s and spurred on by the oil crisis of 1973, serious architectural science research has been devoted to the optimization of environmental controls in buildings, minimizing the use of nonrenewable energy. This research has concentrated on two distinct approaches: the correct design of the physical layout and fabric of the building to minimize the "environmental load," and the application of "appropriate technologies," usually solar- or wind-powered technologies, to stretch a building's energy budget.

As mentioned above, however, such research has aimed for human comfort, and therefore used the interaction of human beings with their environment as its starting point. These interactions are characterized by several factors:

■ The human perception of thermal comfort has both physiological and psychological dimensions.

■ Comfort derives from a complex combination of the four interdependent physical variables involving convective, radiative, evaporative, and conductive mechanisms of heat transfer.

■ Human beings are adaptable within broad "zones of comfort" within which one variable may exceed "normal" bounds, while another offsets the discomfort that would result if the variable factors were independent.

■ Human beings are mobile and can thus leave an uncomfortable place for a more comfortable one.

In most cases, "new" systems or design strategies being investigated in recent research have been based on well-established principles of traditional building. Such vernacular architecture is generally characterized by its effective exploitation of the human attributes that can mitigate the effects of environmental extremes.

Perhaps the most elegant example of this is the traditional building form developed in hot, arid climates. During the day, people retreat to massive living quarters. These are sealed against excess heat infiltra-

tion, staying relatively cool by virtue of the long lag time between the onset of the day's heat and its transmission to the building's interior. Limited ventilation air is passed over water and thereby cooled and humidified by evaporation. The natural shade provided by trees is exploited and enhanced by the use of planting in courtyards, which creates actual and perceived coolness by contrast to the barren glare of the natural environment. At night, people sleep on the roof, cooled by radiation to the night sky, and the heat stored up during the day in the massive construction of the houses is dissipated by ventilation. This nightly cooling is made possible by the large diurnal temperature variation of desert regions.

In hot, humid climates, by contrast, there is little diurnal temperature fluctuation to smooth out. Rather, temperatures generally stay at or above comfort level throughout the day, and often at night. The only measures that can be taken to increase comfort are the reduction of excessive solar load by the use of shading vegetation and large insulating roofs, the use of lofty spaces exploiting temperature stratification to remove hot air from the occupied zone, and the maximizing of natural air movement to enhance evaporative cooling of the skin. The traditional shelter is thermally lightweight and porous, often elevated from the ground to maximize breezes. In spite of these measures, the combination of elevated temperatures and humidity means there are times when physical comfort is impossible to achieve, and the psychological effect of shade and an airy feeling therefore become important. In such climates, much of life is carried on out-of-doors, often with only canopy shelter from the frequent rain.

It will be immediately apparent that, useful as they are for minimizing human discomfort, such approaches have limited application to the maintenance of suitable conservation environments for objects. First and foremost, objects are substantially static—they are unable to move away from unfavorable environments of their own volition. Second, whereas environmental variables are to a degree interdependent, none of the sensory compensations available to human beings can be called on by inanimate objects. Rather, some of those interdependencies exaggerate the potential for damage to objects. An example is the inverse correlation between temperature and relative humidity: The lowering of RH

as temperature rises increases human comfort, but hastens the desiccation of wood. Another example is the way people compensate for cool air temperature by seeking out radiant heat; if objects were treated in this way, they would be subjected to harmful differential temperature stresses. Generally, because there is an overriding requirement to minimize the rate of change in the environment of objects, the exploitation of environmental extremes in the manner described for the traditional architecture of hot, arid zones is of limited utility. And, finally, objects take no comfort from purely psychological compensations for physical stress!

Nevertheless, it is the case that collections of objects have remained in acceptable condition in some passively modified environments in tropical climates while, in contrast, significant degradation has occurred in a shorter period of time to objects held in air-conditioned buildings. The challenge is to identify the characteristics of places that have contributed to preservation and to eliminate or mitigate the harmful factors.

Air Conditioning in Environmental Control

To clarify the role of mechanical equipment in environmental control, it is good to remember that air conditioning is precisely what its name implies—a limited means of conditioning the quality of air in a space. As such, it modifies the temperature, humidity, noise, and pollution regimes of the building as a whole, but is in turn greatly affected by other variables.

For example, air is a poor medium for the transport of heat, having a very low volumetric heat capacity. Thus, large quantities of cool air are needed to remove heat introduced by internal sources and by radiation or conduction through the building fabric. To discuss total environmental control usefully, the variables, including those of air quality, should be defined separately.

If mechanical air conditioning, whether full or partial, is used, it imposes certain limitations on the building design. First and foremost, mechanical air conditioning requires a reduction of the amount of ventilation, including the sealing of leaks in the construction. With significant air temperature differences between the inside and outside, insulating the envelope—including walls as well as roofs, and even floors—becomes critical. Openings must be glazed, and double glazing may be necessary.

Because differences between internal and external humidity levels are just as important as differences in temperature, extreme care must be exercised in the positioning of any vapor barriers in the walls and roofs, to avoid condensation within the building fabric. Condensation can reduce the value of insulation, create sites for mold growth, and even lead to significant structural damage.

As a generalization, the use of refrigerative air conditioning favors compact buildings of small surface-to-volume ratio, constructed to high standards, and made of relatively lightweight, highly insulated materials.

It should be stressed at this point that passive measures and mechanical air conditioning are not mutually exclusive in all respects. Shading, for instance, can reduce the cooling load to be handled by an air-conditioning system. In some cases, a satisfactory compromise may be made whereby one part of a building is air conditioned, and another part is naturally controlled. This is a better arrangement than having the entire building "partly" air conditioned (Baker 1987).

As Pearson (this volume) has stressed, from a conservation point of view, the worst possible compromise is intermittent air conditioning. For the 1988 Kyoto congress on control of museum climate in Asia and the Pacific area, the organizers prepared an analytical report based on information supplied by about thirty museums in the region. In several examples, air conditioning was operated only during hours when the building was open to the public. Where a direct comparison was possible, as in the case of the Bangkok National Museum, it became apparent that air-conditioned rooms were subject to greater and more rapid diurnal variation of both temperature and humidity than rooms that were not air conditioned at all (Aranyanak 1988). Such partial mechanical control, whether determined by administrative policy or the result of unreliable power supplies or equipment, can be justified only—if at all—on the grounds of human comfort.

ENVIRONMENTAL STANDARDS FOR THE CONSERVATION OF OBJECTS

Control of the internal environment of buildings for conservation is conventionally defined as the maintenance of light, temperature, and relative humidity within certain ranges; the stringent limitation of atmospheric pollutants, including gases, particulates, and mold spores; and the exclusion of insects and rodents. Detailed discussion of the effects on objects of each of these environmental variables can be found in Pearson (this volume) and in standard works, such as Thomson (1986).

Several resumés of recommended standards have appeared in the literature. Thomson (1986) and the United States National Research Council study (1986) are evidently regarded as the most authoritative. They display a remarkable degree of consensus, and if the comparative tables by Baer and Banks (1987) are examined, it will be obvious that such standards can be attained only by high-quality air conditioning. Careful review of the sources, however, reveals little consideration of the technical and economic difficulties and possible trade-offs, and of the questionable scientific basis for some of the prescribed standards (Ayres 1988). Trying to determine the appropriate standards to apply where ideal standards cannot be achieved places difficult demands on the administrator of a smaller or less well endowed institution.

Humidity Control. The control of relative humidity is regarded as paramount for several reasons. The most salient of these are:

- its role in chemical reactions, especially the corrosion of metals;
- its direct effect on the moisture content of objects made from hygroscopic and porous materials, and the magnitude of the dimensional changes resulting from variation in moisture content; and
- its influence on the sporulation and propagation of molds.

In the case of the first effect, there appears to be no choice but to store vulnerable objects in environments combining minimum humidity and temperature. The second and third effects, however, are poorly understood, and a more detailed review of the literature raises questions about long-held assumptions.

The moisture content of objects is conventionally considered to be determined by an equilibrium condition, dependent on the relative humidity of the surrounding air at a constant temperature. The moisture content of, say, a wood artifact in a display case, is therefore computed by reference to the so-called moisture isotherms for timber, which are well known.

Unfortunately, moisture isotherms do not show how changes in temperature drive water into and out of materials. As a consequence, there are problems in applying this knowledge, especially at the scale of buildings, and with respect to the storage of larger quantities of organic materials.

> *Equilibrium conditions are convenient devices for scientific study.... In fact most building assemblies are not in equilibrium, but are dynamic. In other words, building assemblies are not containers, and are subject to changing temperatures.... How do building materials exchange humidity with the surrounding air at different temperatures? Unfortunately, that question was late in being asked within the research community, and is still being answered....*
>
> *Most building materials are porous and/or hygroscopic and store large amounts of water. In fact, the quantities of water that building materials store are hundreds of times greater than the quantities of water vapor contained in the air which the materials surround. A medium sized house may contain 10 lb. of water in the enclosed air, and 4000 lb. of water in the building materials* (Hunderman 1988).

Research done in 1984 by Harrje, Cleary, and Burch (quoted in Hunderman 1988) found an almost perfectly linear relationship between air temperature and the dew-point temperature in residential attics. This finding is, of course, at odds with the simple application of psychometric principles. The implications are obvious. At the scale of buildings, or in the case of storerooms housing a significant quantity of organic material of large surface area, the relative humidity of the air will depend on the moisture content of the materials, rather than the moisture content of the materials being determined by the relative humidity .

Furthermore, if such spaces have limited air exchange with the ambient environment, the relative humidity will be buffered by the objects contained, because the materials will desorb water with rising temperature. Temperature change is a greater force in determining moisture content than is change in humidity. Stolow (1979) made passing reference to this phenomenon in discussing the transport of objects in small con-

tainers, and librarians, especially, seem to be aware of the role of books in buffering the atmospheric RH of their stacks. But Padfield and Jensen (1990) appear to be the only authors to have systematically addressed the issue and its application to low-energy climate control—even though the effect has been repeatedly noted, especially with reference to the longevity of vulnerable objects stored in wood buildings at humid sites in Japan.

The relationship between air quality and mold growth is similarly ambiguous. Most of the references in the conservation literature concur that mold growth is a problem when RH exceeds about 65%, and that such growth may be controlled by air movement. In fact, the relationship of mold sporulation and propagation to temperature, humidity, and air movement is much more complex. It has been the subject of considerable investigation in the field of environmental hygiene, because of its role in the incidence of human allergies.

Most organic materials are potential food sources for molds, and nonnutrient materials, such as plaster and brick, can support growth if contaminated by traces of organic matter. It would appear that the availability of water is the limiting factor. "The susceptibility of a material to mould growth varies because at the same atmospheric RH different materials adopt different moisture contents.... Whilst mould developed on leather at 76% RH it did not develop on wood or wool below 85% RH nor on cotton below 96% RH" (Bravery 1980).

A Swedish study (Rytkonen et al. 1988) reports:

> *Relative humidity (RH) had no direct effect on the growth of fungi.... Sporulation increased with rising RH at the optimum growth temperature, and diminished at other incubation temperatures.... Our results also indicate that when water is available in the medium, the fungal germination occurs even when the atmospheric RH is low.... We have previously noticed that an increase in RH decreases spore release and spore count.... The results indicate that fungal growth is possible on cold and moist surfaces regardless of air humidity.... For fast growing fungi very short periods of favorable conditions have been reported to enable the germination.*

Even the anecdotal evidence is at times ambiguous. Freemantle (1988) describes the storage of a large wood-

and-leather object in conditions that led to vigorous mold growth. When repeated fungicidal treatment was unsuccessful, other remedial measures were tried. These included the use of a simple polyethylene tent to isolate the object from its surroundings, and the installation of approximately one-seventh of the quantity of silica gel recommended by Thomson—all they had available— to buffer the object at an acceptable humidity. Predictably, the humidity eventually stabilized at an "excessive" 70%. But, less predictably, mold growth did not recur, even when the exhausted silica gel was removed the following year, and the object remained tented but without additional buffering for some fifteen months. Freemantle attributes this to "the presence of the plastic tent alone … by virtue of its ability to prevent movement of air around the [object], and therefore the movement of mould spores." However, readers should note Pearson's caution (this volume) concerning the possible role of residual volatiles from the fungicidal treatment.

Although it is difficult to determine the relative importance of the variables of temperature, humidity, and air movement in relation to fungi, some important observations can be made. Ample anecdotal evidence (Rosenberg 1986, Pearson 1988, Wolf 1979) has indicated that the single most reliable way to control the growth of mold in hot, humid climates is to provide copious air movement by natural ventilation.

If fungal infestation occurs repeatedly, however, it may be that a viable colony exists elsewhere, along with some means by which its spores are disseminated. In such circumstances, air-conditioning equipment and ductwork may themselves serve as efficient reservoirs of mold growth, and the air-distribution system may serve both to propagate the spores and to produce local conditions favoring their growth. If it is possible to reduce or kill mold infestation once it has taken hold, the best defense against further invasion may be isolation and the reduction of air movement.

Thermal Behavior. Most authorities consider the regulating of temperature to be of secondary importance, except in its relationship to relative humidity, because, they argue, the destructive effects of temperature changes are of less magnitude than those caused by other factors. It is possible, however, that the relationship of temperature to RH is oversimplified, as has already been discussed, and Pearson (this volume)

stresses the varying degrees to which elevated temperature contributes to the rate of destructive chemical reactions for different materials and in different contexts. Although the effects of temperature are never discussed as comprehensively as those associated with relative humidity, it is fair to say that the standards for temperature quoted by Thomson and others are compromises based on human comfort.

Most references agree that whereas variation in temperature is generally acceptable on a seasonal basis, short-term fluctuations are to be avoided. For objects to be affected through dimensional change, very large, rapid changes in temperature are necessary. Such great fluctuations are typically characteristic of radiant heating alternating with active cooling, as when a sunlit surface is suddenly pelted with rain. We rarely see such extreme phenomena in interiors.

The more relevant issue is the difference between the rate of temperature change and the rate of moisture absorption by hygroscopic materials. In conditions of high *relative* humidity, air temperature will drop below dew point more quickly than any absorbent materials can take up the resultant available moisture. Condensation will result, especially on conductive materials of low thermal mass. In contrast, at a time of rising temperature and rising *absolute* humidity, such as occurs typically in the morning in the hot, humid tropics, too much thermal inertia in the building fabric can lead to surface temperatures low enough to induce condensation.

Both these factors become limiting conditions. In the hot, arid zones, buildings characterized by maximum thermal mass with a large internal surface area will reduce diurnal temperature variation, helping to control RH. In hot, humid climates, some internal thermal mass in the construction is beneficial in slowing sudden drops in dry bulb temperature, but disposition and surface treatment are important. Note that the injunction against the use of thermally massive construction in the hot, humid tropics, formulated by Thomson (1972) and since then too-often repeated by others, is based on a limited understanding of the behavior of buildings, and should be accepted only with respect to sunlit external elements, such as walls and roofs.

In air-conditioned buildings in the hot, humid tropics, the temperature set-points specified become doubly important. Not only is heat gain through the

building fabric proportional to the temperature difference to be maintained, but the latent load resulting from the requirement to dehumidify makeup air comprises a more significant proportion of the total load than it would in other climates. If set-points higher than the conventional 19 °C to 24 °C can be used, or the building can be zoned to allow the maintenance of higher temperatures in the majority of perimeter spaces, both energy use and plant capacity can be significantly reduced.

Ventilation. When discussing ventilation, two types must be distinguished. The first is simply a matter of supplying "fresh" air and removing "stale" air. This type of ventilation is conventionally specified in terms of *air changes* per unit of time. Air change is required in order to achieve a dilution of the buildup of internally generated contaminants and also removes heat.

A second type of ventilation is utilized to generate certain surface conditions, such as evaporation from the skin, and is therefore specified in terms of *air movement*. It may be provided by enhancing natural breezes, or by mechanical means such as fans. In order to be effective, the air stream must pass over the occupant or object. Such ventilation becomes more effective as air velocity increases. The maximum values for practical velocities are limited, because above certain speeds, air movement may become a nuisance or even cause damage to light or fragile objects.

The part played by the latter type of ventilation in mold prevention in hot, humid climates is noted often, as previously discussed. Reports of the operational effects of air movement in this role are more difficult to find. Authors fail to distinguish whether it is the mere occurrence of mold that is inhibited, or its continued growth. Fundamental research needs to be done to clarify what actually happens: Does air replacement serve to dilute spore count? Or does air velocity serve to inhibit "settling" of spores, or perhaps to evaporate sufficient surface moisture to inhibit sporulation? As a result of this research gap, no definitive advice can be given as to whether the need is for large quantities of fresh air, or whether the energetic circulation of a relatively closed air mass is the best strategy.

If natural ventilation with air movement turns out to be the prime requirement, stringent limitations are imposed on siting and building form. Permitting free

air exchange with the outside environment creates virtually intractable conflicts with the control of external pollutants, and also makes security and pest control more difficult.

Lighting. The effect of light on stored and displayed objects is well documented and is discussed in some detail by Pearson (this volume). The architectural control of internal illumination by natural light is given less attention, and practice seems to be guided as much by fashion as by reason.

The illumination levels required for storage areas need only meet the requirements for working with the materials in question. General lighting may therefore be quite low, supplemented by intermittent artificial task lighting. Lighting for display poses greater challenges. The levels of "safe" illumination for most materials are much lower than the externally available natural light, which in addition contains excessive UV components.

However, to more usefully discuss natural lighting, it is important to distinguish between sunlight and daylight. The intensity of direct sunlight is several orders of magnitude higher than that of light from other parts of the sky. It probably has no place in a space used for the conservation of sensitive materials. To some degree this applies even to reflections from sunlit surfaces, whether inside or outside such a space. It is possible to design buildings so as to prevent insolation, and the use of shading for thermal control should obviate solar radiation. Technically competent architects should be able to achieve this without compromising other qualities of the building.

Whereas sunlight must be guarded against, daylight may be usefully deployed, and aversion to it by some curators is probably unreasonable paranoia. Not only is daylight economical for general illumination of the building interior, it offers generally favorable color balance for the display of most objects. Daylight falls off in intensity so rapidly with distance from conventional windows that limitation of illumination to given "safe" levels can be accomplished largely through careful display layout.

Reflecting daylight off white-painted surfaces removes more than 80% of all harmful UV rays (Thomson 1972, 1986). In principle, this means that as long as exclusion of sunlight is achieved by a combination of building orientation, shading, and detail design, and

openings admitting daylight are designed so that the light is reflected off painted surfaces, buildings may be detailed to exploit daylight for display purposes without compromising conservation and without resorting to expensive, degradable filters. The great attenuation of intensity of daylight as it penetrates to building interiors may itself be used to differentiate circulation areas from display areas, while providing levels of general illumination bright enough to avoid impressions of "gloom."

Pollution. In the tropics there are several common air pollutants that cause problems. Although particulates arise more easily in hot, arid climates, they are more troublesome in conjunction with high humidity. Airborne salt is a significant problem in areas up to a kilometer from shorelines, except when a combination of topography and vegetation provides screening action.

Vehicle exhausts contain sulfur dioxide and nitrous oxide, the action of which is enhanced by moisture. In the strong sunlight of the tropics, photochemical reactions with automobile emissions produce particularly high levels of ozone, a strong oxidant.

Recent research on the effect of ozone on pigments in traditional artists' colors and organic dyes suggests that most showed some fading, with some being ozone-fugitive and a few highly sensitive to ozone. Ozone reactions with polymers "would appear to be of major importance to conservators.... [I]t has been reported (although no comparative data have been given) that the ozone-induced cross-linking reactions are even more rapid than the thermal or light-induced chemistry" (Cass et al. 1988).

Even more dangerous than external sources of ozone is the use of electrostatic dust filters, which are common in commercial air-conditioning systems. This should be avoided. The lowest indoor ozone levels in the study were found in historic buildings converted to museums that used only limited natural ventilation (Cass et al. 1988). Any building with ventilation strongly linked to the outside will be less effectively protected against air pollution than one whose indoor/outdoor air exchange is more limited.

PEST CONTROL

Of all the agents of destruction of cultural property, the problem of pests—insects in particular—has probably been most comprehensively covered in the literature.

See Nair (1972) and Szent-Ivany (1968) for a comprehensive introduction to the topic, and to Pearson (this volume) for a discussion of the more recent concept of "integrated pest management" (IPM).

Building design can aid in pest control in three principal ways:

- as a first line of defense, by screening possible routes of entry;
- by facilitating good housekeeping through well-thought-out detailing and choice of finishes; and
- by appropriate planning, for example, the sub-division of building volumes to facilitate remedial actions, such as fumigation.

There has been some documentation of traditional methods of insect control by the use of particular kinds of timber in building finishes and display cases, but evidence of efficacy is largely anecdotal (Agrawal 1981). This is an area that could benefit from systematic investigation.

Building Materials and Construction

Although the severity of tropical conditions in comparison to more temperate climates is often exaggerated, the risk of breakdown of materials is somewhat higher in tropical areas. Good construction and adequate maintenance is thus especially important in these regions (DBR 1954).

No generalizations can be made about the building industries of societies as diverse as India, Singapore, and Tuvalu. Most contemporary building materials are used in tropical regions, but in more remote locations, availability and cost impose severe limitations. Some nonindigenous materials have gained disproportionate popularity in developing countries, owing to either convenience of transport or to the development of local production. Most prominent among these materials are concrete block, reinforced concrete, structural steel, aluminium or galvanized-steel-sheet siding and roofing, fiber-reinforced cement sheet products, and timber.

This section summarizes, in note form, the chief characteristics of these materials, with reference to particular applications or limitations on their use in the

tropics. Note that most problems with building products occur under hot, humid conditions.

CONCRETE AND REINFORCED CONCRETE

Concrete is commonly used for most public buildings and as blockwork in residential construction. Advantages include resistance to mechanical damage, fire resistance, earthquake stabilization (with correct construction), imperviousness to rain and wind (with appropriate detailing), poor heat conduction, and, conversely, good heat maintainenance.

In the tropics, the following problems may be encountered during construction:

■ Premature setting of cement still in paper sacks in areas of high humidity. (Remedy: use metal bins, store in enclosed spaces on floors raised off the ground, store for only brief periods of time.)

■ Lack of certificates of quality for steel and cement.

■ Impurities in aggregates. (e.g., humus and soil content of river or quarried material; salt content)

■ Impure mixing water that may contain salt or humic acids.

■ Premature setting. (Remedy: shade fresh concrete from direct solar radiation and water, and avoid working during the hottest part of the day.)

■ Lack of skilled labor and supervision.

■ Expensive formwork in areas where timber is scarce.

The durability of concrete is adversely affected by the corrosion of reinforcing steel by salt or acid contained in aggregates and mixing water. The application of bituminous protective coatings may be necessary to prevent damage to concrete near or below the ground from humic acids. Particular risks are associated with rapid-setting, high-alumina cement, which tends to lose strength if cured at higher than 30 °C in conditions of high humidity, because of chemical reactions (Lippsmeier 1969).

In addition, there are two adverse consequences of the use of concrete and concrete products are of special relevance for conservation environments: Toishi (1979) noted that a short-term problem with new buildings was the release of large quantities of water vapor if concrete used in construction contained water in excess of that required for chemical curing. Some simple precautions can solve the problem: Good supervision during construction can, first of all, ensure that no extra water

is added to improve workability—a measure that offers the added benefit of yielding a higher quality of finished concrete—and, second, can also make sure that concrete blockwork is covered at all times against wetting by rain. After completion, a period of up to six months should, if possible, be allowed before occupation for the building to "season."

A longer-term problem noted by Toishi is the release of strongly alkaline particulates. These cause a variety of problems for collections—of paintings, in particular—and the chemical reactions involved are accelerated at the 30 °C temperatures common in the tropics. Because particle release has been known to persist for many years, the use of concrete without applied finishes in museum interiors is inadvisable (Toishi 1979).

STEEL AND SHEET-STEEL PRODUCTS

Structural steel is used to construct efficient large-span structures—often industrial and storage facilities. It is used in both rolled sections and lighter cold-formed sections. As cladding, sheet steel is stronger and cheaper than aluminum and is more resistant to mechanical failure than fibrous-cement sheeting.

The major limitation in the use of unalloyed steel is corrosion from high humidity combined with industrial smoke or salty air in coastal areas. For coasts with surf, the corrosive effect is estimated at five times that caused by highly polluted industrial air (Lippsmeier 1969). Hot-dip galvanizing is advisable, but gives less effective protection than it does in other environments, because of the rapid loss of the sacrificial metal. Applied protective coatings and frequent maintenance are necessary. The use of stainless steel for decorative steelwork is usually justified by long-term savings.

Sheet-steel products should have high-quality galvanized or "zincalume" protective coatings, and should be prefinished with proprietary factory-applied, light-colored paint. Because of the light weight of sheet steel claddings, particular care should be taken in designing fixings for wind resistance.

FIBER-REINFORCED CEMENT (FORMERLY ASBESTOS CEMENT)

Use of fiber-cement sheet products is widespread in all tropical countries, because of the reduction of building costs permitted by increasing local production. Appli-

cations include sheets, pipes, wall and roof sections, self-supporting folded building components, and monolithic fittings (shells, furniture, etc.).

On the whole, the material is eminently suited to the tropics: waterproof and windproof, with limited thermal conductivity and good heat-storage capacity but low mass, it has a medium reflectivity of 0.3 to 0.5, depending on its age. It is fire-resistant and offers particularly high resistance to corrosion.

Because of this material's sensitivity to sudden mechanical stress, surroundings at considerable distances may be endangered by pieces broken off in hurricane conditions, and walls of fibrous cement sheeting may afford little protection from other flying debris. Considerable destruction is likely in the event of an earthquake.

TIMBER

Timber is the most common traditional building material used in the hot, humid zones. Modern timber products, such as laminated timbers, plywoods, and fiberboards, have extended the range of applications. Most indigenous timbers are hardwoods and include many species with widely diverse properties.

Deterioration may arise from photochemical effects resulting from intense solar radiation, physical weathering caused by changes in temperature and humidity, and from fungal and insect attack. The rapidity and frequency of environmental changes, from heating by the sun to cooling by rain showers, causes continual dimensional changes, which produces checks, splits, warping and raised grain, and poor paint-holding properties.

Differential dimensional change due to moisture migration is the main cause of bowing of doors and other panel construction. The effect is exaggerated in buildings that are artificially cooled or dehumidified.

While mold growth is of mainly cosmetic concern, it can indicate the presence of moisture, which is also a precondition for attack by wood-destroying fungi. Because fungi cannot grow in wood at moisture contents of under 20%, the most important precaution is to keep moisture out and provide adequate ventilation.

A variety of insects may inflict cosmetic or structural damage. In some areas, the risk of attack by powderpost beetles is greater than the risk posed by termites (Building Research Establishment 1972). In tropical conditions, the life cycle of these insects is very rapid. It

is common for beetles to infect the wood within months of a building's completion, causing serious structural damage within just a few years. Termites are discussed separately, because they may attack other materials besides timber.

Timber can be protected by design precautions, careful selection, and treatment measures. Appropriate construction needs to be considered at the outset of the design process. Care should be taken to use properly "seasoned" timber, to provide shelter by overhanging eave, to use and fix metal flashings carefully, to isolate timber from the ground (by the use of properly constructed termite shields, for example), and to detail joints so as to accommodate moisture movements. Fastenings should be made of appropriate materials; in the presence of elevated humidity, the tannins and related compounds in some tropical hardwoods react excessively with ferrous metals, leading to staining and even failure of joints.

Species of timbers may be selected according to the durability they offer under given conditions. Pressure impregnation with copper chrome arsenate preservative can make the use of a cheaper, nondurable timber feasible even where there is risk of decay or insect attack.

PAINTS

Paint finishes vary widely in their response to the climatic conditions of the tropics. Their behavior depends on their chemical composition. Chemical resistance may be closely matched to requirements by careful specification. Care needs to be taken in the choice of desired paint properties. For example:

- Reflectivity varies with both color and and surface finish.
- Function in water-vapor control varies, from airtightness (with gloss finishes) to porosity (with emulsion paints).
- Thermal conductivity is greatly increased by metallic additives.

The durability of painted surfaces is compromised by destructive physical, chemical, and photochemical processes resulting from intensive solar radiation and high temperatures. Damage may also occur below the surface of paint, which absorbs some of the ultraviolet radiation. In hot, humid regions, considerable deterio-

ration may result from continual humidity and from rain striking directly on the paint surface, and in maritime zones, from moist air containing salt. Brittleness and cracking of paint is accelerated by large, frequent temperature changes, and chalking may occur when there are rapid alternations between rain and sunshine.

Paints based on natural materials, and some plastic-based paints, are prone to destruction by termites. Equally dangerous is termite attack on structural elements hidden by an intact coat of paint; such undetected destruction can lead to collapse. Discoloration, marking, and decomposition of paint by mold fungus are all common—oil-based paints are in particular jeopardy; plastic paints are somewhat less vulnerable.

The Special Problem of Termites

In *Tropenbau: Building in the Tropics*, J. G. Lippsmeier (1969) warns that "The extent of damage done to buildings by termites is considerable. Results of an investigation in Jamaica in 1943 showed that 61% of all buildings were infested by termites and of the remaining 39% about 40% were contaminated. In general, it can be assumed that about 10% of all old buildings in the tropics have been attacked."

Although timber is the structural material most likely to be affected, other organic materials in building finishes or in the collections housed—materials such as silk, cotton, linen, jute, and wool—are also vulnerable to termite damage. Natural rubber, foam rubber, and latex products are safe only if they have been treated with an insecticide—a point that carries important implications for building seals.

Concrete, brickwork, mortar, and stone are unaffected, but their porous nature can provide passages to the building interior, where termites may attack interior fittings, such as wood furniture, decorations, books, and the like.

Some materials can be damaged by the mortarlike pulp from which termites build their surface communications. This substance attacks the surface of metal or glass.

Polyvinylchloride, cellulose acetate, neoprene, and synthetic resin adhesives are among the plastics that can be damaged by termites. Lippsmeier (1969) notes that termites sometimes chew the glue from wood without touching the wood itself, and observes that plastic-based wall paints were completely removed from walls.

Preventive measures rely on appropriate physical detailing of construction, which permits termite galleries that connect to the ground to be detected readily. The ability to regularly inspect subfloor spaces for evidence of infestation may become a strong determinant of building form, reinforcing other incentives to utilize construction elevated on columns or stilts. The flooding of subsoil with residual poisons such as dieldrin, as advocated in the past, is now considered too dangerous as a routine procedure and moreover is of little long-term efficacy where the soil is subject to rapid leaching. However, it may still be employed to destroy infestations of existing buildings. Agrawal (1981) reports some unexplained chemical deterrent effect exerted by the growing of bananas near buildings, but the most effective approach is to "build termites out."

Passive Environmental Control Strategies

As briefly noted earlier, there are some limits to the potential of passive environmental control to produce conditions meeting conservation standards, especially in hot, humid climates. Environmental extremes can be modified incrementally by:

- appropriate siting;
- reducing loads on the building;
- layout planning that subjects the least vulnerable spaces to the most exposure, in order to *isolate* rather than *insulate* vulnerable spaces; and
- the use of local controls.

This principle of "layered control" is familiar to curators and conservators. Considerable literature discusses the progressive reduction of RH variation or ozone concentration from exterior to interior space and even within display cases. The same principle can be applied to some degree to all environmental variables. It relies first and foremost on restricting the degree of air exchange between each "layer" of space, with the rate for air exchange for display cases measured in changes per day, rather than per hour.

Airtightness in the construction of display cases is difficult to achieve, and of doubtful value anyway. The benefits of such construction—which may, for example, call for the use of saturated salts for RH buffering—are

outweighed by the dangers of the potential for condensation as a result of temperature changes, and by the progressive concentration of released volatiles. If the ventilation is designed to be limited, however, one can achieve more effective filtration of air, because of the very small volumes involved in the small scale of the typical display case. Padfield (1968) has long recommended the provision of a ventilation opening sized according to showcase volume and fitted with a commercial active-carbon filter cartridge. The effectiveness and cost benefits of pollution control, even in harsh urban environments, are maximized by such arrangements.

HOT, ARID REGIONS

The principal problems encountered in arid regions are excessive solar radiation, heat, low humidity, undesirable winds, windborne dust and sand, and other air pollution.

Siting. Following the general principles outlined above, the first line of protection is appropriate siting. In urban settings, this would include the placement of buildings close to one another to afford mutual shading, especially on the east and west, and the restriction of large open spaces. Compact building forms reduce external surfaces subject to solar loads, and courtyards and walled gardens increase the opportunity for the use of vegetation.

Landscaping. Carefully selected planting can significantly reduce the environmental loads on the building. In traditional Islamic walled gardens, tall, narrow-leafed cypresses have been used at the periphery to filter the dust and reduce wind speeds. The cleaner—but still dry—air is then humidified by a second screen of broad-leafed trees. Pavilions in such a garden would be shaded by a large tree, a plane tree, for example. It has been noted (Lesiuk 1983) that "one such tree could transpire as much as 500 liters of water a day," and the extraction of the radiant and convective heat required to evaporate such a volume of water would typically represent a drop in temperature from, say, 57 °C above the crown to 32 °C in the shade, while humidity under the canopy might be raised by 30%.

More radical use of plant material has been proposed and investigated. Measurements were taken in the Gibson Desert in Western Australia of a lightly clad building with a plant canopy of vines grown on a framework spaced from the walls and roof. Net heat flow into the building was shown to be uniform and virtually negligible (Lesiuk 1983).

Thermal Control. The elimination of radiant solar load is paramount. Consideration should be given to lightweight shading superstructures, especially over the roof of a building; in any case, roofs should be of reflective colors and well insulated.

Conventional temperature control in buildings in hot, arid regions relies primarily on the damping effect of massive construction. By careful design of exterior elements, a lag exactly matched to the time difference between the incidence of greatest heat load and of lowest night temperature can be achieved. Similarly, massive internal walls absorb excess heat and reradiate it at cooler periods on a daily cycle.

Earth Shelter. Where earth-sheltered or underground construction can be safely undertaken without risk of flooding, the available thermal mass is even greater. Seasonal differences in temperature can be utilized. At 6 m below the surface, undisturbed soil remains effectively at a steady temperature equal to the annual dry bulb average. Nearer the surface, temperature swings are greater, but even with only 600 mm cover, the temperature follows that of the monthly averages. If the soil surface is shaded and irrigated, such temperatures can be depressed by another 7 °C (King 1984).

Humidification. In deserts, humidification may be achieved by quite simple means. The Mohenjo-daro Museum, on the Indus in Pakistan, utilizes massive brick walls set parallel to the prevailing winds, and a concrete double roof. A large pool of water is incorporated along the whole windward facade. Air passing over the pool is cooled and humidified and partially deposits sand and dust it carries before it enters and ventilates the museum halls. The Chandigarh Fine Arts Museum employs similar passive humidification by being arranged around a courtyard with a large pool (Saini 1980).

Better control of airflow, humidification, and temperature may be achieved by more complex building forms, incorporating variations on the traditional wind catchers of Pakistan and Iran, and modern solar chimneys (Bahadori 1978, Cunningham et al. 1986).

Natural Light. Light control should not rely on conventional window placement based on the practice

of more temperate regions, then remedied by external or internal shading devices. Instead, relatively small external openings should be used. These should be located strategically for sun control, and detailed to provide reflected daylight to floor, wall, and ceiling surfaces. Where planted courts can be established, visual relief for the interior can be provided by views of the vegetation. The Japanese practice of placing openings low in the wall directs one's gaze downward to a relatively small area, which can be highly landscaped and well maintained, perhaps with a boundary wall. Thus, contrast between the low internal light level and that of external illumination is reduced and glare eliminated.

Hot, Humid Regions

Siting. The desirability of reducing environmental loads applies equally in the hot, humid tropics. However, the implications for siting and building are different. Buildings will be generally more widely spaced, reflecting the relative ease of maintaining shade on intervening open areas by fast-growing planting, and the need to encourage access to breezes for naturally ventilated buildings.

Building Shape. Individual buildings may be more elongated, with their long axes running east to west. This is in order to control overhead sun, which may come from either north or south, by using of roof overhangs. Radiation from the low rising and setting sun is more difficult to avoid. "Shallow" building plans can also facilitate cross ventilation by prevailing breezes.

Natural Ventilation. Any decision to deal with elevated humidity by the traditional technique of encouraging natural ventilation alone will dictate the planning, form, and construction of the building. Ventilation under such circumstances can be assured only by exploiting and enhancing available breezes, because so-called stack effects, based on temperature differences in interior volumes, cannot produce the air movement required.

Building plans must therefore ensure that cross ventilation is not obstructed by internal partitioning. Orientation is not as critical as one might think, as planting and other external elements can be used to modify the distribution of high and low air pressure around the building. The placement of openings in the building fabric is critical. To enhance the velocity of a light breeze, outlet openings must be larger in area than inlet openings, which in turn must be so located as to direct the air stream onto occupants and the stored objects.

Design for natural ventilation is still understood poorly by most architects, and is explained inadequately in most texts. Extreme care should be taken to follow reliable literature, such as the seminal work from the Texas Engineering Experiment Station (White 1952).

Driving Rain. Control of permanent ventilation openings should be the major design parameter. Where buildings are orientated perpendicular to the direction of the prevailing wind for natural ventilation, openings are vulnerable to driving rain. Water finds a way through the smallest opening, and wind can force it up a vertical surface. Even with deep roof overhangs, penetration of water through openings designed for ventilation may be difficult to avoid.

It is best to find the solution to this in planning, rather than in construction: Areas on the periphery of the building may be dedicated to circulation spaces, with finishes designed to cope with intermittent wetting. Storm shutters may be required for some extreme situations.

Openings and Sunscreening. Openings for light generally do not need to be as restricted as in the hot, arid zone. But again, it is better not to rely on screening conventional openings from the sun using *brise-soleil-*type grids. Heat from solar radiation will transfer from such screens to ventilating air passing over them on the way to the interior. If the screen is structurally connected to the building, heat will also be passed to the interior by conduction.

Thermal Mass. As long as solar gain is minimized, permanent ventilation for air movement ensures that the thermal environment of the building will closely follow that of the outside, almost regardless of the materials of construction.

However, even with the smaller diurnal temperature swings of 5 °C to 10 °C in a hot, humid climate, designing to exploit "cool storage" in structural mass is worth considering. This is particularly true if the building is to be unoccupied at night—as museums typically are—since the usual goal of rapid cooling to improve sleeping conditions does not apply.

Szokolay (1985) reports the simulated behavior of a thermally massive building in Darwin, Australia. The heavyweight building is considerably warmer at night, which would probably be unacceptable for housing,

but in the daytime peak temperature is reduced 2 °C. This performance improves if the daytime ventilation rate is decreased to one air change per hour (AC/H) and the nighttime ventilation is increased to 30 AC/H; peak day temperature is almost 4 °C lower than for lightweight buildings, and nighttime temperature is only about 1 °C higher:

> The results look very encouraging but would require a radically different approach from solutions previously advocated. The most fundamental difference is the ventilation pattern—the reduction of ventilation rate to 1 AC/H in the daytime will make a radical difference to the thermal behavior of the building. When designing a building to give high air movement, one anticipates ventilation rates in excess of 50 AC/H. This means that internal gains would be ventilated away quickly. With a reduced ventilation rate in the daytime, the building will be much more sensitive to internal gains of any kind, and much more care must be taken with shading, etc. (Baer and Banks 1987).

Furthermore, if the daytime ventilation rate is restricted to 1 AC/H, all physiological cooling effects for occupants, and any role in prevention of mold due to natural air movement, will be lost. This air movement would have to be provided mechanically, typically by overhead fans.

Dehumidification. Where air exchange with the outside is restricted, consideration may be given to dehumidification by either mechanical or "passive" means. A system built and tested at the Miami University in Oxford, Ohio, is of interest:

> The system consists of two identical adjacent solar collector arrays of horizontal screen trays filled with a dark granular desiccant material. One collector array is covered with a glazing material and is exposed to solar radiation which heats, dries and regenerates the desiccant material. The array of horizontal trays is arranged in a stair-step configuration to maximize solar exposure and to allow solar induced convective air flow to pass through the desiccant screens, enhancing the drying process. The heated moist air is then vented to the exterior.

> The opposite array is covered with a reflective, insulating panel. Cool, moist air is drawn through the desiccant screens and its specific humidity is lowered.... Air movement through the entire system is induced by the solar heated convection in the regenerating array. When the desiccant is exhausted, the roles of the two arrays are reversed, by moving the insulating covers and changing the damper configurations. ... [Of] the desiccants studied so far, activated charcoal is preferable for the present system. It regenerates readily in the pertinent relative humidity and temperature ranges, can be recycled indefinitely, has inherent deodorization properties and is readily available at relatively low costs (Moore 1983).

The source of the makeup air could be subfloor spaces, where air would be cooled close to the monthly average wet-bulb temperature, by passing it over the large heat exchange surface of shaded and evaporatively soil cooled by evaporation. Additional control over the performance and geometry of the arrangement could be obtained by the use of a fan.

Indirect Evaporative Cooling. Despite high ambient RH, some limited potential for evaporative cooling does exist. However, to be utilized, such evaporative cooling has to be "indirect." In simple terms, the cooled but saturated air produced by a conventional evaporative cooler must be passed through a heat exchanger to cool another separate stream of air without adding moisture to it. Such units can be used only in conjunction with some dehumidification, since the RH of the interior would still rise as the temperature of the air drops.

A specialized form of indirect evaporative cooling that may be useful where water is plentiful is spraying the roof by means of simple sprinklers. Surface temperature of roofing is reduced from more than 45 °C to typically 28 °C (Kukreja ca. 1978).

Roofs. In the hot, humid zones roofs must be designed to shed rain quickly, and most often should be steeply sloping. Because they are the major source of radiant solar load, ventilated double roofs should be given careful consideration.

The use of light metal roof sheet as the external roofing in this case is problematic, as the drumming noise from frequent rain can exceed 70 dB and can compromise activities in the building. In normal single-roof

applications, thermal insulation would be placed in contact with the external sheeting to dampen this noise. In double-skin roofs, however, the insulation's potential for heat reduction would be wasted if it were installed in this location. Therefore, a rigid, massive external roof finish, such as tiles, may be more conducive to noise control. The permanent ventilation of the roof cavity can be assured by correctly designed ridge ventilators, and additional extract ventilation may be used to exhaust some of the warm air from under the ceiling.

Some Suggestions for Optimizing Mechanical Air Conditioning

Where conditions are required that simply cannot be achieved by passive measures, some old principles and new developments can increase the likelihood that air conditioning will give satisfactory performance over the long term.

The principle of "isolation rather than insulation" holds even more emphatically where air-conditioned buildings are concerned. The economy and reliability of the air conditioning will depend on the success of the building design in limiting the environmental loads. In principle, those spaces requiring the steadiest conditions should be placed at the center of a compact building, surrounded by spaces—such as circulation, offices, and concession areas—that can afford to be more vulnerable to some outside influences. Such "cocooning" spaces may even serve as return or exhaust air plenums for the main spaces, achieving intermediate conditions "for free."

DISPLACEMENT AIR CONDITIONING
Where general space conditioning is required, a dramatically different method of air supply, which has been slowly gaining in recognition over the last few years, should be considered. The system is a version of the underfloor plenum air conditioning originally used to cool large computers. To distribute the conditioned air through the building, instead of sheet-metal trunk ducting, false floors with access panels are used.

The main advantages for such a system are:

Energy Savings. Conventional air-conditioning layouts supply overcooled air at a high level, which mixes with the warm air in the room to produce desired temperatures at the occupied levels. By supplying air at a low level in interior spaces and exhausting from the ceiling, displacement systems permit higher supply temperatures for the cooled air to be maintained. The warmer air will naturally stratify toward the ceiling.

Pollution Control. It is possible that with suitable design to limit mixing turbulence, pollutants can be carried upward out of the occupied zone, and even particulate settlement rates may be inhibited.

Hygiene. One of the greatest problems with conventional air conditioning is that, once installed, ductwork cannot be cleaned conveniently, even to remove the original builders' rubbish. With subfloor plenums, regular cleaning can be carried out more readily, and condensation and mold growth quickly detected and remedied.

Adaptability. Localized conditions, such as "hot spots" caused by mechanical equipment or artificial lighting, can easily be given extra cooling.

The interesting point is that this approach works best with higher-than-normal ceilings. As these are not uncommon in museums and other cultural institutions, displacement air conditioning may be particularly suited to such applications.

DISPLAY-CASE DEHUMIDIFICATION
The ultimate economy in limiting air conditioning is to cool only display cases. However, the use of a "conventional" system to feed air to several large cases at the Egyptian Wing of the Metropolitan Museum of Art in New York was a conspicuous failure, mainly because of the rapidity and magnitude of undesirable conditions that developed when the control system failed.

A more fruitful approach, using a humidification/dehumidification unit designed to be robust, simple to build, and low in cost (under $1,000 for parts in 1982) is reported by Michalski (1982). Notable features of the prototype were:

■ Use of an automotive air filter to achieve cheap, high-efficiency, long-life particulate filtration.

■ Adaptation of a domestic refrigerative dehumidifier's compressor, cooling, and evaporative coils. Most such units have an expected life of ten years, even under arduous conditions.

■ A centrifugal blower operated significantly below its designed power.

■ An air heat-exchanger made from an automobile radiator core.

- Use of a relatively expensive humidistat capable of maintaining less than 5% drift unadjusted over six months.
- Humidifier arrays and silica-gel buffer columns, both of which are economical in parts but labor-intensive. The RH buffering is provided to smooth the ripples produced by the humidistat switching and to ensure the unit will produce dangerous levels only gradually and slowly, even if it malfunctions.
- An absorption filter of loose charcoal.

The unit supplies air to display cases through plastic piping of a maximum of 3 cm to as small as 1–2 mm bore, just fast enough to overcompensate for natural leakage. The author estimates that a total of approximately 200 cases, each one up to a cubic meter in volume, could be supplied from a unit of such specification, over a radius of 30 m. He declares that "The module will be ideal in a museum hall that has many ordinary leaky display cases in an area of uniform temperature…. Here it can provide humidity and pollution control at low cost and with little modification to the existing displays" (Michalski 1982).

Conclusions

In concentrating on aspects of the building environment in the preparation of this paper, it became obvious that the long-term integrity of objects is basically a function of good physical conditions combined with good management.

At a regional seminar on conservation in humid climates, one participant recounted how, in the attempt to upgrade storage conditions, the collection of the Fiji Museum was damaged extensively by poor handling of objects that had remained in good condition for years (Wolf 1979). The sorry state of affairs is made even more poignant by the description at the same seminar of relatively low-cost "appropriate technology" systems, which have made it possible to safely store, handle, and study difficult objects in the ethnographic collection of the University of Queensland (Lauer 1979).

This paper has made no attempt to address those more general issues of storage and security, or how sound building design can influence the effective management of a cultural institution. Such issues are not characteristically changed by geography, except insofar as they conflict with appropriate design for climate.

Emphasis has been placed instead on examining the major premises of preventive conservation that are determined by the difficult climatic conditions of the tropics. In particular, the paper has highlighted the dangers of assuming that air conditioning will solve all problems. The potentially adverse role of air conditioning in mold propagation has not previously been canvassed, whereas the dangers of temperature and RH fluctuations resulting from intermittent operation of mechanical air-conditioning systems should be well known. Even in the technologically advanced societies, mechanical systems fail—and when they fail, things tend to go wrong very quickly and very badly. In places where power supplies are unreliable and the expertise and resources to maintain sophisticated equipment are limited, one must find design approaches that are culturally, technologically, and environmentally appropriate.

At present, it must be acknowledged that for the satisfactory preservation of certain kinds of materials, the intractable problems of a hot, humid, monsoonal climate cannot be overcome by passive means alone. The best new thinking advocates the judicious combination of advanced but sturdy technologies with regionally adapted passive design. The conclusion it is hoped readers will draw is that one can build to enhance user comfort, functional efficiency, and economic viability by the enlightened use of contemporary technology, while preserving regional identity in harmony with local beliefs, methods, and customs.

Biography

Steve King, ARAIA, is Senior Lecturer in Architecture with SOLARCH, School of Architecture, University of New South Wales. His postgraduate qualfications are in Building Science, and his research specialization is in passive solar behavior and natural cooling of buildings. He has previously taught at the University of Canberra and has been a Visiting Scientist at the Jacob Blaustein Institute of Desert Research, Israel.

References

Agrawal, O. P.

1981 "Appropriate" Indian Technology for the Conservation of Museum Collections. In *Appropriate Technologies in the Conservation of Cultural Property.* Museums and Monuments 7. Paris: Unesco.

Aranyanak, C.

1988 Control of Museum Climate in Thailand. In *Control of Museum Climate in Asia and the Pacific Area.* Preprints of meeting held in Kyoto, Japan, 18 Spetember 1988. Kyoto: Japanese Organising Committee of IIC Kyoto Congress.

Aynsley, R. M.

1980 Protective Construction in the South Pacific. *General Report GRL9.* Sydney: Department of Architectural Science, University of Sydney.

Ayres Ezer Lau Consulting Engineers

1988 *Energy Conservation and Climate Control in Museums* (AEL Project No. 36300). Marina del Rey: The Getty Conservation Institute.

Bahadori, M. N.

1978 Passive Cooling Systems in Iranian Architecture. *Scientific American* 268:144–55.

Baer, N. S., and P. N. Banks

1987 Conservation Notes: Environmental Standards. *The International Journal of Museum Management and Curatorship* 6:207–09.

Baker, N. V.

1987 *Passive and Low Energy Design for Tropical Island Climates.* London: Commonwealth Secretariat Publications.

Blight, G. E.

1988 Construction in Tropical Soils. In *Proceedings of the 2nd International Conference on Geomechanics in Tropical Soils.* Singapore: A. A. Balkema.

Bravery, A. F.

1980 Origin and Nature of Mold Fungi in Buildings. In *Mold Growth in Buildings,* pp. 2–12. Princes Risborough, Aylesbury (U.K.): Building Research Establishment.

Building Research Establishment

1972 *Timber in Tropical Building.* OBN No. 146. Garston.

Cass, G. R., J. R. Druzik, D. Grosjean, W. W. Nazaroff, P. M. Whitmore, and C. L. Wittman

1988 *Protecting Works of Art from Photochemical Smog.* Marina del Rey: The Getty Conservation Institute.

Cunningham, W. A. et al.

1986 Passive Cooling with Natural Draft Cooling Towers in Combination with Solar Chimneys. In *Proceedings of The Fourth International Conference on Passive and Low Energy Architecture (PLEA).* Pecs, Hungary.

DBR

1954 *Behaviour of Building Materials in Tropical Regions* (No. SB 30). Sydney: Commonwealth Experimental Building Station.

Feilden, B. M.

1979 Design of Museums for Conservation of Cultural Property. In *Regional Seminar on the Conservation of Cultural Materials in Humid Climates,* C. Pearson (ed.), pp. 66–77. Canberra: Australian Government Publishing Service.

1987 *Between Two Earthquakes: Cultural Property in Seismic Zones.* Rome/Marina del Rey, California.: ICCROM/The Getty Conservation Institute.

Freemantle, E.

1988 Humidity Control for Small Volumes. In *Control of Museum Climate in Asia and the Pacific Area.* Preprints of meeting held in Kyoto, Japan, 18 September 1988. Kyoto: Japanese Organising Committee of IIC Kyoto Congress.

Gazzola, P.

1972 Restoring Monuments: Historical Background. In *Preserving and Restoring Monuments and Historic Buildings.* Paris: Unesco.

Hunderman, H. J.

1988 Humidity and Building Materials in the Museum Setting. In *The Interior Handbook for Historic Buildings,* C. E. Fisher (ed.), pp. 4.29–4.34. Washington, D.C.: Historic Preservation Education Foundation.

Kervanto, A.

1988 Urban Conservation in the Third World. In *Proceedings of Building Conservation 88 Symposium,* M. Ivars (ed.), pp. 107–14. Helsinki: Finnish National Commission for Unesco.

King, S. E.

1984 State of the Art in Passive Cooling. In *Proceedings of 'ANZES',* R. K. H. Johnson (ed.). Canberra: Canberra College of Advanced Education.

Kukreja, C. P.

ca. 1978 *Tropical Architecture.* New Delhi: TATA McGraw-Hill.

Lauer, P.

1979 The Economy of Artifact Storage. In *Proceedings of Regional Seminar on the Conservation of Cultural Materials in Humid Climates*, C. Pearson (ed.). Canberra: Australian Government Publishing Service.

Lesiuk, S.

1983 Landscape Design for Energy Conservation in the Middle East. In *Islamic Architecture and Urbanism*, A. Germen (ed.), pp. 215–31. Damman: King Faisal University.

Lippsmeier, J. G.

1969 *Tropenbau: Building in the Tropics*. Munich: Callwey.

Maheu, R.

1970 *Protection of Mankind's Cultural Heritage*. Report to the Executive Board, UNESCO, May 1970. Paris: UNESCO.

Michalski, S.

1982 A Control Module for Relative Humidity in Display Cases. In *Proceedings of Science and Technology in the Service of Conservation*, N. S. Bromelle et al. (eds.), pp. 28–31. Washington, D.C.: The International Institute for Conservation of Historic and Artistic Works.

Miller, A. A.

1961 *Climatology*. London: Methuen.

Moore, F.

1983 Learning from the Past: Passive Cooling Strategies in Traditional and Contemporary Architecture. In *Islamic Architecture and Urbanism*. A. Germen (ed.). Damman: King Faisal University.

Munich Reinsurance

ca. 1990 *Windstorm*.

Nair, S. M.

1972 Biodeterioration of Museum Materials in Tropical Countries. In *Proceedings of Conservation in the Tropics*, O. P. Agrawal (ed.). New Delhi: ICCROM.

Padfield, T.

1968 Design of Museum Showcases. In *Proceedings of Museum Climatology*. London: International Institute for Conservation.

Padfield, T., and P. Jensen

1990 Low Energy Climate Control in Museum Stores. In *Proceedings of ICOM Committee for Conservation, 9th Triennial Meeting*, pp. 596–601, Dresden. Los Angeles: ICOM Conservation Committee / The Getty Conservation Institute.

Pearson, C.

1988 The Problems of Environmental Control in Pacific Island Museums. In *Control of Museum Climate in Asia and the Pacific Area*, pp. 1–10. Preprints of meeting held in Kyoto, Japan, 18 September 1988. Kyoto: Japanese Organising Committee of IIC Kyoto Congress.

Pitchard, P.

1984 Emergency Measures and Damage Assessment After an Earthquake. Paris: UNESCO.

Rosenberg, A.

1986 Report on a Visit to the National Museums of Gabon, Central Africa. In *The Care and Preservation of Ethnological Materials*, R. Barclay, et al. (eds.). Ottawa: Canadian Conservation Institute.

Rytkonen, A.-L., et al.

1988 The Effect of Air Temperature and Humidity on the Growth of Some Fungi. In *Proceedings of Healthy Buildings 88*, B. Berglund and T. Lindvall (eds.). Stockholm: Swedish Council for Building Research.

Saini, B. S.

1980 *Building in Hot Dry Climates*. New York: J. Wiley.

Stolow, N.

1979 *Conservation Standards for Works of Art in Transit and on Exhibition*. Paris: UNESCO.

Szent-Ivany, J. J. H.

1968 Identification and Control of Insect Pests. In *The Conservation of Cultural Property, with Special Reference to Tropical Conditions*. Museums and Monuments 11. Paris: UNESCO.

Szokolay, S. V.

1985 Passive and Low Energy Design for Thermal and Visual Comfort. In *Proceedings of Third International Conference on Passive and Low Energy Architecture (PLEA)*. New York: Pergamon.

Thomson, G.

1972 Climate and the Museum in the Tropics. In *Proceedings of Conservation in the Tropics*, O. P. Agrawal (ed.). New Delhi: ICCROM.

1986 *The Museum Environment*. 2d ed. London: Butterworths.

Toishi, K.

1979 Tropical Climate and New Concrete Buildings for a Museum. In *Proceedings of Regional Seminar on the Conservation of Cultural Materials in Humid Climates*, O. P. Agrawal (ed.). Canberra: Australian Government Publishing Service.

United States National Research Council

1986 *Preservation of Historical Records.* Washington: National Academy Press.

White, R. F.

1952 *Effects of Landscaping on Natural Ventilation of Buildings and Their Adjacent Areas.* College Station: Texas Engineering Experiment Station.

Wolf, S. J.

1979 Appendix A: Delegates Statements: Fiji. In *Proceedings of Regional Seminar on the Conservation of Cultural Materials in Humid Climates*, C. Pearson (ed.), pp. 105–6. Canberra: Australian Government Publishing Service.

Recommended Reading: Design for Climate with Emphasis on the Tropics

Aronin, J. E.

1979 *Climate and Architecture.* New York: AMS Press.

Bahadori, M. N.

1978 Passive Cooling Systems in Iranian Architecture. *Scientific American* 268:144–55.

Baker, N. V.

1987 *Passive and Low Energy Design for Tropical Island Climates.* London: Commonwealth Secretariat Publications.

Building Research Establishment

1980 *Building in Hot Climates.* London: Her Majesty's Stationery Offices.

Evans, M.

1980 *Housing, Climate and Comfort.* London: Architectural Press.

Fry, M., and J. Drew

1964 *Tropical Architecture in the Dry and Humid Zones.* London: Batsford.

Givoni, B.

1976 *Man, Climate and Architecture.* 2d ed. New York: Van Nostrand Reinhold.

Golany, G. S.

1983 *Design for Arid Regions.* New York: Van Nostrand Reinhold.

Koenigsberger, O. H.

1974 *Manual of Tropical Housing and Building.* London: Longman.

Konya, A.

1980 *Design Primer for Hot Climates.* London: Architectural Press.

Kukreja, C. P.

ca. 1978 *Tropical Architecture.* New Delhi: TATA McGraw-Hill.

Lippsmeier, J. G.

1969 *Tropenbau: Building in the Tropics.* Munich: Callwey.

Munich Reinsurance

ca. 1990 *Windstorm.*

Olgyay, V.

1975 *Design with Climate.* Princeton: Princeton University Press.

Robinette, G. O.

1977 *Landscape Planning for Energy Conservation.* Reston, Virginia: Environmental Design Press.

Saini, B. S.

1980 *Building in Hot Dry Climates.* New York: J. Wiley.

Yannas, S.

1983 *Passive and Low Energy Architecture.* Crete: Pergamon.

Appendix

Disasters and Extreme Events

The careful work of patient preservation under routine circumstances can be rendered useless if culturally significant materials are not safeguarded from catastrophic loss or damage.

The term "protective construction" was coined during the 1950s in studies initiated by U.S. Civil Defense authorities. It refers to the conscious design and construction of buildings to resist infrequent but severe load conditions. A principal aim of protective construction is to lessen the impact and resulting damage inflicted on the community by disasters, including violent windstorms, earthquakes, volcanic eruptions, flood, fire, and human-made problems of riot and unlawful entry. From the beginning, the literature on the subject has stressed that design with consideration for each of the above problems results in similar construction features; thus, for a small increase in cost, buildings can be designed to provide a significantly greater degree of protection to occupants from a wide range of harmful events (Aynsley 1980). Three types of extreme events are characteristic of tropical regions and are discussed below.

CYCLONES

Whether referred to as hurricanes, typhoons, cyclones, or one of many other locally used names, these severe conditions are one and the same phenomenon: a huge eddy of clouds building up over tropical and subtropical oceans and leaving behind incredible damage in their wake. These storms entail intense windstorm, storm surge, and inundation.

Tropical cyclones are confined to regions where the water temperature at the surface of the ocean is above approximately 27 °C. Below this threshold temperature—or over land—cyclones cannot "fuel" themselves, and quickly lose energy. Within about 5° of the equator, cyclones fail to develop, because the Coriolis force resulting from the rotation of the earth is too weak to divert air currents into the eddy formations that develop in other latitudes.

Wind velocities generated by a cyclone result from the sum of its speed of rotation and its general rate of progress. The destructiveness of a cyclone can therefore be determined according to whether it passes a location with its "bad" side or its "good" side facing inland, the difference in maximum wind speeds between "good" and "bad" ranging as high as 100 km per hour.

A booklet published by Munich Reinsurance (ca. 1990) notes:

Not only the extremely high wind velocity (measurements have shown speeds of more than 300 kph) in the event of a cyclone will cause considerable damage, but also the high storm surge are particularly hazardous in flat coastal areas: masses of water are forced against the coast by the storm, while at the same time the water is lifted up by the low barometric pressure in the center of the eddy. The sea will also become very rough for many days with enormous waves causing severe erosion damage in conjunction with the very strong currents. Yet another factor is that tropical cyclones contain huge amounts of vapor and condensed water resulting in incredible rainfall above all in mountainous regions along the coast. Up to 2,000 mm of rainfall (that is 2,000 liters per square meter) have been measured within just 1–2 days; it is quite obvious that precipitation of this magnitude will cause devastating floods particularly when accumulating in the catchment area of several rivers. Last but not least, the high-speed winds around a cyclone sometimes cause smaller eddies at the edge when hitting topographical obstacles or simply on account of shear forces, such smaller eddies then going their own way as cyclone-induced tornadoes and causing even greater local damage.

The Consequences for Buildings. Buildings in cyclone-prone areas must be designed to withstand the forces generated by extreme winds from all directions. Single-story and lightly constructed buildings are particularly vulnerable because their mass is less than the suction force engendered. Reinforced-concrete struc-

tures are considered particularly safe because of their construction and high dead load.

The rapid and extreme changes of air pressure pose further hazards. If a building is particularly well sealed—as are modern, fully air-conditioned structures—and it is hit too quickly by the center of a storm with its extremely low pressure, the building fabric can be explosively blown out by the pressure differential (Lippsmeier 1969).

The general provisions for strong winds may be summarized as: (1) resistance to lateral loads; (2) resistance of fixings for cladding materials to repetitive dynamic suction loads; and (3) debris resistance of the external envelope of the building.

Building Regulations. Fundamental research leading to regulation of all of these construction attributes was carried out in Australia following the 1973 Townsville and 1974 Darwin cyclones. The recommendations have been incorporated in Australian standards for construction, and should serve as guidelines for the use of contemporary construction techniques in other countries in the region.

The recommendations may be summarized as:
■ Generously dimensioned foundations, continuous systems of ties anchoring wall- and roof-framing to the footings, and the use of screwed and bolted fixings in place of more conventional clips for wall and roof claddings
■ Stringent bracing of framed construction, and steel reinforcing of hollow concrete blockwork
■ Care with the corrosion protection of steel fixings and reinforcements, particularly when they are hidden from view
■ Strengthened anchorages for door and window frames, with special attention to hinges and the protection of glazed areas
■ Special attention to waterproofing, because conventional detailing will not withstand the wind-driven rains

The codes of practice are based primarily on protecting human life, and thus in some situations where windborne debris is likely to occur, for economic considerations significant debris resistance may be restricted to a single small enclosure within a building. In a museum setting, this requirement would need to be significantly expanded.

The following notes of caution regarding regulations are based on remarks offered by Munich Reinsur-ance (ca. 1990), a major international insurer with extensive experience in situations of catastrophic loss:

■ In some countries, regulations are recommended, but not mandatory. The result is that principals and contractors often try to "economize" in designing new buildings—a mistake, considering that even in highly exposed coastal regions the additional cost of making a building resistant to wind forces amounts to no more than 1% to 4% of the overall cost of construction, while at stake is the risk of the total loss of the building.

■ The forces acting on a building are generally calculated in accordance with the maximum wind velocity anticipated to occur once in fifty years, as a mean ten-minute value and a peak gust. However, this definition, and a number of other aspects set forth briefly below, cause various problems obstructing the introduction and application of suitable construction rules.

■ The meteorological data available are not sufficient for calculating such fifty-year values reliably, particularly in topographically rough areas. In addition, it is not possible to reliably forecast future changes in wind conditions.

■ The fifty-year values may constitute too great a residual risk for a museum or archive to accept.

■ Nowadays, often only specialists are capable of properly interpreting the pertinent building regulations, which have become so complicated that they are beyond the scope of the average engineer or architect. As a rule, straightforward calculation examples are lacking.

■ The pertinent regulations and directives cover buildings of only relatively simple design and with standard shapes. In practice, however, things tend to be far more complicated, particularly when it comes to highly exposed areas, such as the roofs and facades of buildings. Moreover, not enough is known even today on the distribution of pressure acting on the building and generated inside the structure itself.

■ New findings in the field of building aerodynamics, in particular new loss experience, are only taken into account in the pertinent regulations after many years. Conversely, it is quite possible that after just a few years without a major windstorm disaster principals, architects, and contractors will seek to have the rules slackened and restrictions waived.

■ The interaction of adjacent buildings is not taken into account sufficiently. In large cities, for example,

wind velocities are considerably lower and buildings "protect" each other, while at the same time there is a substantial risk of widespread damage caused by debris flying through the air.

■ More than in designing buildings to withstand earthquake forces, many details have to be taken into consideration in designing buildings to withstand all the flow and pressure effects generated by strong wind, meaning that the responsible engineers, architects, and builders must have years of experience and comprehensive know-how in this field. If such experience is applied properly, however, it would appear quite possible to design, construct, and operate any kind of building so safely that all wind forces can be mastered without problems.

EARTHQUAKES

With the exception of peninsular India and most of Australia, the whole South Asia/Pacific region falls into recognized seismic zones. In Sir Bernard Feilden's words, "We must always be aware that we live between two earthquakes" (1987). While the effects of earthquakes are uncertain insofar as the magnitude, detailed location, and time of occurrence are at present unpredictable, certain precautions can minimize the likelihood of unacceptable loss of cultural property.

Seismological records allow the calculation of the "return period" of an earthquake of a particular intensity at any given place. As with cyclones, this is a statistical concept, useful in the formulation of policy as to the relative benefits of various safety precautions, but of little use in predicting the detailed effects at particular sites.

The destructive potential of each earthquake is dependent on a complex set of local factors, of which by far the most important is unfavorable ground conditions. After the relatively minor earthquake in Newcastle, Australia, in 1989, which led to disproportionate structural damage in some areas, authorities went so far as to propose that earthquake risk for a particular location be expressed as a function of the foundation conditions of buildings, rather than on the basis of return periods.

On this basis, detailed maps of any particular area showing sites of particularly high risk may be prepared, using only geological data. Where such "microzona-

tion" has not been carried out, the principles can be applied in the examination of individual sites. The following summary abstracted from Feilden (1987) should serve as a general guide:

Sites underlain by Holocene and Pleistocene sedimentary deposits undergo shaking of intensities 2.6 to 3.4 times greater than those underlain by crystalline rock. Void ratio has a strong influence. Void ratios in the 0.8 to 0.9 range indicate a mean response on soil six times greater than crystalline rock, and three times greater than soils with low void ratios. High silt-to-clay and saturation ratios are both unfavorable, as are situations in which the water table is close to the surface. High short-period response may also occur at sites underlain by rock if these sites are near ridgecrests or other pronounced topographical features.

In general, maximum amplitudes of motion are worst on alluvial soils, and of all types of sites, these should be avoided most assiduously when planning new buildings.

Building Responses. The general vernacular response to building in seismic zones in the Pacific region has been the use of lightweight timber construction. This was motivated by two considerations. First, in the absence of technologies to impart tensile strength to masonry structures, it was advantageous for the building to be flexible rather than rigid. Second, in the event of collapse, casualties were minimized by the use of lightweight claddings. Unfortunately, under such circumstances as in Tokyo in 1923, fire became a greater destructive force than the earthquake that induced it.

With contemporary technology, reinforcing of concrete and blockwork to achieve given degrees of earthquake resistance is quite feasible. As a consequence, construction that allows for the magnitude of lateral forces anticipated in an earthquake is not constrained by building materials alone. The necessary details and other associated measures are well documented in the building regulations of New Zealand, Japan, and California.

The exception to the use of massive construction would be for the accommodation of vehicles. Pitchard strongly advises that in order to ensure the serviceability of vehicles in an emergency, garage and carpark sites should be chosen with care:

In an earthquake area, garages made of light material... will always be preferable to masonry garages. Particular care should be taken not to park under several storeys of offices or apartments. Even temporary parking of vehicles should be prohibited near buildings (within a distance of twice the height of the building), and not merely prohibited by signs but physically obstructed by planting trees, terracing, erecting low walls, digging ditches, etc. (Pitchard 1984).

Historic buildings may be protected from excessive damage in earthquakes by a reasoned strategy of continuous maintenance and appropriate structural intervention. The key to a successful program is informed risk assessment, good documentation, adequate disaster planning, periodic inspections, and continuous maintenance.

Practical advice regarding preparation for earthquakes is available in the ICCROM/GCI publication *Between Two Earthquakes* by Sir Bernard Feilden (1987).

TIDAL WAVES AND STORM SURGES
Earthquakes under the sea, called marine earthquakes, are hardly perceptible where the water is very deep. But they produce tidal waves known as *tsunami,* which may cause enormous damage. The flood tide caused by a marine earthquake is preceded by a very low ebb tide. Tsunami are characterized by very long wavefronts and extremely rapid rates of propagation. This tremendous kinetic energy builds them to considerable height and enables them to develop great destructive power as they approach land over shallow water. They travel very large distances at sea before dissipating their energy. The highest tidal wave to date—213 feet high—was recorded in 1737.

Storm surge caused by cyclonic activity is usually of lesser magnitude, but of longer duration. The effect is that of an unusually high tide resulting from masses of water driven toward the coast by the storm, combined with a rise of water level as a result of lower atmospheric presssure. Low, flat coastlines are particularly vulnerable to the combination of higher water level and aggressive wave action. Severe coastal erosion can result.

Traditional housing on coasts exposed to storm surge has often employed construction elevated on stilts, to allow wave action to take place with minimal

resistance. Ultimately the only protection available to larger, more critical facilities—such as museums—is appropriate siting on high ground.

THE GREENHOUSE EFFECT
Despite the large number of different hypotheses underlying the complicated climate models applied today, current extrapolations indicate a worldwide increase in temperature of about 1 °C to 5 °C by the middle of the next century, which would give us the highest mean global temperatures since the Ice Age began some 2.5 million years ago. Half of this projected effect is attributed to CO_2, about 17% to chlorofluorocarbons (CFCs)—the propellants in sprays, refrigerators, and foamed plastics—and another 33% to the effects of other trace gases.

The warmest year, since the beginning of worldwide meteorological measurements about 130 years ago, was 1988. Five other years in the last decade also had mean global temperatures higher than all other mean yearly temperatures recorded so far. This certainly indicates a significant increase in the temperature of the atmosphere, meaning that the anthropogenic greenhouse effect is already becoming noticeable.

This increase in temperature has been observed in recent years above all in tropical areas, while not much has changed in the polar regions. Surprisingly, this contradicts nearly all climate model calculations and their forecasts, where temperatures in the polar regions had been predicted to go up several times faster than on a global average. This alone indicates that a certain amount of skepticism would still appear appropriate as regards the application of such model calculations in general and their regional implications in particular.

A further rise in sea level, which in this century already amounts to about 10 cm, is just as difficult to predict as any ongoing increase in temperature. It would appear that a rise in sea level by another 30 cm by the middle of the next century is likely, but a rise of as much as 1.5 m is possible. Most of this would be the result of the melting of inland ice, which has already occurred on a dramatic scale in some areas such as the European Alps. A further decrease in the amount of ice in the next few years may already be regarded as certain to occur owing to the slow response of such melting processes to weather conditions.

A warmer atmosphere and warmer seas result in greater exchange of energy and add momentum to the vertical exchange processes so crucial to the development of tropical cyclones, tornadoes, thunderstorms, and hailstorms. Accordingly, such natural hazards will increase not only in frequency and intensity, but also in duration and the size of the areas at risk.

This applies above all to tropical cyclones, which will penetrate moderate latitudes and thus also affect areas so far not exposed to this risk. Detailed measurements in the Pacific show that the areas with water temperatures at the surface above 27 °c have expanded by about one-sixth in the last two decades. While substantial fluctuations from one year to the next and additional factors, such as the complex of climatological effects known as El Niño, make it impossible so far to prove the effect of such higher temperatures on the frequency of tropical cyclones, superhurricanes Gilbert and Hugo may certainly be regarded as a clear sign of an increase in hurricane intensity. According to estimates, hurricane activities in the Caribbean, for example, will increase considerably in the next two to three decades, the loss potential going up by more than 50%. Together with the rising level of the sea, this also means a much greater risk of storm surges in densely populated coastal regions in the tropics and subtropics (abstracted from Munich Reinsurance, ca. 1990).

The Plenary Session:
Summary of the Discussion

■

The five invited papers, participants' presentations, and working sessions of the first three days of the symposium proved to be catalytic, generating many ideas about how to introduce protection of cultural property into policy contexts and into educational initiatives for professional groups and the general public. Knowing that government policies must be developed and implemented by individuals, the participants of the symposium reviewed the discussions of the first four days, with the goal of identifying specific actions that would encourage public and private support for conservation of cultural property. What follows here is a summary of the discussions in the final session.

In governments and societies where scientific conservation and the protection of cultural heritage are new ideas, creating an awareness of this need takes time. Not only must elected and appointed officials be persuaded by experts, they must be convinced that there is support from the citizenry. To build a new approach for those who make policy, then, conservation advocates must first develop public awareness of the importance of cultural resources and the need for their stewardship.

In these final sessions, the symposium participants drew on their own experiences and on the ideas generated in the working groups as they suggested strategies to accomplish this objective. Five general questions served to organize the first part of the discussion. In the second part of the sessions, participants named specific organizations that assist nations in the region to develop policy and foster professional enhancement in the area of heritage protection.

How can support for heritage protection be promoted among the general public?

Encourage public support for museums, historic preservation, and archaeology through memberships or subscriptions in voluntary groups (e.g., Friends of Cultural Heritage, National Trusts, Friends of Museums, etc.).

Use public relations and marketing strategies to capture the public imagination. Enlist corporate sponsors for advice and support in implementing such strategies.

Use the print and broadcast media to encourage public support for government action. For example, develop two-minute public service announcements for placement on television just before the evening news or during the most popular viewing time for adults.

Work through news organizations to influence decision-makers by educating journalists about the issues and needs involved in heritage protection. Develop an accessible resource library or database for journalists to consult on heritage conservation and/or management questions.

Publish picture books (on recycled paper) to demonstrate the need for conservation, to attract funding for certain projects, and to capture the attention of influential people both inside and outside of government.

Encourage people to love and care for their heritage through formal and informal education at all levels.

Formal school programs can use school curricula and field trips to educate children. When possible, the materials developed for these programs can be sent home with the children for family use. Informal education programs should concentrate on those groups in the best position to change attitudes among policy makers, teachers, religious leaders, and others.

Implement essay competitions for school teachers relating to cultural property protection and the national interest.

Tailor teaching materials on cultural heritage to the specific context using local images and examples.

Where appropriate, encourage churches, temples, and/ or monasteries to serve as centers of information about cultural heritage.

To focus public and political attention on issues, develop National Heritage Awards for children, university students, and adults.

Develop informative signage for monuments and sites that emphasize their importance and signal that they are valued and protected.

In what ways can government officials encourage citizens to value cultural heritage?

Establish conservation and protection of cultural heritage as a high national priority.

Persuade elected representatives interested in cultural heritage to pressure their governments to control sites and to coordinate activities with other ministries.

Using other regional examples as models, design a project to develop an inventory of cultural property, which should then be prioritized according to carefully considered criteria. This inventory, along with a clear set of objectives for conservation, could be incorporated into legislation.

Link community-based plans for conservation education to other local/regional planning processes.

Promote "grassroots" educational campaigns in the countryside to encourage appropriate action by local residents who encounter archaeological materials or sites.

Declare local or national "cultural heritage days" (or months, weeks, etc.) to focus public attention and political action on a single event.

Where officials change jobs frequently, ask representatives from the official heritage body to give periodic lectures to civil servants and to heads of government sections.

When new cultural heritage policies are being considered, how can government officials prepare for their approval and implementation?

Organize a national cultural heritage development service.

Develop appropriate legislation to protect the cultural heritage from obvious and subtle threats resulting from overt action and indirect policies. Before policies are approved, explore possible inadvertent negative consequences for cultural heritage protection.

Once government action begins to focus on these issues, policies for conservation must become more sophisticated. Investigate the current legal structure regarding cultural property protection, find areas where new legislation or policy would be helpful, and look for ways to introduce the appropriate legislation.

Integrate heritage conservation and management into national environmental policy and land use planning at all levels. Look to other national programs for models.

Use law enforcement personnel as allies in eliminating loss of cultural property. For example, educate customs officials about issues of ownership and trade concerning movable cultural property.

Take advantage of the role of Interpol, an international police organization active in collecting and disseminating information on the illegal trafficking of cultural property, in publicizing threats to cultural property. National governments are responsible for distributing Interpol notices.

How can governments identify partnerships that will enhance their ability to protect the cultural heritage?

Encourage regional cooperation in the development of legislative tools as well as other matters of common interest.

Send mayors and other policymakers to view developments in town center conservation, planning, conservation training, site management, arts programs, etc., in other countries. (The United States organized such a trip to Europe in 1965, which resulted in the 1966 National Historic Preservation Act.)

Ratify UNESCO conventions in order to gain support in regional efforts to protect threatened heritage.

What strategies improve a nation's ability to protect cultural heritage without economic loss?

Funds required for cultural heritage conservation must be seen as an investment. The cultural heritage of a nation is an asset, not a liability. In order to make these ideas clear to policymakers, proponents of cultural heritage protection need to identify ways of placing conservation issues on the agendas of all multilateral and bilateral meetings where aid is discussed.

Protection of cultural heritage—ancient and historic —should be built into any national plan.

Protective programs for natural or cultural heritage are very attractive for visitors. Such efforts generate awareness of the need for conservation and demonstrate the state's interest and commitment. This, in turn, inspires confidence in those responsible for funding.

Public awareness of the economic costs and benefits of each project, and of conservation efforts in general, enhance the intangible benefits of "nation building."

A nation's heritage can be a profitable resource that—if managed wisely—can be sustained indefinitely. Well-managed tourism can promote growth in all economic areas.

Because the best funding sources are specific to projects and national contexts, local sources of support should be strongest. A localized and protective sense of "ownership" works best.

Tax incentives should be investigated. Here again, regional models might be instructive.

Government agencies should look to both public and private sectors for alternative ways of fundraising for the management of historic and archaeological sites and collections.

Where allowed by law, museums can offer memberships to the general public and to schools in order to raise revenues.

Public involvement in, and support for, archaeological projects as well as museums can be encouraged through membership or subscription through museums or departments of archaeology.

Many countries have published compendia of information on sources of funding for heritage programs. Other regional compendia could be developed on these models. Workshops could be held on techniques for financing cultural conservation; these materials could also be published.

The possibilities for debt-swapping to finance efforts in heritage conservation should be investigated through local channels. In a debt exchange, a conservation organization acquires commercial bank debt of a developing country, either by purchasing it at a substantial discount from the debt's face value or receiving it as a donation. The organization then agrees to cancel the debt in return for the borrower country's commitment of additional resources to local conservation. This innovative financial mechanism allows conservation organizations to help underwrite their conservation investments while simultaneously providing a way for a host country to reduce its external debt (from *The Debt-for-Nature Exchange*, 1989, Conservation International, Washington, D.C.)

Creative research can turn up underused resources.

Some regional possibilities were suggested:

The Asian Development Bank (ADB) has usually refused to fund cultural projects, but it has recently approached Nepal with a request for projects. Japan is playing an increasingly supportive role in bilateral cultural aid programs.

The World Bank can be approached for assistance in a few specific areas; they can be approached directly with requests for information.

There has been a recent decline in conservation assistance from foundations based in the United States. Two possible alternatives might be UNESCO and the United Nations Development Program.

The United Nations World Food Programme might be helpful in certain circumstances as a mechanism for supporting projects of cultural heritage conservation. It has been involved in Sri Lanka's "Cultural Triangle" Project, for example, and should be investigated for support of similar applications elsewhere.

Most individuals who raise funds recognize that managing the fund-raising effort is at least as important as receiving the funds. Many loans and grants are provided on a one-time basis and do not address the ongoing needs of the project. Conservation of cultural heritage is, in most instances, a protracted process, so those who are procuring funds should devise long-term financing whenever possible.

Endowments are rarely available for support of conservation activities; funding recipients are usually prohibited from investing research money in order to earn interest. Concerted efforts should be made to present projects in a way that makes giving endowment funds attractive to funders.

Operating funds can be difficult to procure, but they are easier to obtain if they are requested at the beginning of the project as part of the overall planning process. In Bhutan, for example, multilateral funds were used to establish a trust for such purposes.

Recommendations for Specific, Immediate Action

The working groups of the symposium recommended a wide variety of measures that could be taken immediately. They generally concurred that actions should be conceived regionally and should include the Pacific Island states.

Organize regional conferences/symposia on the following themes:

Conservation planning in urban areas

Heritage site management and resource planning

National cultural heritage legislation and charters to guide protection and conservation activity

Planning of national strategies for professional training

Protection of movable cultural property

Public education and involvement

Technical conservation practices

Tourism, economics, and conservation

Develop regional specialized training opportunities in the following areas:

Creation of private, nonprofit heritage organizations to facilitate fundraising and the use of volunteers

Cultural site and collections management

Development of community support for, and government sensitivity to, the importance of cultural heritage to the fabric of the nation

Documentation and application of traditional building techniques and materials, such as wood and stone

Identification of sources of funding; how to frame requests for assistance

Legal practices and enforcement of existing laws and regulations

Preventive conservation for movable cultural property

Regional art, architectural history, and local or regional history

The use of both craftsmanship and modern technology in conservation

The following professional groups are suggested for future exchange fellowships or travel grants for the purpose of learning new approaches to problems commonly faced in conservation:

Archaeologists

Architects and architectural historians

Archivists, registrars

Art historians

Civil servants

Cultural heritage educators
Curators
Museum administrators
Objects conservators

Actions Suggested for Participant Nations

Bring the successful methods of the environmental conservation movement to cultural heritage conservation.

Broaden regional exchange of information, experience, technical expertise, and resources (including published material and databases) related to cultural heritage conservation.

Consider developing national guidelines for heritage conservation based on the principles of the ICOMOS Venice Charter, tailored specifically to local and national needs and traditions.

Move toward ICOMOS membership and development of national committees. Membership is also encouraged in ICOM, through national committees, and ICCROM (Associates and Member States).

Promote the idea that heritage conservation can be a form of sustainable development.

Work to reconnect immovable with movable cultural property in legal and normative documents and attitudes.

Ratify the UNESCO conventions: The Hague Convention of 1954; The Convention on the Means of Prohibiting and Preventing the Illicit Import, Export, and Transfer of Ownership of Cultural Property; and The World Heritage Convention of 1972.

Resource Guide

The symposium organizers and participants suggested the names of some institutions and organizations around the world that might help in the regional implementation of the actions proposed above, through exchanges of information on fundraising, site management, museum development, training, policy, and conservation programs.

INSTITUTIONS AND ORGANIZATIONS

AAM — American Association of Museums
1225 Eye Street N.W., Suite 200
Washington, D.C. 20005, U.S.A.
Welcomes international membership.

AATA — *Art and Archaeology Technical Abstracts*
The Getty Conservation Institute
4503 Glencoe Avenue
Marina del Rey, California 90292, U.S.A.
Publishes two volumes annually, 5,000 abstracts per year. Available by subscription.

ACCU — Asian Cultural Center for UNESCO
c/o Nihon Shuppan Kaikan
6 Fukuromachi, Shinjuku-ku
Tokyo 162, Japan

ASEAN — Association of South East Asian Nations
Jalan Sisingamangaraja 70A
Jakarta, Indonesia

CIN — Conservation Information Network
CHIN — at Canadian Heritage Information Network
365 Laurier Avenue West
Journal Tower South, 12th Floor
Ottawa, Ontario KIA OC8, Canada
Contains 130,000 citations (including those in AATA), primarily bibliographic information. Available through the GCI or CHIN.

ICCROM — International Center for the Study of the Conservation and Restoration of Cultural Property
Via di San Michele, 13
00153 Rome, Italy
An intergovernmental organization (countries are members). The annual newsletter is available free of charge.

ICOM — International Council of Museums
Maison de l'UNESCO
1 Rue Miollis
75732 Paris Cedex 15, France

Individual and institutional memberships available. Its excellent document on conservation ethics is available for conservation professionals involved in movable cultural property.

See also:

ICOM Asia Pacific Organization
c/o Dr. Saroj Ghose, Chair
National Council of Science Museums
Block GN, Sector V
Bidhan Nagar, Calcutta, India

ICOMOS International Council on Monuments
and Sites
7 Rue de Temple
75003 Paris, France
Individual or institutional memberships are available (with five members, a start-up committee; with eighteen, a full voting committee).

GCI The Getty Conservation Institute
4503 Glencoe Avenue
Marina del Rey, California 90292, U.S.A.
Telephone: 310-822-2299
Facsimile: 310-821-9409
Publishes Conservation: The GCI Newsletter *three times per year. Subscriptions are available free of charge. Also organizes courses (see next section).*

IFAR International Foundation for Art Research
46 East 70th Street
New York, New York 10021, U.S.A.
Publishes the IFAR Report, *which includes articles on art law, cultural property, and theft and recovery. It is published ten times per year.*

IIC International Institute for Conservation
6 Buckingham Street
London WC2N 6BA, United Kingdom

IUCN International Union for the Conservation
of Nature and Natural Resources
Avenue du Mont-Blanc
CH-196 Gland, Switzerland
Publishes regional inventories of protected areas. Two that have been published for the Asia/Pacific region include cultural sites; for most countries, however, it is noted that no information is available. To remedy this, send information to the World Monitoring Center in Cambridge, England.

SAARC South Asian Association for
Regional Cooperation
(also SAARC Archaeological Congress)
Kathmandu, Nepal

SPAFA South East Asian Ministers of
Education Organization
Regional Centre for Archaeology and
Fine Arts
Darakarn Building
920 Sukhumit Road
Bangkok 10110, Thailand
Organizes courses, publishes SPAFA Digest *twice per year; active in conservation and underwater archaeology.*

Pacific Regional Conservation Center
Bishop Museum
1525 Bernice Street
P.O. Box 19000-A
Honolulu, Hawaii 96817, U.S.A.

Tokyo National Research Institute for
the Conservation of Cultural Properties
13-27 Ueno Park, Taito-ku
Tokyo 110, Japan

UNESCO United Nations Educational and
Scientific Organization
Division of Physical Heritage
7 Place de Fontenoy
75700 Paris, France

USIS United States Information Service
 Contact the U.S. Embassy in your country
 *The USIS representative should be kept
 informed of local programs and projects of
 cultural heritage conservation for general
 information sharing and advice.*

 The World Bank
 1818 H Street N.W.
 Washington, D.C. 20433, U.S.A.

WHC World Heritage Committee
 c/o UNESCO, World Heritage Centre
 I, Place de Fontenoy
 75700 Paris, France
 *Governments on the twenty-member commit-
 tee are asked to nominate experts to attend
 meetings. Meetings are open to anyone inter-
 ested, and minutes/reports are available upon
 request.*

WMF World Monuments Fund
 174 East 80th Street
 New York, New York 10021, U.S.A.

TECHNICAL RESEARCH AND
TRAINING OPPORTUNITIES

For a listing of available courses arranged by country, see
the *International Index on Training in Conservation of
Cultural Property,* copublished by ICCROM and the GCI.

The Getty Conservation Institute (4503 Glencoe Ave-
nue, Marina del Rey, California 90292, U.S.A.)
offers short-term training courses for midcareer pro-
fessionals. Courses are announced in *Conservation:
The GCI Newsletter,* and information may be
requested from the Training Program.

The National Research Institute for the Conservation
of Cultural Property (13-27 Ueno Park, Taito-ku,
Tokyo 110, Japan) holds training courses and semi-
nars on Asian cultural heritage.

The National Research Laboratory for Conservation of
Cultural Property (C-257, Nirala Nagar, Lucknow
226007, India) offers both training courses and
research opportunities.

The national park services of many countries offer tech-
nical assistance and consultation, as well as occa-
sional training opportunities. Canada has several
good, published examples of site management case
studies that are available through the Parks Service
(Parks Canada, Conservation Branch, 1550 Liver-
pool Court, Ottawa, Ontario, Canada). Also con-
tact the U.S. National Park Service, Office of
International Affairs (800 North Capital Street NW,
Room 330, Washington, D.C. 20001).

The Cultural Triangle Project, Sri Lanka offers paid
internships and field training in excavation and con-
servation, and supports students (undergraduate,
graduate, and postgraduate) for a few positions
(Central Cultural Fund, 212 Bauddhaloka
Mawatha, Colombo 7, Sri Lanka).

The International Journal for Cultural Property, (Walter
de Gruyter & Co., Genthiner Str. 13, D-1000, Ber-
lin 30) is a new professional journal covering a
broad spectrum of issues in site management, legis-
lation, policy, ethics, and conservation. It also
offers book reviews, notices of meetings, and other
network assistance. It deals with both tangible and
intangible cultural heritage, as well as movable and
immovable resources.

The University of Canberra, Australia (POB I, Belcon-
nen, ACT 2616) has courses in cultural heritage
management, museum studies, and conservation
at the B.A., MA., and Ph.D. levels.

All museum studies courses are listed in *Museum Studies
International,* published annually by the Smithso-
nian Institution (900 Jefferson Dr., Washington,
D.C., U.S.A.).

George Washington University has a one-year certificate program in museum administration, designed especially for foreign students (The George Washington University Museum Studies Program, Academic Center, T-215, Washington, D.C. 20052, U.S.A.).

The AAM/ICOM International Partnerships for Museums Program allows exchanges of personnel between the United States and other nations. For information, contact the USIS cultural affairs officer at the United States Embassy in your country.

Distance learning (correspondence) courses in museum studies and cultural heritage management are available through the University of Victoria in Canada (University of Victoria, P.O. Box 1700, Victoria, British Columbia V82 2Y2, Canada).

Massey University in New Zealand offers a museum studies course that can be taken as a three-year correspondence course (Museum Studies, Faculty of Social Sciences, Massey University, Palmerston North, New Zealand).

ICCROM offers short-term courses (2–7 months) on architectural conservation and wall paintings conservation, as well as ceramics, paper, and preventive conservation (ICCROM, Via di San Michele 13, Rome, RM-00153).

Symposium Participants

AUSTRALIA

Mr. Max BOURKE

General Manager
Australia Council
181 Lawson Street, Redfern NSW 2016
Telephone: 61-2-950-9003
Facsimile: 61-2-950-9059

Dr. Colin PEARSON

Director
National Centre for Cultural Heritage and
Science Studies, University of Canberra
Post Office Box 1, Belconnen, ACT 2601
Telephone: 61-6-252-2368
Facsimile: 61-6-201-5999

Ms. Sharon SULLIVAN

Executive Director
Australian National Heritage Commission
Post Office Box 1567, Canberra, ACT 2601
Telephone: 61-6-271-2111
Facsimile: 61-6-273-2395

BANGLADESH

Dr. A.K.M. Shamsul ALAM

Director
Department of Archaeology and Museums
22/1 BL.-B, Barbar Road, Mohammadpur, Dhaka 1207
Telephone: 88-2-237-608

Mr. Shah Alam ZAHIRUDDIN

Chief Architect
Directorate of Archaeology and Museums
Purto Bhaban, Segunbagicha, Dhaka
Telephone: 88-2-256-792

CHINA, THE PEOPLE'S REPUBLIC OF

Mr. MAI Yinghao

Honorary Director
Guangzhou Museum
Room 307, 74 Xihu Street, Guangzhou 510030

Mr. SONG Beishan

Deputy Manager of Promotions Centre
State Bureau of Cultural Relics
29 Wu Si Street, Beijing 100009
Telephone/Facsimile: 86-1-4013101

FRANCE

Dr. Lyndel V. PROTT

Chief, International Standards Section
Division of Physical Heritage, UNESCO
1, Rue Miollis, 75015 Paris
Telephone: 33-1-45-68-10-00

INDIA

Mr. Dev MEHTA

Chairman and Managing Director
Maharashtra Tourism Development
Corporation Ltd.
Express Towers, 9th Floor, Nariman Point
Bombay 400 021
Telephone: 91-22-202-4482
Facsimile: 91-22-202-4521

Indonesia

Mr. I. Gusti Ngurah ANOM

Director, Directorate of Protection and Development of Historical and Archeological Heritage
Directorate General of Culture
Ministry of Education and Culture
4 Jalan Cilacap, Jakarta 10310
Telephone: 62-21-384-8272
Facsimile: 62-21-310-7734

Mr. Martono YUWONO

Chief Architect / Planner
City of Jakarta Urban Planning and
Development Office
Dinas Tata Kota Balai Kota Lantai 13/Block G
Medan Merdeka Selatan 8-9, Jakarta 10110
Telephone: 62-21-384-8254
Facsimile: 62-21-384-8254

Japan

Dr. Nobuo ITO

Professor, Kobe Desogn University
Chairman, ICOMOS National Committee, Japan
19-18, Midorigaoka, Kashiwa-shi, Chiba-ken 277
Telephone: 81-78-794-5031
Facsimile: 81-78-794-5032

Mr. Tadateru NISHIURA

Head of Asian Cultural Heritage
Conservation Division
Tokyo National Research Insititue of
Cultural Properties
13-27 Ueno Park, Taito-Ku, Tokyo 110
Telephone: 81-3-3823-2241
Facsimile: 81-3-3828-2484

Malaysia

Mr. ADI Haji Taha

Acting Director of Antiquities
National Museum of Malaysia
Museums Department
Jalan Damansara, 50566 Kuala Lumpur
Telephone: 603-238-0255
Facsimile: 603-230-6294

Ms. RABIAH Mas Haji Adom

Architectual Conservator
Conservation and Urban Design Unit
No. 2, Jalan Sotia Bakti, Bukit Damansara
50350 Kuala Lumpur
Telephone: 603-291-6962
Facsimile: 603-291-8675

Micronesia, Federated States of

Mr. Teddy A. JOHN

National Historic Preservation Officer
Division of Archives and Historic Preservation
Federated States of Micronesia National Government
Post Office Box PS35, Palikir, Pohnpei 96941

Mr. Andrew KUGFAS

Yap State Historic Preservation Officer
Office of the Governor
Post Office Box 426, Colonia, Yap 96943
Telephone: 691-350-2198
Facsimile: 691-350-2381

Nepal

Dr. Shaphaiya AMATYA

Acting Director General
Department of Archaeology
Ramshah Path, Kathmandu
Telephone: 44-1-273701

Mr. Karna Bahadur SAKYA

President
Nepal Heritage Society
c/o Hotel Ambassador
Lazimpat, Kathmandu
Telephone: 977-1-414432
Facsimile: 977-1-413641

New Zealand

Mrs. Mina L. McKenzie

Director
Manawahatu Museum
321-325 Church Street, Post Office Box 1867
Palmerston North
Telephone: 64-6-358-3951
Facsimile: 64-6-355-4184

Mr. Graham Stuart PARK

Director
Auckland Institute and Museum
Private Bag, Auckland
Telephone: 64-9-309-0443
Facsimile: 64-9-799-956

PAKISTAN

Mr. Syed Zaigham S. JAFFREY, AIAP, AIA

Habitat Pakistan
223-E, First Floor, Block 2 Pechs, Karachi, 75400
Telephone: 92-21-493-1770
Facsimile: 92-21-531-972

Dr. Ahmad Nabi KHAN

Director General of Archaeology and Museums
Government of Pakistan
27-A Central Union Commercial Area
Shaheed-E-Millat Road, Karachi
Telephone: 92-21-430-638

PHILIPPINES

Father Gabriel CASAL

Director
The National Museum of the Philippines
Executive House
P. Burgos Street, Ermita, Manila
Telephone: 63-2-481-427 or 63-2-404-183

Ms. Edda HENSON

Administrator
Intramuros Administration
5/F, Palacio del Gobernador, Cor. Gen. Luna and
A. Soriano Streets, Intramuros, Manila 1002
Telephone: 63-2-461-188 or 63-2-476-667
Facsimile: 63-2-522-2194

SINGAPORE

Mr. GOH Hup Chor

Deputy Chief Planner
Planning and Design
Urban Redevelopment Authority
URA Building, 45 Maxwell Road, Singapore 0106
Telephone: 65-321-8107
Facsimile: 65-224-8752

Mr. KWA Chong Guan

Director
The National Museum
Stamford Road, Singapore 0617
Telephone: 65-330-0919
Facsimile: 65-330-0963

SRI LANKA

Dr. Senake D. BANDARANAYAKE

President, ICOMOS/Sri Lanka
Director, Postgraduate Institute of Archaeology
Post Office Box 1531, 212 A Bauddhaloka Mawatha
Colombo 7
Telephone: 94-1-503-061
Facsimile: 94-1-575-599 or 575-535

Dr. Roland SILVA

President, ICOMOS
Hôtel Saint Aigan
75, Rue du Temple
75003 Paris
Telephone: 94-1-421-370
Facsimile: 94-1-449-659

Mr. Gamini S. WIJESURIYA

Director, Architectural Conservation
Department of Archaeology
Colombo 7

THAILAND

Mr. Pises JIAJANPONG

Head, Project for the Survey and Registration
of Ancient Monuments
Archaeology Division
Fine Arts Department
81/1 Sri Ayutthaya Road, Bangkok 10300
Telephone: 66-2-282-3767

Professor Srisakara VALLIBHOTAMA

Associate Professor of Anthropology
Department of Anthropology
Silpakorn University
Na Phra Larn Road, Bangkok 10200
Telephone: 66-2-221-3898
Facsimile: 66-2-225-7258

UNITED STATES OF AMERICA

Dr. William J. Murtagh

Director, Pacific Preservation Consortium
University of Hawaii
Sixth West Cedar, Alexandria, Virginia 22301
Telephone: 703-548-5477

Dr. June Taboroff

Cultural Resource Specialist, World Bank
1818 H Street, NW, Washington, D.C. 20433
Telephone: 202-472-2982
Facsimile: 202-477-0568

Dr. James L. Westcoat

Consultant, World Bank
2891 Ellison Place
Boulder, Colorado 80304

Sponsoring Organization Representatives

UNITED STATES INFORMATION AGENCY

Dr. William P. Glade

Associate Director for Educational
and Cultural Affairs (through August 1992)

Mr. Jack Josephson

Chairman, Cultural Property Advisory Committee

Mrs. Ann Guthrie Hingston

Executive Director, Cultural Property
Advisory Committee (through February 1993)

Mrs. Maria Papageorge Kouroupas

Deputy Director, Cultural Property
Advisory Committee

301 4th Street, sw, Room 247
Washington, D.C. 20547
Telephone: 202-619-6612
Facsimile: 202-619-5177

UNITED STATES COMMITTEE
OF THE INTERNATIONAL COUNCIL ON
MONUMENTS AND SITES:

Mrs. Terry B. Morton, Hon. AIA

President

Mr. Russell V. Keune, AIA

Vice President for Programs

Mr. Robertson E. Collins

Chairman, ICOMOS International Committee
on Cultural Tourism

1600 H Street, NW
Washington, D.C. 20006
Telephone: 202-842-1866
Facsimile: 202-842-1861

THE GETTY CONSERVATION INSTITUTE

Mr. Miguel Angel Corzo

Director

Dr. Frank Preusser

Associate Director, Programs

Dr. Nicholas Stanley Price

Deputy Director, Training Program

Dr. Margaret G. H. Mac Lean

Senior Coordinator, Training Program

4503 Glencoe Avenue
Marina del Rey, California 90292, USA
Telephone: 213-822-2299
Facsimile: 213-821-9409

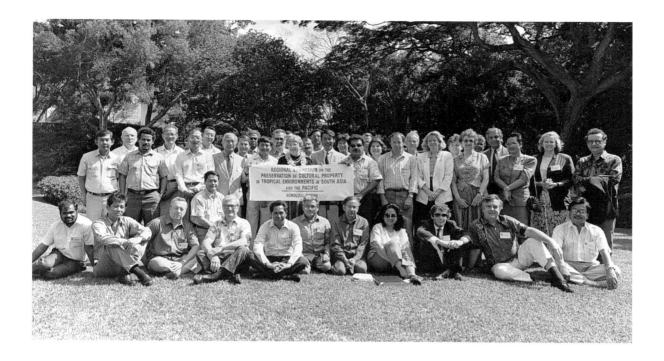

Symposium Participants

Front row (left to right): Gamini S. Wijesuriva (Sri Lanka), Martono Yuwono (Indonesia), Russell V. Keune (United States), Gabriel Casal (Philippines), William J. Murtagh (United States), I. Gusti Ngurah Anom (Indonesia), A.K.M. Shamsul Alam (Bangladesh), Ahmad Nabi Khan (Pakistan), Rabiah Mas Haji Adom (Malaysia), Frank Preusser (United States), Max Bourke (Australia), Karna Bahadur Sakya (Nepal).

Second row (left to right): Pises Jiajanpong (Thailand), Adi Haji Taha (Malaysia), Goh Hup Chor (Singapore), Nobuo Ito (Japan), Shaphalya Amatya (Nepal), Terry B. Morton (United States), Tadateru Nishiura (Japan), Teddy A. John (Micronesia), Colin Pearson (Australia), Ann Guthrie Hingston (United States), Mina L. McKenzie (New Zealand), Edda Henson (Philippines), Margaret G.H. Mac Lean (United States), Syed Zaigham S. Jaffrey (Pakistan).

Third Row (left to right): Robertson E. Collins (United States), Mai Yinghao (People's Republic of China), Song Beishan (People's Republic of China), Nicholas Stanley Price (United States), Graham Stuart Park (New Zealand), Dev Mehta (India), June Taboroff (United States), Maria Papageorge Kouroupas (United States), Jack Josephson (United States), Sharon Sullivan (Australia), Roland Silva (Sri Lanka).

Fourth Row (left to right): Senake D. Bandaranayake (Sri Lanka), Shah Zahiruddin (Bangladesh), James Westcoat (United States), Srisakara Vallibhotama (Thailand).

Participants not in photograph: Miguel Angel Corzo (United States), William P. Glade (United States), Kwa Chong Guan (Singapore), Andrew Kugfas (Micronesia), Lyndel V. Prott (France).